COLOUR
Demystified

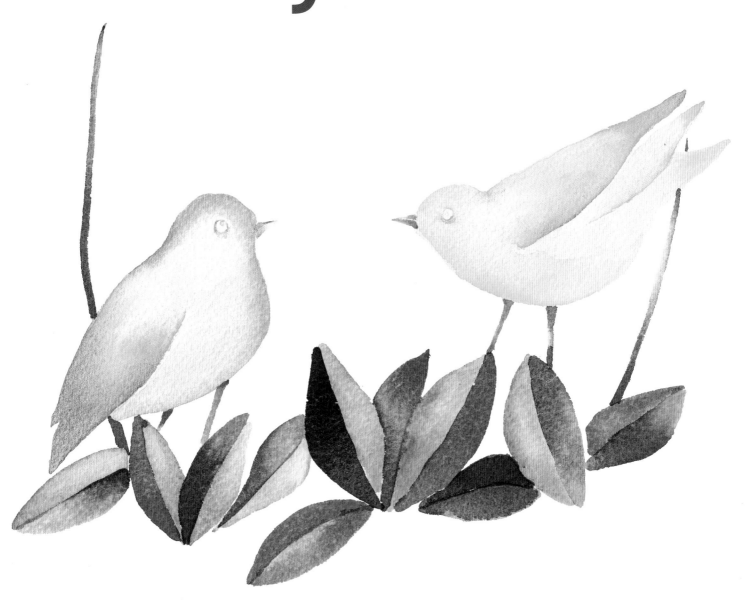

For Sam and Joe, my greatest teachers.

Acknowledgements

As part of the research for this book I visited the paint manufacturers Winsor & Newton. I was fortunate to be shown some of the processes as well as the many machines and equipment that are vital to making the paints that we use. It was wonderful to have the opportunity to see behind the scenes; I had never before appreciated the expertise, research and development that goes into a tube of paint.

I am very grateful for all the support and the sponsorship I have received while writing this book. I would like to thank the following people for their time, encouragement, generosity and enthusiasm for my work on colour.

Beth Harwood, Search Press

Katie French, Search Press

Mark Davison

Berni Donohoe, Premium Art Brands

Catherine Frood, St Cuthberts Paper Mill

Varsha Bhatia, RI

Lilias August, RI

Claire Harkess

Christine Forbes

Dr Sally Bulgin, *The Artist* magazine

Deborah Wanstall, *The Artist* magazine

Prints and Drawings Room, Tate Britain

St Cuthberts Paper Mill

Premium Art Brands

Daniel Smith Watercolours

Stephanie Tebbia, ColArt

Laura Triptree, ColArt

Mark Cann, ColArt

Debbie Bryan, ColArt

Winsor & Newton

Chris Horridge

Sam Horridge

Joe Horridge

First published in 2021
Search Press Limited
Wellwood, North Farm Road,
Tunbridge Wells, Kent TN2 3DR

Reprinted 2022

Text copyright © Julie Collins

Photograph on page 39 by iStock.com/Cakeio; photographs on page 40 by Julie Collins.

All other photographs by Mark Davison for Search Press Studios.

Pages 6, 82–83, images © Lilias August, RI; pages 75–76 and 96–97, images © Claire Harkess; page 77, images © Varsha Bhatia, RI; pages 94–95, images © Christine Forbes.

Photographs and design copyright © Search Press Ltd. 2021

ISBN: 978-1-78221-797-8
ebook ISBN: 978-1-78126-754-7

The Publishers and author can accept no responsibility for any consequences arising from the information, advice or instructions given in this publication.

Suppliers
If you have difficulty in obtaining any of the materials and equipment mentioned in this book, then please visit the Search Press website for details of suppliers: searchpress.com

You are invited to visit the author's website: www.juliecollins.co.uk

COLOUR
Demystified

A COMPLETE GUIDE TO MIXING AND USING WATERCOLOURS

Julie Collins

SEARCH PRESS

Contents

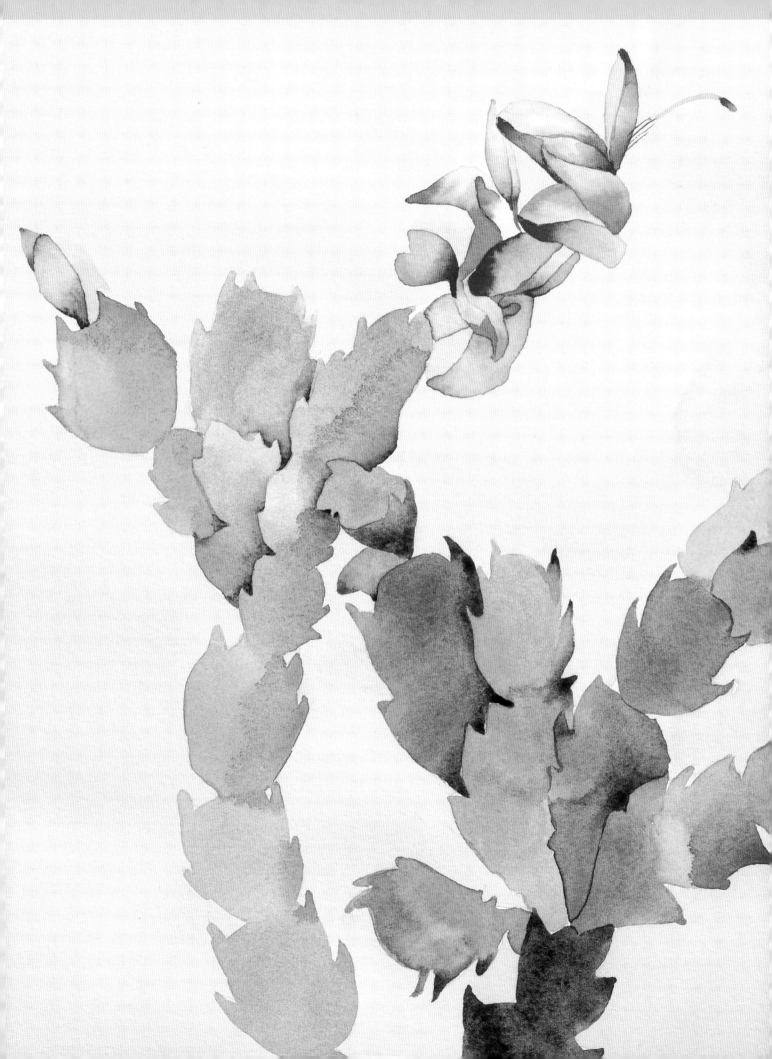

Introduction

Colour is a vast and complex subject. In the process of writing this book, I have become obsessed with colour. I wrote my first book on colour in 2006, and since then I have spent countless hours thinking, planning and deciding how to present to you my personal approach to colour. As time goes on and I write more about colour and paint new pictures, my fascination with the subject increases. It has been a great joy to be able to look into the subject in more depth and with fresh eyes.

I have a huge admiration for artists who use bright and bold colours successfully; my own use of colour is often very subtle. Our colour choices are transient, however, and will often also depend on where we are, the weather conditions and how we feel. Last summer, the weather in Cornwall, UK, was more like the Mediterranean, and the watercolour paintings I created then were very bright – a true reflection of the weather and of my mood. I had also recently visited an exhibition of the work of Patrick Heron (1920–1999) at the Tate St Ives gallery. I greatly admire Heron's use of colour and was undoubtedly inspired by looking at his work. By looking, learning and trusting my own response, I became much more confident with my own use of colour. I encourage you to visit as many exhibitions as you can and examine your own response to the paintings and the colours you see. You may only get to see some of these paintings once in your lifetime, so take your time and have a good look at them while you can. Art transports you to another place, informs you in new ways and can literally move you to tears.

Contemporary painters become colourists through a long process of growth and learning. This involves studying the works of the great masters, reading about colour and experimenting with their palettes. Inspirational paintings by several artists are included in this book to give you

TEN GREEN BOTTLES
Lilias August, RI
89 × 30cm (35 × 11 ¾in)

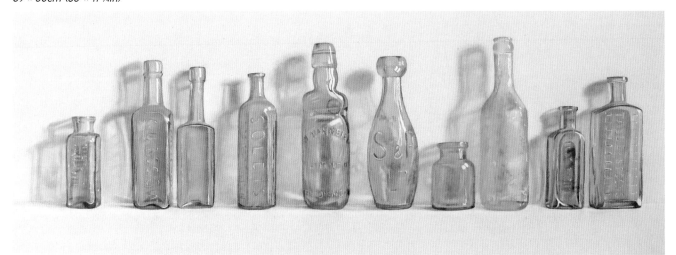

a flavour of the many diverse colour palettes and styles of painting used in watercolour. As such, the works of other artists and their unique use of colour will inevitably inspire your own colour palette.

The purpose of this book is to help you create a coherent colour-mixing reference guide and to inspire your colour choices through the understanding – the demystifying – of colour. I encourage you to follow the exercises and the step-by-step projects and build up your own workbook to refer to in the future. This practical approach will help you, as an artist, learn a considerable amount about colour. Reading around the subject is useful, but you cannot beat the hands-on experience of trying something yourself. The chapters are presented in a logical order, beginning with the basics of colour relationships. I have always found that getting back to basics is very useful – almost like having a spring clean or a clear-out to get rid of things that you no longer need.

I always advise my students to look closely and learn how to *see* colour. By looking and seeing, you will begin to think more about colour and relate to colour in your own way. The main aim of this book is to convey my personal view on the practical use of colour in art, inspire you and, ultimately, demystify the subject.

As well as learning how to handle colour, you also need to learn to feel colour and appreciate how it works. I will never forget when, as a young art student, Anish Kapoor (b. 1954) arrived as one of our visiting lecturers for the day. He sat us round in an informal circle and showed us his early works, which were cone-shaped piles of coloured powders: such a simple but effective idea. These pieces had been inspired by the spice stalls he had seen in India – this was part of his heritage and was very personal to him and his family. He had literally seen the colour, and then created his art in a truly authentic way. He had made the old and familiar new.

Throughout this book, therefore, we explore what it is about colour that is such an inherent part of how and why we paint in the way we do.

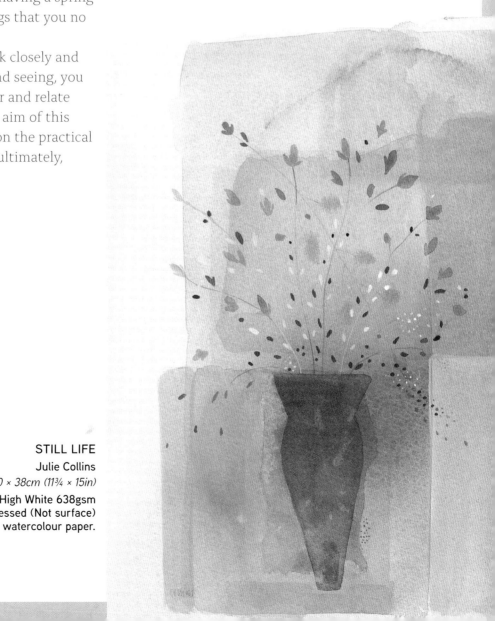

STILL LIFE
Julie Collins
30 × 38cm (11¾ × 15in)
Painted on Saunders Waterford High White 638gsm
(300lb) Cold-pressed (Not surface)
watercolour paper.

MATERIALS

One of the many wonderful aspects of watercolour painting is that you don't have many materials and tools. A limited palette of colours, a mixing palette, a selection of good-quality brushes, watercolour paper, a drawing board, sketchbook, masking tape, kitchen paper and a water pot are all you need.

WATERCOLOUR PAINTS

It is important to get to know the brands and qualities of the paints that are available. Watercolour paints are typically separated into two categories: artists' or professional, and students' paints. Artists' paints are more expensive as they contain more pigment than the students' range and therefore are of better quality; in a students' range, the quality, richness and light-fastness of the colours will not be as good. In addition, many colours are not available in the students' ranges.

My advice is always to buy the best paint that you can afford, and for ease of use and understanding of your colours, it is a good idea to work with one range to begin with. However, most ranges can be mixed together.

I'm often asked which watercolour paints to buy. This is a personal choice, but I favour tubes of watercolour to pans. For large paintings I use paint straight from the tube and mix in the palette. I also squeeze paint into empty pans (as seen in the watercolour boxes opposite) to be used for smaller paintings and *plein air* painting. I favour empty watercolour boxes so that I can select the colours that I want to use. Every watercolour box shown opposite has had the paints filled from tubes with the exception of the top-middle watercolour box. I have used artists' and professional tubes and pans for all the artwork in this book, including Daniel Smith Extra Fine watercolour tubes, Winsor & Newton Professional watercolour tubes, QoR tubes and Daler-Rowney artists' pans.

A selection of some of the many tubes of paint and a few pans that I have used in this book. This includes several manufacturers' brands, and a pot of black ground, far left. The black ground, from Golden, is used to make a black background that can be used with iridescent watercolour as shown on page 141.

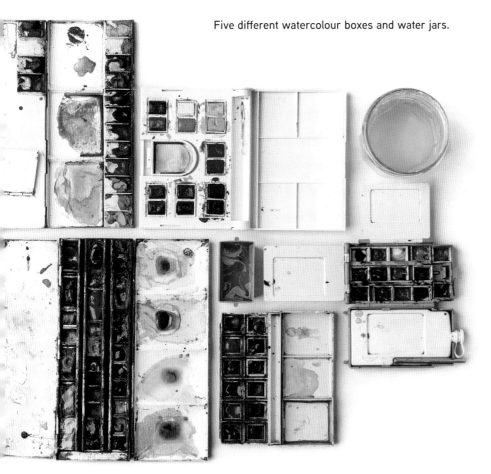

Five different watercolour boxes and water jars.

Watercolour boxes

My preference is for a metal watercolour box: the two on the left of the photograph are metal, as is the small outdoor painting box on the right (which has a water bottle included on one side). The plastic box in the middle of the top row is a good, affordable Cotman (students') box: this comes with pans of watercolour and is fine to start out with.

9

Mixing palettes

Mixing palettes come in various shapes and sizes as shown on the right. I have at least twelve porcelain palettes so that I can organize my mixing, but, as you can see from the picture, things can get out of hand!

A ten-well slant palette is handy as you can put pure colour in the smaller round wells and your mixes in the slanting oblong wells. The daisy-shape palettes are good for mixing larger quantities of paint. The palettes on the side of my watercolour box are also always well-used for mixing too. For very large amounts of paint, I use large ceramic bowls.

I'm not keen on plastic palettes as they are much harder to mix on. I also avoid using plates for mixing as I find them hard to organize and the different mixes tend to run into each other.

Clockwise from top-left: two porcelain ten-well slant mixing palettes, a medium porcelain daisy-shape seven-well palette, a ceramic six-well slant ceramic palette, a porcelain ten-well slant palette and a large porcelain daisy-shape seven-well palette.

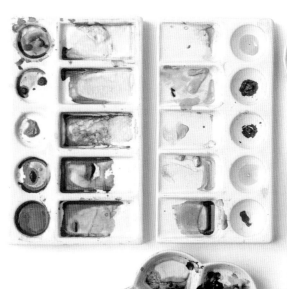

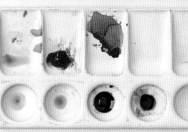

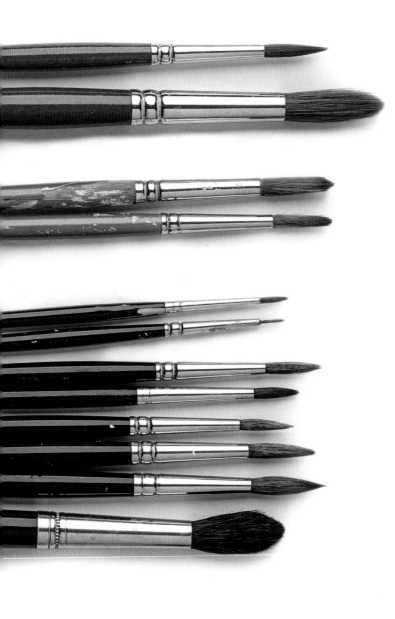

Brushes

There are so many brushes to choose from, but as you can see from the images on the left, I use only round brushes for my watercolour painting. These range from good-quality synthetic brushes to the finest sable and squirrel mops. The most important thing is that the brush has a good point. Once the point is ruined, you won't be able to paint well with it. A squirrel mop has the advantage of having a very good point and it also holds a lot of paint, which is advantageous when covering a large area. Finest sable brushes hold a lot of paint too, but are increasingly expensive. The synthetic brushes, like the ones shown left, are extremely good quality, and if you buy a decent make and look after them properly, they will last for a long time.

I always recommend using an old brush for colour mixing as it is a waste to wear out an expensive brush for this purpose.

Other shapes of brushes can be useful for making particular effects – for instance, a rigger is good for branches and a large flat brush is good for watercolour washes. However, I have always been able to achieve the marks that I want in my watercolour painting with various round brushes, just like the ones that you see here.

The most important point to remember is to look after your brushes and replace them when they get worn out, otherwise you will not be able to paint successfully with them.

MY BRUSHES, FROM TOP TO BOTTOM

1. Winsor & Newton Sceptre Gold II sable synthetic brushes: two sizes;

2. Winsor & Newton Cotman III round synthetic brushes: two sizes;

3. Winsor & Newton Series 7 Finest sable brushes: three sizes;

4. ABS 3 Kolinsky Sable;

5. Winsor & Newton Series 7 Finest sables: three sizes;

6. Rowney UK brush;

7. Isabey 6234 Petit Gris squirrel mops: sizes 2/0, 2, 4 and 8.

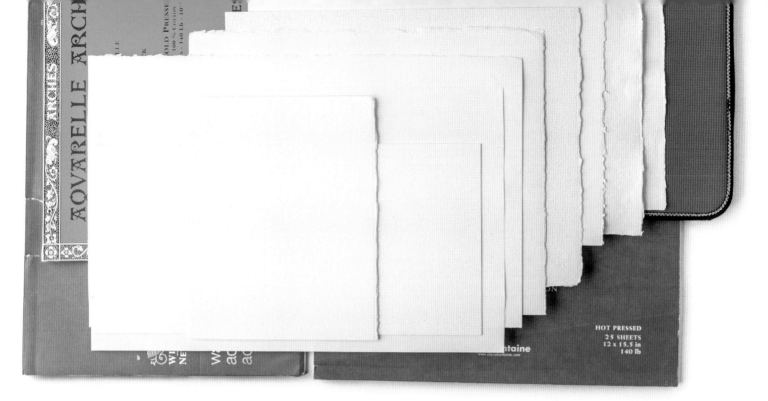

A selection of the watercolour papers used in this book.

Papers

The image above shows several watercolour papers that vary greatly in texture, colour, surface and weight. These include Saunders Waterford Hot-pressed and Cold-pressed (Not) surfaces in White and High White; Bockingford Rough; Khadi Rough, Arches Rough and Hot-pressed, Fabriano Hot-pressed, and three watercolour blocks of Arches, Winsor & Newton and Clairefontaine. You may notice an embossed watermark on the more expensive brands of paper – this is the manufacturer's symbol or name. The small fuchsia portfolio is idea for carrying around paper and artwork safely.

Watercolour paper from St Cuthberts Paper Mill was used for all the artwork in this book. This includes the Saunders Waterford and Bockingford papers. The Cold-pressed (Not) – or CP/NOT – surface has a texture that is ideal for still life and landscape paintings. The rougher the paper, the more texture will appear in your painting. This does vary from one manufacturer to another; however, all Bockingford papers create amazing texture, as seen throughout the book, as they are quite rough and textured.

Hot-pressed (or HP) paper has a smooth surface and is wonderful for painting flowers. It can create blooms if used in larger areas of paint – of course this is fine if you want this in your work. It is much easier to paint a flat or smooth wash on CP/NOT or Rough paper.

The last consideration with paper is the weight. The heavier the weight, the more expensive the paper will be. In addition, unless they are soaked and stretched, lighter papers can cockle and bow, especially if you paint in a wet style. I use 638gsm (300lb) watercolour paper for most of my work as I don't like to soak and stretch my paper onto a board. This weight is almost as great as cardboard, and has been used for many of the paintings in this book.

Take care to note the weight of your papers in both pounds (lb) and grams per square metre (gsm): it can be easy to think that a 300gsm is a heavy paper when in fact it equates to 140lb, which is comparatively light.

11

Caring for your watercolour paper

Caring for your paper is extremely important in order to preserve the quality and the colour-fastness of your paintings. It is a good idea to store your watercolour paper in sealed, clear plastic, out of the light and away from any changeable atmospheric conditions. Remember that sunlight will always spoil your paper. Paper that isn't stored correctly will be ruined by the size rising to the surface: the paper then behaves like blotting paper and cannot be used for watercolour painting. Size is the gelatinous substance applied to watercolour paper to reduce its absorbency.

Workspace materials

Other materials that I find invaluable within my workspace include a brush case, to protect brushes in transit, and brush protectors to keep good points on my brushes. My pencil case holds various pencils, including HB, 2B and 6B; a putty eraser, as this is gentle on watercolour paper; a pencil sharpener; a wax candle (for wax resists – see page 154) and masking tape. Scissors, a heavy-duty knife, a scalpel, metal rulers and a cutting board are invaluable for cutting watercolour paper to the size that I need. I have various drawing boards in numerous sizes up to A2 – 420 × 594mm (16½ × 23⅜in).

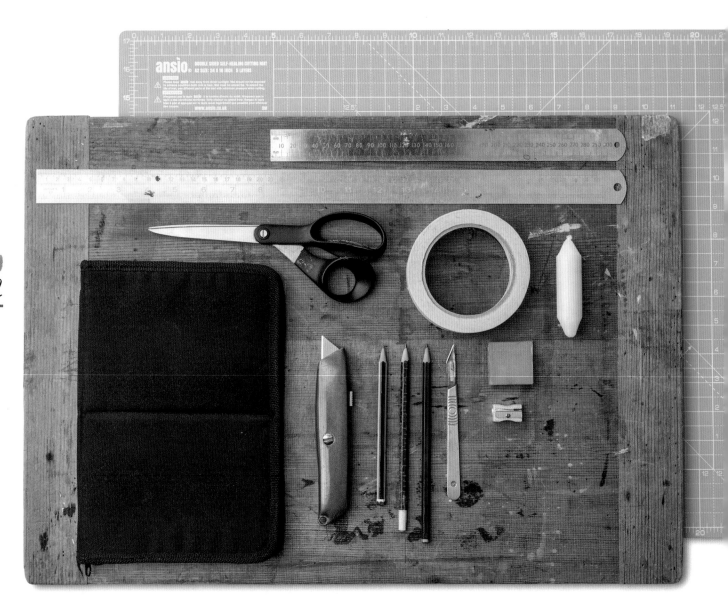

Sketchbooks

There are many sketchbooks available to the watercolour artist – I use a cartridge paper sketchbook for drawing; a small Moleskine sketchbook as it's handy to carry around in my bag; a notebook which I also take everywhere; and various Rough-paper watercolour sketchbooks, such as from Khadi.

Tips before you begin painting

I have noticed that, in the process of writing this book, I have tidied up some of my bad habits in the studio. Instead of being impatient, I have been taking more time preparing myself to paint and I am more thoughtful about colour and colour combinations.

- Tidy up any mess.

- Ensure that you have good lighting. Ideally, this will be daylight, or a lamp with a daylight bulb.

- Check that you have all the materials that you need for an exercise before you begin work.

- Make sure that your working space is comfortable and the right temperature for you to work in.

- Get into the right frame of mind by carefully cutting paper to the sizes you need.

- Clean your palettes and check that your brushes are completely clean too.

- Organize your paints into colour groups.

- Make sure that you have several pots of clean water.

THE LANGUAGE OF COLOUR

As watercolour painters, we depend upon luscious colour to tell our stories in paint. In this chapter, we go back to the basics, beginning with examples of how to make creative colour wheels and charts. The pure scientific study of colour is unlikely to inspire an artist; however, if these points are presented in a creative, visual way, then they can be of use.

That said, the history of colour and colour theory is a fascinating subject. It was only in the comparatively recent seventeenth century that the concepts of primary and secondary colours emerged. These are concepts that we now take for granted, but it is believed that the ancient Greeks saw colours running from white to black, where blue was slightly lighter than black and yellow was slightly darker than white.

In 1704, Isaac Newton (1642–1727) published *Opticks*, a study of the nature of light and colour. He demonstrated that colour arises from light, whereby each hue is refracted at a characteristic angle by a prism or lens. Newton's colour wheel proved to be hugely influential and his spectrum of seven colours (red, orange, yellow, green, blue, indigo and violet) meant that white and black were no longer considered colours and the spectrum no longer ran from light to dark. The colour wheel, colour relationships and complementary colours had a profound effect on art in the future.

While researching for this book, I visited Winsor & Newton, where I studied their heritage collection. The heritage pieces include a beautifully hand-painted reference guide to pigments, illustrated in 1804 by the chemist George Field (1777–1854). This annotated book gives specific information on the characteristics and lightfastness of each pigment. Field's own book, *Chromatography*, was written in 1835 and is a fascinating insight into the pigments he researched at the time. Each colour is catalogued: for example, Number 68 Cadmium red: 'This is a most vivid orange-scarlet, the red predominating, of exceeding depth and intense fire.'

FLOWER VASE
38 × 28.5cm (15 × 11¼in)

Painted on Saunders Waterford High White 638gsm (300lb) Cold-pressed (Not surface) watercolour paper.

Research for this book has also introduced me to the vast array of charts and systems created from the late seventeenth century to the late eighteenth century. *Werner's Nomenclature of Colours* (1814), features some of the first colour charts used to describe colour in the taxonomy of plants and animals. This book, compiled by the geologist Abraham Gottlob Werner (1749–1817) was used by Charles Darwin (1809–1882) to describe colours in nature on his voyage on the *HMS Beagle*. *Werner's Nomenclature of Colours* provided immense handwritten detail as to where particular colours could be found in nature – for example, that Prussian Blue could be located in the beauty spot of a mallard's wing.

When Michel-Eugène Chevreul (1786–1889) designed his colour wheel in 1839, he highlighted that the appearance of a colour was influenced by the colours surrounding it. His book, *The Laws of Contrast of Colour*, was extremely popular in Britain and undoubtedly influenced many artists.

Much of my personal interest in colour is about particular colour combinations used for painting a picture. As I am looking at colour from an artist's point of view, my aim is, therefore, to keep the text as brief as possible, and instead show you my ideas in charts, worksheets and paintings, including the colour charts and wheels within this chapter. Although an understanding of the traditional colour wheel may not be the most creative aspect of painting, it is essential to learn about colour and colour relationships if you're going to be a successful watercolour painter.

TULIPS
45 × 50cm (17¾ × 19¾in)

Painted on Saunders Waterford High White 638gsm (300lb) Cold-pressed (Not surface) watercolour paper.

PRIMARY, SECONDARY AND TERTIARY COLOURS

The three primary colours are red, yellow and blue – they are equidistant from one another on the colour wheel (see overleaf); and cannot be mixed from any other pigments.

THE THREE PRIMARY COLOURS

Red

Yellow

Blue

THE THREE SECONDARY COLOURS

Orange, violet and green are the 'secondary' colours: mix two primaries together to make your secondary colours.

**Red + blue
= violet**

**Red + yellow
= orange**

**Blue + yellow
= green**

Understanding colour

When I first began painting in watercolour, understanding colour wasn't my priority. However, as I became more expressive with my watercolour, I found that I needed to learn significantly more about the subject, as my limited knowledge was holding up the evolution of my painting. My haphazard approach to colour no longer served my needs, and I learned to be very organized and disciplined in my colour mixing. Planning my use of colour has now become an integral part of my work.

THE TERTIARY COLOURS

Mix a primary with the adjacent secondary colour on the colour wheel (see overleaf) to produce a tertiary colour.

**Blue + green
= blue-green**

**Blue + violet
= blue-violet**

**Red + violet
= red-violet**

**Red + orange
= red-orange**

**Yellow + orange
= yellow-orange**

**Yellow + green
= yellow-green**

THE TRADITIONAL COLOUR WHEEL

Making a traditional colour wheel is a very good place to start in getting back to the basics of watercolour painting; I have found this process very useful in my own painting. Although you could simply look at this wheel and study the colours and mixes, the best way to learn is to paint it yourself. Trace the shape and size of the wheel below as a starting point for creating your own colour wheel. By mixing the paint and planning the chart you will remember this vital information. At first glance, it is a very simple image; however, it takes careful colour mixing, a lot of concentration and quite a disciplined approach to paint a successful colour wheel. It is especially important to maintain the same tone in each section (see *Tone & Value*, pages 58–71).

In the colour wheel shown below, the primary colours are Cadmium Red, Cadmium Yellow and French Ultramarine.

Painted on Saunders Waterford High White 638gsm (300lb) Cold-pressed (Not surface) watercolour paper, using Winsor & Newton Professional watercolours.

P: Primary
S: Secondary
T: Tertiary

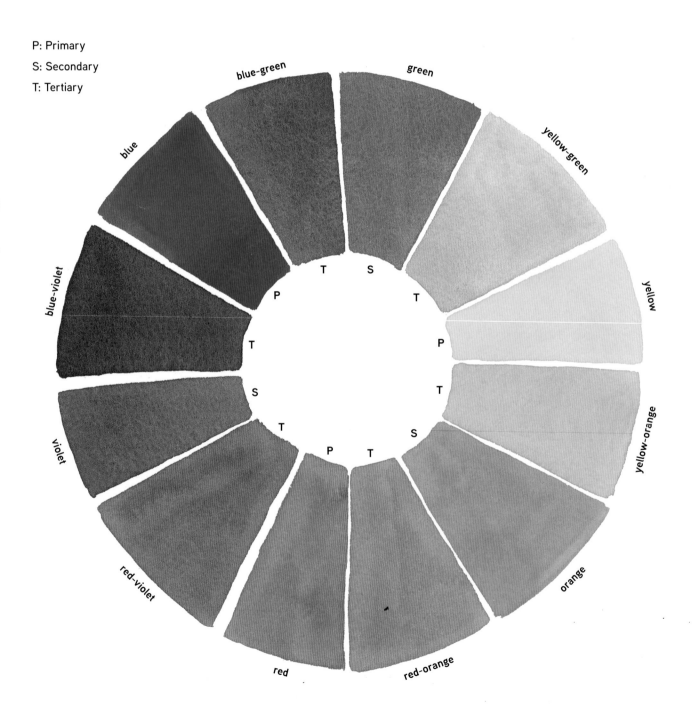

18

WORKING WITH PRIMARY AND SECONDARY COLOURS

Once you have painted the colour wheel on the previous page, you will have come to know the colours well. This first worksheet is an opportunity for you to experiment with some of the colours on the previous pages. The six colours below are the primaries and secondaries, where I have added water to each swatch to see some more of the tonal range, and also how certain colour mixes separate and become very interesting.

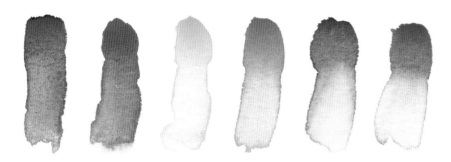

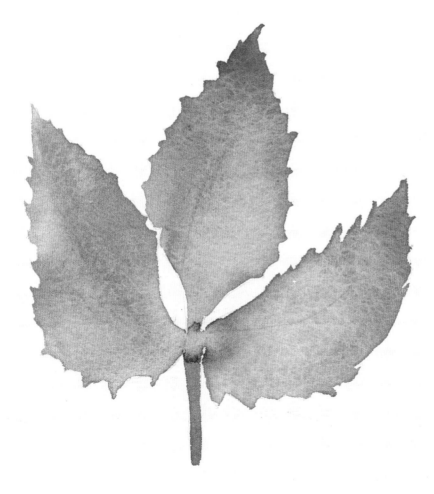

PAINTING A HELLEBORE LEAF

To paint this Hellebore leaf, mix the colours from the three primaries in the colour wheel opposite. There are so many mixes that you can make from only three colours; I encourage you to try experimenting with your own mixes from a similarly limited palette. Below are the colours that you can mix for this leaf:

 French Ultramarine + a touch of Cadmium Yellow: makes a lovely blue-green

 French Ultramarine + more Cadmium Yellow: makes a good olive green

 French Ultramarine + more Cadmium Yellow: the yellow in this mix is more dominant

 Cadmium Red + French Ultramarine: more red than blue

 Cadmium Red + French Ultramarine: more blue than red

PETAL COLOUR WHEEL

I enjoy experimenting with various formats and designs of colour wheels: I find that trying a different design from the traditional wheel keeps life interesting. By adopting a flower or petal format, you can produce a very attractive, and still informative, image.

The primaries in this petal colour wheel are represented by Permanent Alizarin Crimson, French Ultramarine and Aureolin.

Painted on Saunders Waterford 638gsm (300lb) High White Cold-pressed (Not surface) watercolour paper, using Winsor & Newton Professional watercolours.

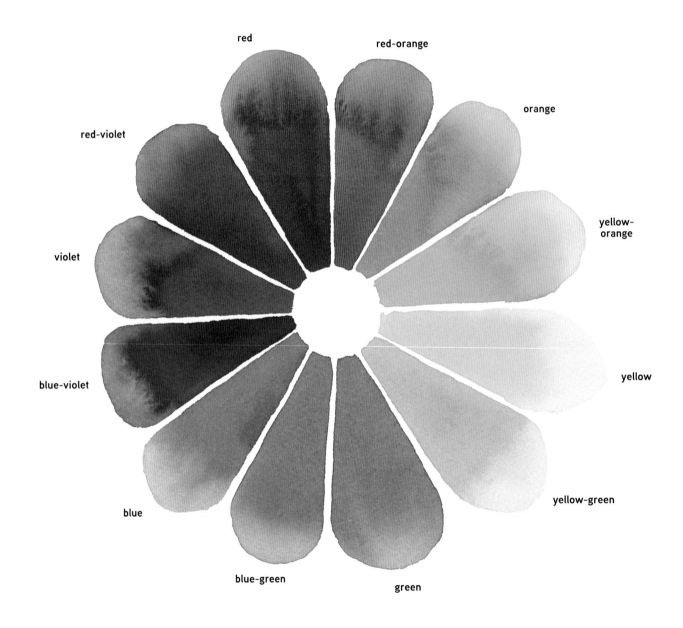

red

red-orange

orange

red-violet

yellow-orange

violet

blue-violet

yellow

blue

yellow-green

blue-green

green

PAINTING A FREEHAND TULIP

Use Hot-pressed paper for this painting as the smooth surface will encourage the paint to flow well over the surface and creates blooms in the petals. Study the tulip carefully as a rough guide as to where to apply the colours. You can mix the colours in your mixing palette but also encourage the colours themselves to mix on the paper.

The colours and mixes used for the freehand tulip are below. For this study, you can use Winsor & Newton Professional watercolours in Permanent Alizarin Crimson, Winsor Blue Red Shade and Aureolin.

Painted on Saunders Waterford White 425gsm (200lb) Hot-pressed watercolour paper, using Winsor & Newton Professional watercolours.

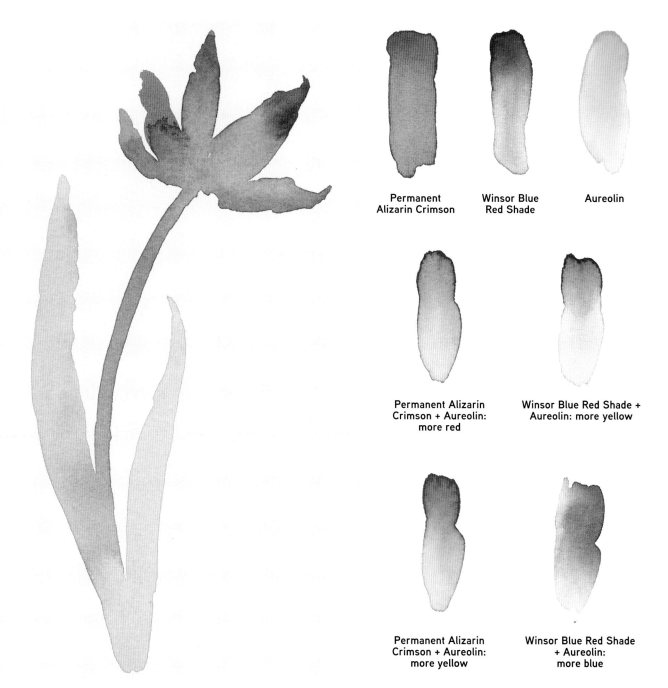

Permanent Alizarin Crimson

Winsor Blue Red Shade

Aureolin

Permanent Alizarin Crimson + Aureolin: more red

Winsor Blue Red Shade + Aureolin: more yellow

Permanent Alizarin Crimson + Aureolin: more yellow

Winsor Blue Red Shade + Aureolin: more blue

21

SHELL COLOUR CHART

Although this is not strictly a colour wheel, it is another interesting way to create a colour chart. As an alternative to the traditional colour wheel, which can feel quite rigid and carefully laid out, painting a colour chart in an unique motif or format can inspire you to think of colour more creatively than scientifically.

See whether you can think of another creative format.

The primary colours in this chart are Quinacridone Red, Winsor Lemon and Cobalt Blue.

Painted on Saunders Waterford High White 638gsm (300lb) Cold-pressed (Not surface) watercolour paper, using Winsor & Newton Professional watercolours.

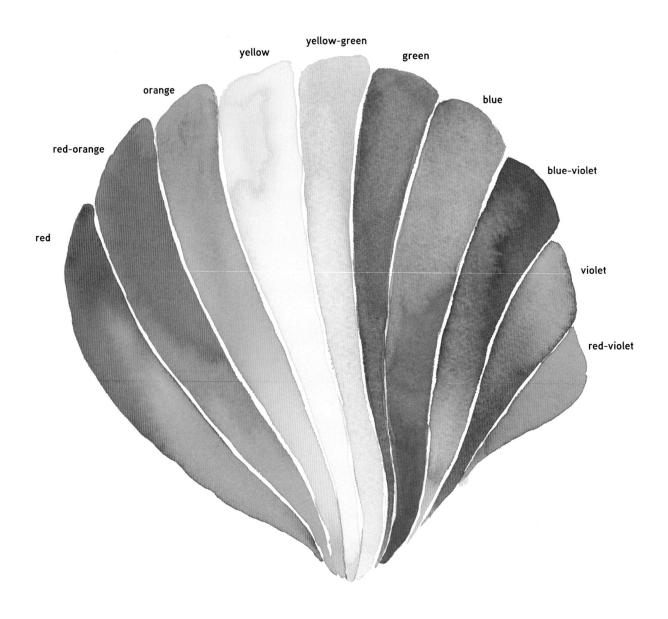

PRIMARY COLOURS MIXED ON THE PAPER

In this chart, you can use the primary and secondary colours from the shell colour chart opposite, and experiment by letting them run into each other to produce a wider range of colours and effects.

Some of the shells that I have in my studio gave me the idea for the painting below. Use the colours in the experimental chart, above, to create this picture. Where the shells overlap, you can see the effects of glazing one layer of colour over another. This subject is examined in more depth in *Glazing*, pages 126–135.

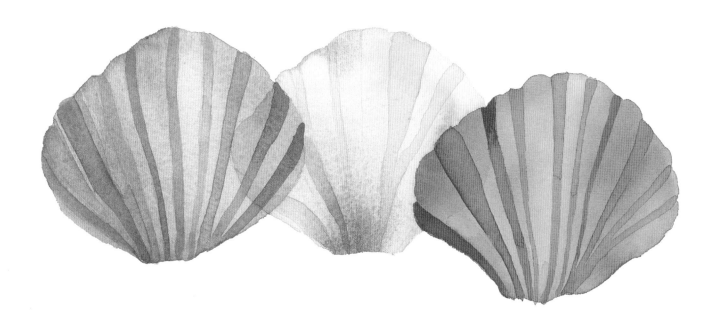

COMPLEMENTARY COLOURS

Complementary colours are found opposite each other on the colour wheel. They are highly contrasting colours, such as red and green, and when placed next to each other, they will appear very bright and intense and enhance the brilliance of each other. The colour chart below shows the primary, secondary and tertiary colours – a triangle links together the three primary colours and the dashed lines indicate the pairs of complementary colours that are also featured on the opposite page.

Any pair of complementary colours will comprise all three primaries. For example, the complementary colour of red is green, which is the mix of yellow and blue, so the pair between them contains a complete trio of primary colours. Likewise, the complementary colour of blue is orange, the mix of red and yellow.

In order to understand how to make successful colour mixes, you must not only understand the structure of the colour wheel and the relationships between the primary, secondary and tertiary colours, but also the bonds between complementary colours. If you take the time to replicate the colour wheels and charts in this book, it will help you greatly with your understanding of colour mixing. The primary colours in the chart below are French Ultramarine, New Gamboge and Organic Vermilion.

Painted on Saunders Waterford High White 638gsm (300lb) Cold-pressed (Not surface) watercolour paper, using Daniel Smith Extra Fine watercolours.

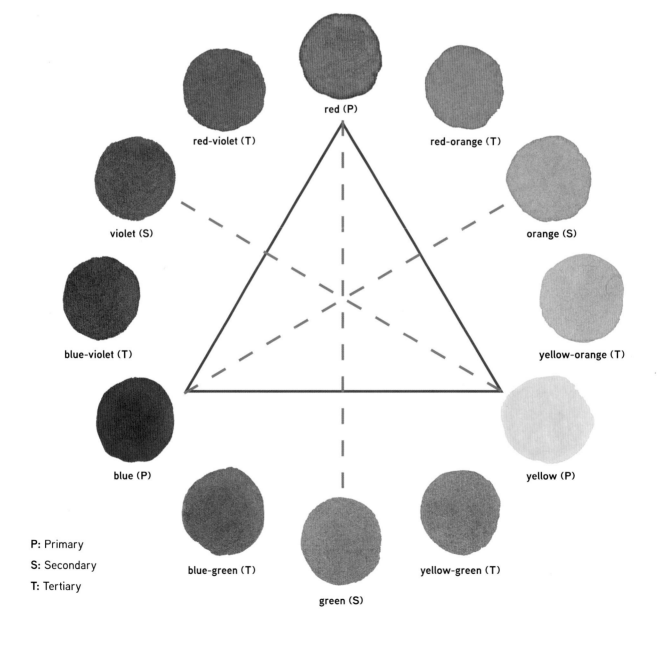

red (P)

red-violet (T)

red-orange (T)

violet (S)

orange (S)

blue-violet (T)

yellow-orange (T)

blue (P)

yellow (P)

P: Primary

S: Secondary

T: Tertiary

blue-green (T)

yellow-green (T)

green (S)

PAINTING 'STILL LIFE'

The painting below is an example of the use of several complementary pairings. The brown-orange background complements the blue of the vase, and the yellow squares in turn complement the blue flowers. The effect is a harmonious colour scheme.

It is always worth spending plenty of time planning your colours before you begin a painting. This ensures a successful picture and has the added benefit of helping you learn which colours work well together.

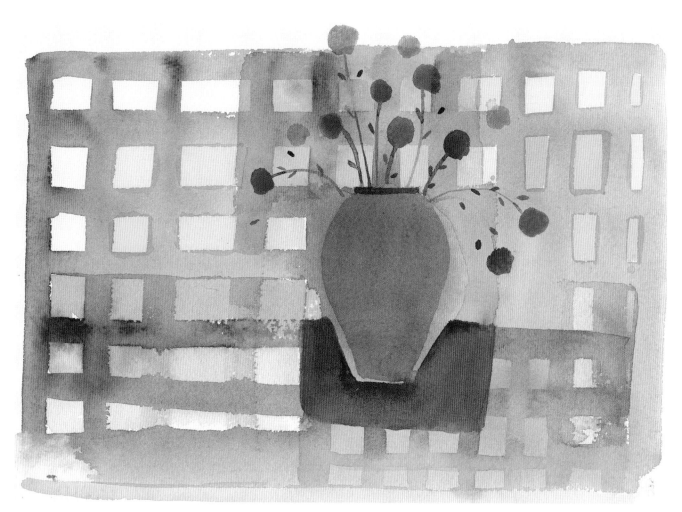

COMPLEMENTARY COLOUR PAIRS

This is a very simple chart showing a different set of the basic complementary colours featured in the colour wheel on the opposite page. I find it helpful to see complementary colours in isolation from the wheel – the chart below may prove useful to you when you are planning a colour scheme for a painting, as you can see immediately which colours complement each other.

├──── **Orange and blue** ────┤ ├──── **Red and green** ────┤ ├──── **Yellow and violet** ────┤

MIXING WITH COMPLEMENTARY COLOURS

Here we will look at two different ways of how to learn about complementary colours and how we might use them. Although you can learn a lot from looking at the charts, the best way is to make the colours for yourself.

The two complementary charts, **A** and **B**, shown on the following pages, show the complements – for example French Ultramarine and Cadmium Orange. In the central row of each chart, mix the colours together in equal proportions, to show the 'neutral' colour that they make. This is the next step on from understanding the simple complementary colour pairs on pages 24–25 and there is a lot to be learned from recreating these charts.

MIXING IN THE PALETTE

The mixes in **Chart A** can be carefully mixed in the mixing palette; the neutral colour created from mixing the two complementary colours is very useful as it can be used as the shadow colour for each one (see pages 115–116 for more detail on applying shadow colours).

If you use only two complementary colours, you will still be able to mix enough additional colours from them to make an interesting painting.

Making a neutral

A neutral is made when you dull a colour. This can be achieved by adding black to a colour; however, black will deaden a colour, so I find that it's better to mix two complementary primaries together for shadows as this dulls rather than deadens the colour.

A

French Ultramarine

Cadmium Orange

Cobalt Blue

Winsor Red

Prussian Blue

Cadmium Scarlet

Indanthrene Blue

Cadmium Scarlet

Cobalt Turquoise

Cadmium Red

Winsor Blue Green Shade

Scarlet Lake

Winsor Blue Red Shade

Cadmium Orange

B

Cadmium-Free Red Deep

Winsor Green Blue Shade

Permanent Rose

Viridian

Permanent Alizarin Crimson

Winsor Green Yellow Shade

Cadmium-Free Red

Cerulean Blue

Quinacridone Magenta

New Gamboge

Ultramarine Violet

Cadmium-Free Yellow Pale

Dioxazine

Cadmium-Free Lemon

MIXING ON THE PAPER

Chart B uses a completely different – more experimental – approach to using and mixing complementary colours.

Try this exercise to see how different complementary colours work together when they are mixed on the paper rather than in the mixing palette, as in Chart A, which is a far more formal approach.

EXPERIMENTING WITH COMPLEMENTARIES

Choose any two complementary colours – for example, Cobalt Blue and Cadmium Orange. Working very wet, start with one colour; flood in the other colour and allow the colours to mix on the paper. Try to keep the pure colours at each end of the swatch.

This exercise helps you to get to know how different pigments behave together; as you can see, some pigments will move around more than others.

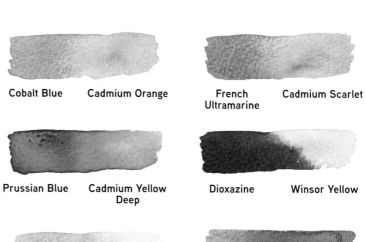

Cobalt Blue | Cadmium Orange

French Ultramarine | Cadmium Scarlet

Prussian Blue | Cadmium Yellow Deep

Dioxazine | Winsor Yellow

Ultramarine Violet | Winsor Lemon

Viridian | Permanent Rose

Winsor Green Yellow Shade | Permanent Carmine

WARM AND COOL COLOURS

Another consideration when choosing the most appropriate colour for your painting is its temperature – that is, whether a colour is warm or cool. If you look at any colour wheel, there is a distinction between the warm side and the cool side. We tend to think of reds and oranges as warm colours and blues and greens as cool colours. However, upon closer inspection of individual hues, it is more complicated than this. Some reds may have cool undertones, just as some blues may have warm undertones. For example, the undertone of French Ultramarine is a warmer mauve and the undertone of Cobalt Blue is a slightly cooler green; Cadmium Red is a warm red as its undertone is slightly orange, while Permanent Alizarin Crimson is a cooler red as its undertone is slightly blue.

The colour wheel below shows the temperature subtleties of particular colours. The context of a colour will, of course, affect its temperature – on pages 98–111, we look in more depth at the interaction of colour.

All of the colours in this colour wheel are pure – there are no mixes.

Painted on Saunders Waterford, Bockingford White 535gsm (250lb) Cold-pressed (Not surface) watercolour paper, using Winsor & Newton Professional watercolours.

28

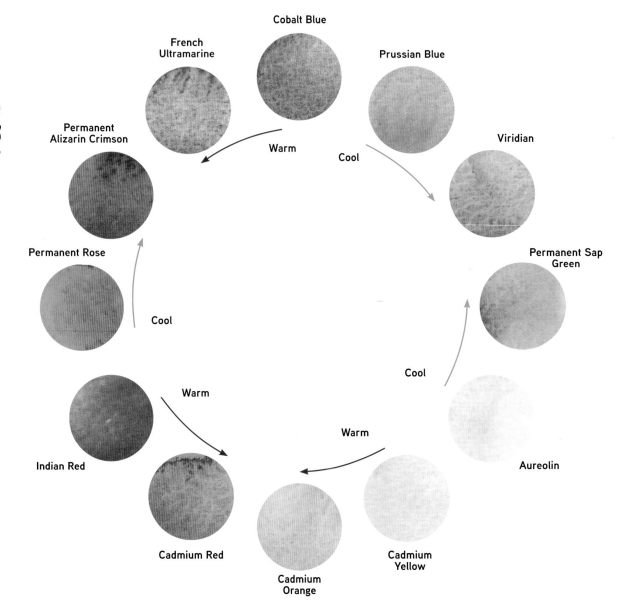

WARM AND COOL COLOUR SWATCHES

Make a swatch chart of warm and cool colours to help you look more carefully at the undertones of the colours in your palette. By making a specific chart of the colour temperatures, you will have a handy reference for planning the use of warm and cool colours depending on their particular qualities. For example, warm colours are associated with daylight and sunsets, and cool colours with overcast days.

Painted using Winsor & Newton Professional watercolours.

WARM COLOURS

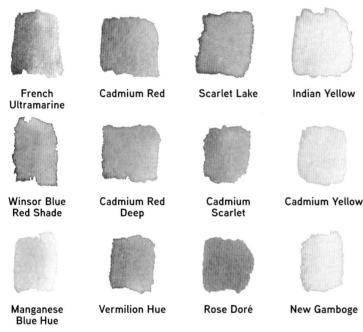

French Ultramarine	Cadmium Red	Scarlet Lake	Indian Yellow
Winsor Blue Red Shade	Cadmium Red Deep	Cadmium Scarlet	Cadmium Yellow
Manganese Blue Hue	Vermilion Hue	Rose Doré	New Gamboge

COOL COLOURS

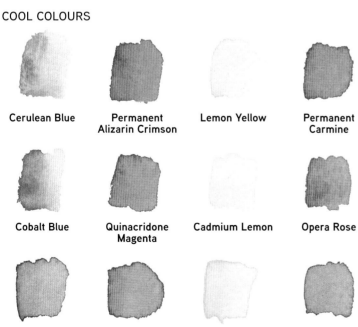

Cerulean Blue	Permanent Alizarin Crimson	Lemon Yellow	Permanent Carmine
Cobalt Blue	Quinacridone Magenta	Cadmium Lemon	Opera Rose
Indanthrene Blue	Permanent Rose	Winsor Lemon	Permanent Magenta

ANALOGOUS COLOURS

Analogous colours are found next to each other on the colour wheel and together create a scheme of beautiful, harmonious colours. They are a group of three adjacent colours such as blue, blue-green and green. In the images that follow, two analogous colour schemes are shown as slices of the traditional colour wheel.

Each colour in an individual scheme can be labelled, respectively, A, B and C. By referring to the components of an analogous scheme as ABC, we have an easy way to refer to the order of the colours.

An analogous colour scheme can be represented either as a portion of the colour wheel, as shown left, or in the form of a swatch chart, as below. In the top row of the analogous chart, green is A, yellow-green is B and yellow is C. Similarly, in the small slice or section of the colour wheel shown below, left, Cadmium Red is A, red-violet is B and violet (from French Ultramarine) is C.

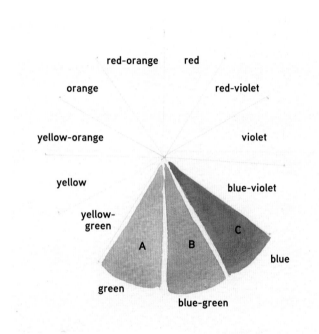

In this diagram, green, blue-green and blue are mixes of Aureolin and Cobalt Blue.

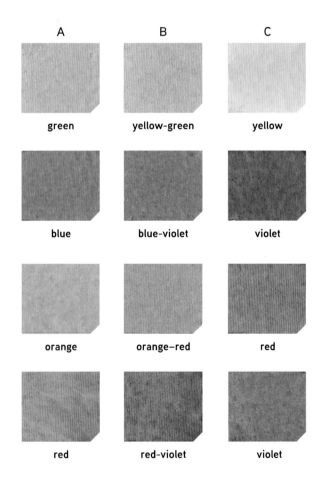

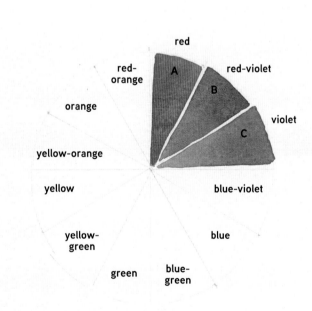

Here, red-violet and violet are mixes of Cadmium Red and French Ultramarine.

PAINTING THE PARROT TULIP

I started out by selecting a vibrant palette of colours (see pages 84–85) to create fresh, bright flowers, but mixed them with enough water to make a more muted painting. Quinacridone Rose is a beautiful transparent pink and works very well with the Rhodonite Genuine and French Ultramarine to mix lovely pinks and violets both in the palette and on the paper.

This effect can also be created by wetting the petal of the flower all over with clean water and then flooding your bright colours in. I advise you to try out this technique on some test paper to practise getting the correct tone for your painting.

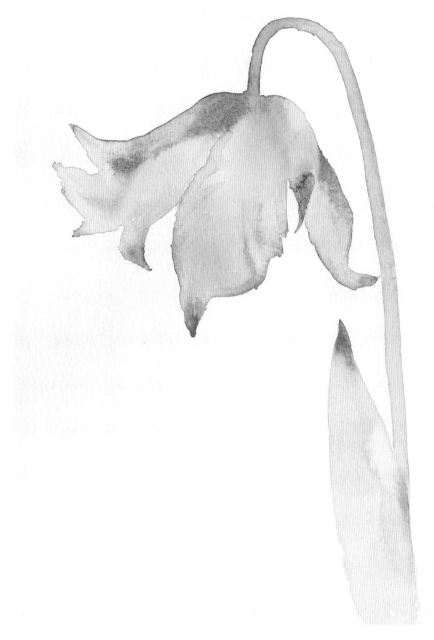

PARROT TULIP
17.5 × 25.5cm (7 × 10in)

Painted on Saunders Waterford High White 638gsm (300lb) Cold-pressed (Not surface) watercolour paper, using Daniel Smith Extra Fine watercolours.

			A	B	C	D
Rhodonite Genuine	**Quinacridone Rose**	**French Ultramarine**	**French Ultramarine + Rhodonite Genuine: more blue**	**French Ultramarine + Rhodonite Genuine: more red**	**French Ultramarine + Quinacridone Rose: more blue**	**French Ultramarine + Quinacridone Rose: more rose**

USING ANALOGOUS COLOUR SCHEMES

The freehand flower paintings shown here follow the ABC analogous scheme, with the addition of one of the three colours in a paler tone. For example, in the study of *Poppies*, A is red, B is orange-red, C is orange and D is pale orange.

An analogous colour scheme always includes a complete section of a colour wheel but as the scheme becomes more complex, tonal variations can be included. The tonal colour wheel on page 62 can be used as a useful reference for this; we explore tonal variation in more depth on pages 58–71.

Mix your set of analogous colours in the palette before you begin, and you will find that you produce very colourful paintings from this very limited scheme.

Foxgloves

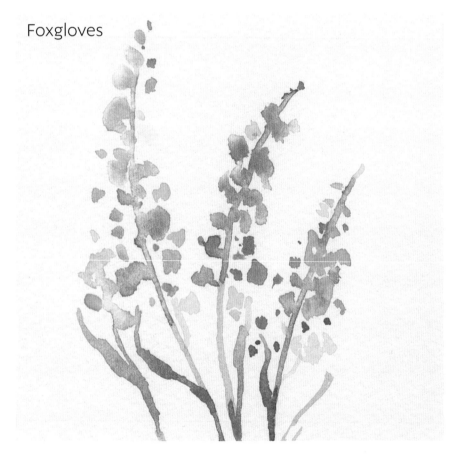

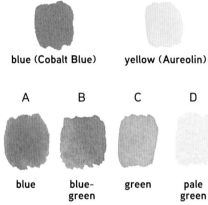

blue (Cobalt Blue) yellow (Aureolin)

A B C D

blue blue-green green pale green

Violets

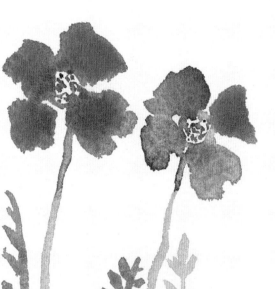

blue
(French
Ultramarine)

red
(Cadmium Red)

A	B	C	D
blue	blue-violet	violet	pale violet

Poppies

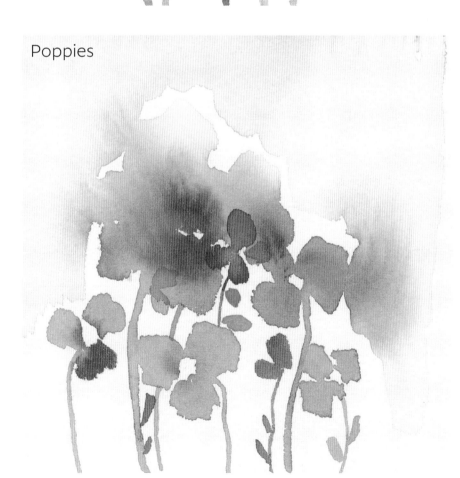

red
(Scarlet Lake)

yellow
(New Gamboge)

A	B	C	D
red	orange-red	orange	pale orange

HARMONIOUS COLOUR

'Harmony' originates from the Greek word '*harmonia*' which means 'to fit together'. A harmonious painting engages the viewer and provides an inner sense of order. When colours are bland, the viewer will not be engaged and when the colours are chaotic, the viewer will be confused or even repelled.

I always imagine harmonious colour as a very pleasing arrangement of colours. We have already looked at an analogous colour scheme and the concept of complementary colours, which are harmonious; here I will show you a few more examples of harmonious colour.

Nature is the best place to look for harmonious colour, there are thousands of examples of beautiful flowers that are complemented by green leaves and they give the perfect colour combination. There are four examples of harmonious colour schemes over the following four pages. After you've tried these, you can begin to experiment and plan other harmonious schemes from your watercolour palette.

TULIP

The tulip was created by mixing all of the colours I needed in the palette before I began painting. All of these were directly observed by looking at a tulip and its leaves: here, the pink and orange complement the greens and give a natural opportunity for a harmonious picture.

I used all of the pure colours and two mixes listed here. I began working very quickly, wet-into-wet, dropping pure Permanent Rose and Cadmium Yellow into the strong colour areas of the petal. The top part of the stem was also painted quickly as I wanted the stem and flower colours to merge slightly with each other. I allowed this part of the painting to dry before painting the leaves using the same technique and dropping in a strong mix of the two greens for the shadows and tips of the leaves. The main tip for this style of painting is to mix colours in advance, keep your painting very wet and work swiftly.

Painted on Saunders Waterford High White 638gsm (300lb) Cold-pressed (Not surface) watercolour paper, using Winsor & Newton Professional watercolours.

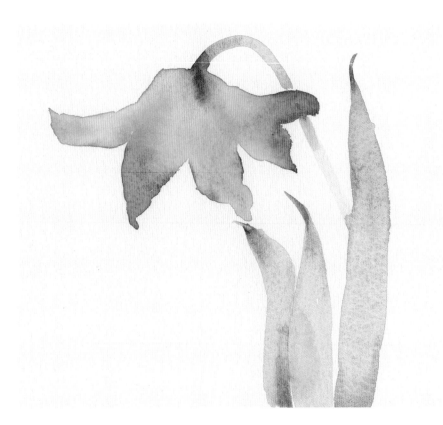

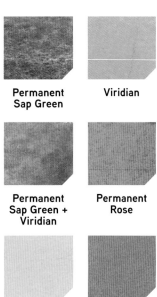

Permanent Sap Green Viridian

Permanent Sap Green + Viridian Permanent Rose

Cadmium Yellow Permanent Rose + Cadmium Yellow

A HARMONIOUS LIMITED PALETTE

Using a limited palette is a good way to create harmony in a painting: by choosing three primary colours and mixing all your colours from them, you will create unity in your picture.

All of the colours can be mixed in advance so that you can paint quickly using a wet-into-wet technique. Try the same technique using one red, one yellow and one blue. You will be amazed at how many colours you can make from a limited palette of three.

Before you begin this painting, mix the colours in both medium and pale tones, as seen in the colour chart below, by adding a lot of water to create the pale tone, and less for the medium tone. There is much more information about tone in the chapter *Tone & Value*, pages 58–71.

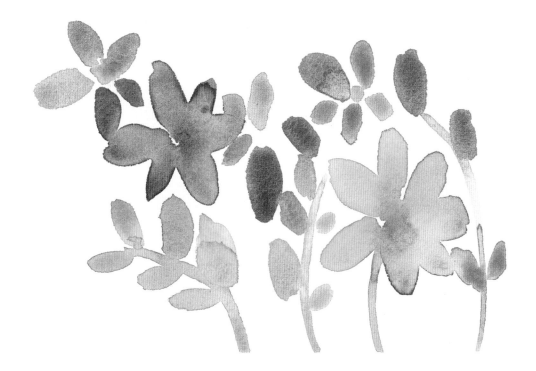

Painted on Saunders Waterford White 300gsm (140lb) Hot-pressed watercolour paper, using Winsor & Newton Professional watercolours.

35

MEDIUM TONES	PALE TONES	MEDIUM TONES	PALE TONES	MEDIUM TONES	PALE TONES
New Gamboge + a touch of Permanent Alizarin Crimson		New Gamboge + Permanent Alizarin Crimson: 50:50 mix		Permanent Alizarin Crimson + a touch of New Gamboge	
French Ultramarine + a touch of Permanent Alizarin Crimson		French Ultramarine + Permanent Alizarin Crimson: 50:50 mix		Permanent Alizarin Crimson + a touch of French Ultramarine	

French Ultramarine

Permanent Alizarin Crimson

New Gamboge

TWO VIBRANT PAINTINGS

The aim here is to create two unified paintings using a limited, vibrant palette: any composition abstracted from plants will serve this purpose well.

The compositions below were carefully planned and the colours mixed, and I gave careful consideration to where each colour belonged.

Think about the feeling you wish to express in a painting and choose your colours accordingly. A red-violet scheme conveys a happy, warm feeling and green-blue conveys freshness and clarity. When you are choosing a colour scheme for your own painting, you can also refer to a colour wheel and choose an analogous scheme.

Painted on Saunders Waterford High White 638gsm (300lb) Cold-pressed (Not surface) watercolour paper, using Winsor & Newton Professional watercolours.

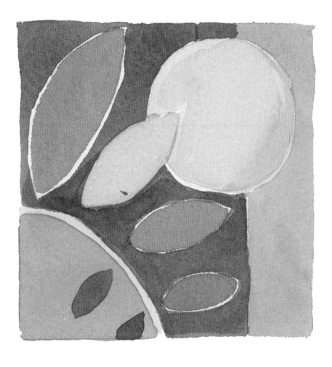

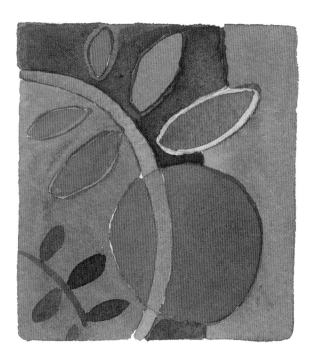

GREEN COMPOSITION

| Permanent Sap Green + Lemon Yellow | Permanent Sap Green | Permanent Sap Green + Viridian | Viridian | Viridian + French Ultramarine: 50:50 mix | Viridian + French Ultramarine: more blue |

RED COMPOSITION

| Lemon Yellow + Quinacridone Red | Quinacridone Red | Quinacridone Red + Permanent Alizarin Crimson | Permanent Alizarin Crimson | Permanent Alizarin Crimson + French Ultramarine: 50:50 mix | Permanent Alizarin Crimson + French Ultramarine: more blue |

ABSTRACT IMAGINATIVE PAINTING

I really enjoy creating abstract and imaginative paintings. If you would like to try to replicate the painting below, and are unsure where to start, set up a plant or a vase of flowers and draw only a small area of the composition. Concentrate on the shapes you see rather than focusing on reproducing the subject matter.

Once you feel that you have an interesting drawing, select one red, yellow and blue and mix a beautiful set of colours from these three only. Don't forget to consider tonal variation so that you have some very dark and very light areas in your picture (see pages 35, and 58–97).

You can experiment with this concept by making several paintings at once.

The painting below has been made using Cadmium Yellow Light Hue, Organic Vermilion and Cobalt Blue.

Painted on Saunders Waterford 638gsm (300lb) Cold-pressed (Not surface) watercolour paper, using Daniel Smith Extra Fine watercolours.

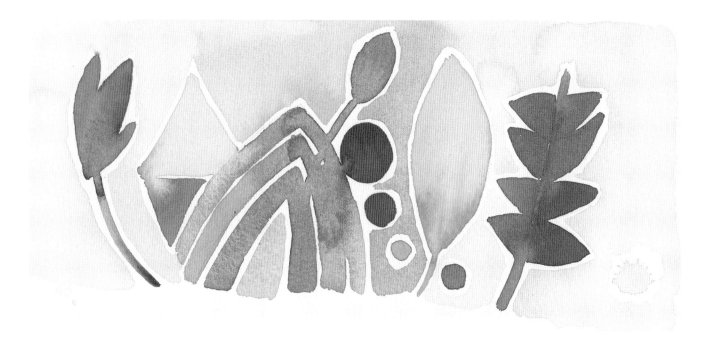

PIGMENTS DEMYSTIFIED

The subject of pigments is fascinating and complex. The word 'pigment' is thought to originate from the Latin word *'pingere'*, meaning to paint, which evolved into the word *'pigmentum'*, and then into 'pigment'.

There are so many wonderful stories about the names and origins of pigments. Ultramarine is one of my favourite colours, and the word itself means 'beyond the sea' – to me, this is a perfect visual description of this beautiful colour. In my mind's eye I see a bright, blue ocean, in the same way that the pigment ultramarine is a wonderful, fresh blue colour.

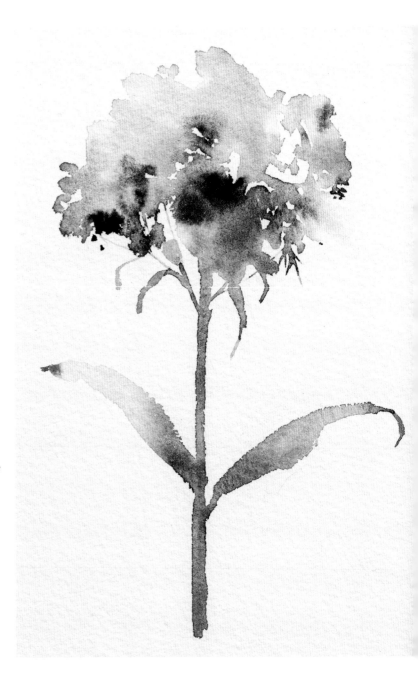

VIOLET FLOWER
15.5 × 20cm (6⅛ × 7⅞in)

A freehand flower created with paint made at the Winsor & Newton laboratory (see page 40).

My excitement at using the paint I had made shows in the painting, as it is lively and fresh. The pigments have separated beautifully on the paper, creating a rich texture within the flower.

Pigments are the materials that give paint its colour and can be made from either natural or synthetic materials.

Organic pigments contain carbon atoms and have been made from living things such as earth, stone, plants, glass, minerals, insects, insect blood, roots, twigs – even cow urine. Historically, these pigments generated colours such as Indian Yellow, Rose Madder and Carmine. Nowadays, most of these pigments are created synthetically but still with a carbon base.

Inorganic pigments are composed of metallic compounds and salts, such as chromates, metallic oxides and sulphates, not from living matter. Inorganic pigments constitute the earth colours, such as ochres, umbers, sienna, chromes, Cobalt, French Ultramarine, Viridian, Lamp Black and whites. The cadmiums, iron and other metal oxides are also synthetic inorganic pigments.

The history of pigments goes back hundreds of thousands of years: the Aboriginal people of Australia were painting with ochres about 40,000 years ago, and in Africa people were working with red ochre thousands of years before that. They used natural pigments that were made from white chalk deposits, ochres from the rocks and the earth itself.

Developments throughout history meant that Egypt and China increased the range and quality of pigments. Egyptian Blue was developed some 4,500 years ago. It is a bright blue crystalline substance, and is believed to be the earliest artificial pigment. Egyptian Blue was widely used in ancient times in wall paintings, on mummies' coffins, and in the Egyptian tombs.

In China there were further developments using synthetic pigments. Here they made Han Purple and then Blue (also known as Chinese Purple and Chinese Blue). These pigments were used in ancient and imperial China from 1045–771 BC, until the end of the Han dynasty, around AD 220.

MAKING PIGMENTS

Pigments are heated, ground, mixed or manipulated to produce colouring agents. The pigment then becomes paint – to do so, the pigment is added to a binder. The binder joins together the small particles so that the powder or colour adheres to the surface – in watercolour painting, this is the paper.

Gum arabic is the binder commonly used in making watercolour as it dissolves easily in water. It is a natural gum that is gathered from various species of acacia trees. The gum is left to harden before it is gathered, and is ground into crystals and then into a soluble powder. Historically, gum arabic has been sourced from Far Eastern countries such as Afghanistan, though much now comes from countries such as Sudan.

MAKING WATERCOLOUR PAINT

As part of the research for this book I spent time at Winsor & Newton paint manufacturers in London, where I saw first-hand how watercolour paint is made. In their laboratory, I enjoyed the opportunity of making my own watercolour paint, which is shown and explained in the photographs below. Firstly, the pigment is mixed into the binder with a fine spatula until the pigment is completely wet. Then this mixture is ground either with the spatula or with the aid of a muller, as seen in the photographs here. The lid of the muller is closed firmly on top of the mixture; the muller then spins at high speed to crush the pigments entirely.

The muller seen here is a table-top machine that makes a small amount of paint. In paint factories, huge machines do this job on a large scale.

Mullers are available in many sizes and formats, including a hand-held glass tool with a handle, which is ideal if you want to make and mix your own watercolour paints at home.

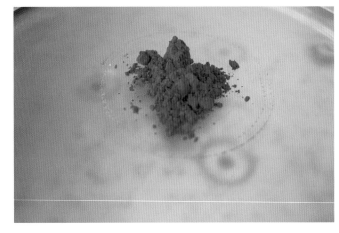

French Ultramarine pigment in powder form on the muller.

40

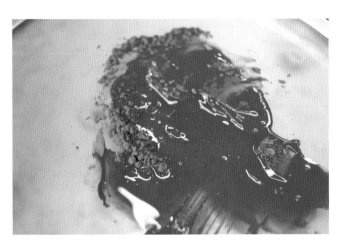

French Ultramarine pigment being mixed with binder – gum arabic – on the muller.

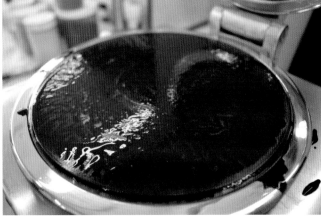

French Ultramarine and Quinacridone Magenta pigments being mixed with the binder on the muller. This pigment was used to paint the freehand flower on page 38.

PIGMENT CODES AND PAINT NAMES

Pigment codes and paint names are an extremely complex subject, not least because the quality and characteristics of a pigment will vary hugely from manufacturer to manufacturer. There are many factors that affect the performance and appearance of a pigment: the chemical and physical properties of the pigment, how the pigment reacts to light, and the fineness or granularity of its particles. The characteristics of the binder that has been used are also contributing factors. In addition, individual manufacturers are likely to have sourced their pigments from different places.

Each colour has a unique code, called the colour index name or number. This code is found on the side of a tube or pan of paint, and begins with P for pigment.

The colour index name will give you the ingredients of the tube or pan, and a good idea of the colour:

R: red	V: violet	W: white
Y: yellow	O: orange	Br: brown
B: blue	G: green	Bk: black

So, for example, a paint with the prefix PV will be a violet. The number that follows – for example, 19 – indicates where the colour sits on an official, universal colour index.

However, paints that carry the same pigment code are not necessarily the same colour. Here is an example for you to consider. Both of the following paints has the pigment code PV19 (Pigment Violet 19).

Winsor & Newton – Permanent Rose

Daniel Smith – Quinacridone Rose

These two colours with the same code are not the same, but they are similar, and both can be classed as violets. Similarly, colours such as Royal Purple Lake (by Old Holland), and Red Rose Deep (Quinacridone, manufactured by the Da Vinci company), carry the same code – PV19 – and are classed as violets but appear very different from one another, and from the swatches shown above.

If you want to keep things simple, then it can be good idea to source all of your paints from the same manufacturer. However, this is not entirely failsafe either: paints issued by the same manufacturer may have the same pigment code and still differ in hue.

Consider the following Winsor & Newton watercolours: Permanent Rose, Permanent Magenta and Permanent Carmine. All three colours have the same code – again, PV19 – but as you can see from the swatches below, the colours themselves are not the same.

Permanent Rose (PV19)

Permanent Magenta (PV19)

Permanent Carmine (PV19)

This information has been included to attempt to demystify pigment codes, but do remember that this is only one aspect of colour. Using the colour charts and experimenting with mixing is the best way to learn about colour for your paintings.

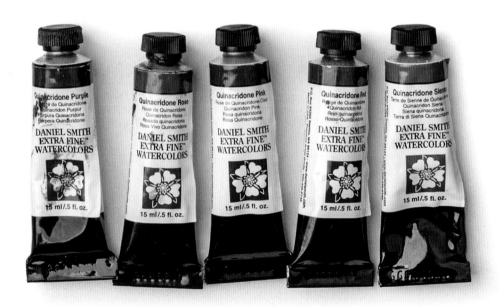

COLOUR COMPARISONS

Just as two paints with identical pigment codes may not be alike, two paints with identical names, albeit from different manufacturers, may also differ considerably. The colour or marketing name of a tube or pan of paint will also vary from one manufacturer to another. The comparison chart below shows the differences in the appearances of pigments that have the same name. For example, notice how in the first row of colours, Raw Sienna varies greatly from one manufacturer to another. The manufacturers of these pigments are Daniel Smith, Winsor & Newton and Daler-Rowney.

To make your life easy, I recommend starting out by using a limited palette of watercolour paint from one manufacturer. When you have familiarized yourself with the colours that you have, then you can add new colours and try paint from other manufacturers.

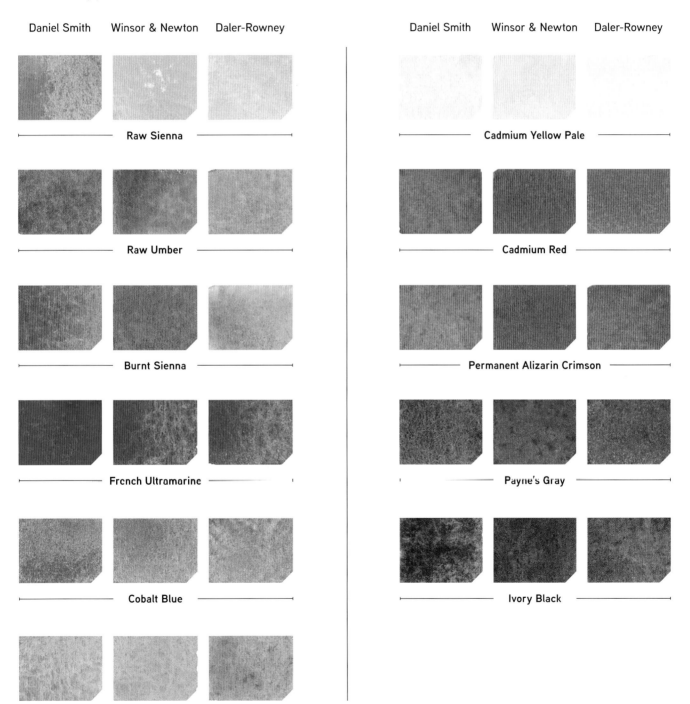

Daniel Smith Winsor & Newton Daler-Rowney

Raw Sienna

Raw Umber

Burnt Sienna

French Ultramarine

Cobalt Blue

Viridian

Daniel Smith Winsor & Newton Daler-Rowney

Cadmium Yellow Pale

Cadmium Red

Permanent Alizarin Crimson

Payne's Gray

Ivory Black

PIGMENT CATEGORIES

It is useful to put pigments into categories, as it can help you to understand them better. To give you an easy reference guide, I have categorized the pigments into: the cadmiums; cadmium-free; transparent, semi-transparent, opaque and semi-opaque pigments, earth pigments, staining colours, quinacridones, granulating colours and finally pigments with unusual names. Each pigment category is presented alongside painted examples to show how they appear in both charts and paintings.

THE CADMIUMS

The cadmiums are among the most durable pigments and first became commercially available in 1840. Cadmiums are made from cadmium sulphide and are very commonly used by artists as they are extremely stable and lightfast. As art students, these were the first pigments we added to our palettes.

Cadmiums are opaque pigments (see pages 46–47) – notably reds, oranges and yellows – with high colouring strength and brilliant colour.

THE CADMIUMS

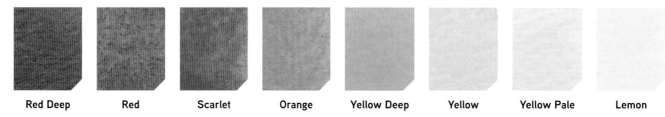

| Red Deep | Red | Scarlet | Orange | Yellow Deep | Yellow | Yellow Pale | Lemon |

CADMIUM-FREE

Cadmium-free watercolour is a recent innovative development from Winsor & Newton, providing an environmentally-friendly alternative to cadmiums, which, when poured down our drains, can enter the water system.

Cadmium-free watercolours give the same performance as genuine cadmium paints as you can see in the chart shown below. Cadmium-free paints also mix beautifully with other colours, in the same way as traditional cadmium watercolour paints can be mixed – see opposite.

THE CADMIUM-FREE COLOURS

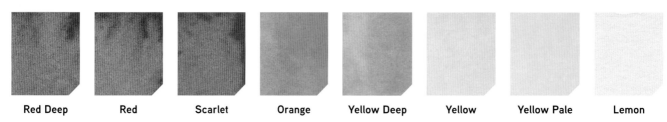

| Red Deep | Red | Scarlet | Orange | Yellow Deep | Yellow | Yellow Pale | Lemon |

CADMIUM-FREE COLOUR COMBINATIONS

You can experiment by mixing combinations of cadmium-free watercolours with other watercolours from the same manufacturer. Winsor & Newton quinacridones, for instance, are very bright and fresh and can be combined with the cadmium-free colours to make beautiful, vivid mixes – particularly pinks, reds and violets. The Winsor colours, such as Winsor Blue Red Shade, are also particularly bright and make strong mixes with the cadmium-free range. Combining a colour such as Cobalt Blue with the cadmium-free colours will, in addition, create some interesting textures.

Make charts of the colours you discover through your mixing experiments. Label your mixes with the pigments that created them so that you can refer to them and recreate them at any opportunity.

Recreate the four freehand flowers, below, using pure cadmium-free pigments and mixing them with colours from the same manufacturer.

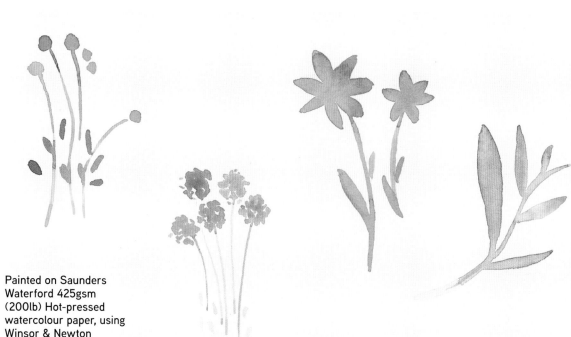

Painted on Saunders Waterford 425gsm (200lb) Hot-pressed watercolour paper, using Winsor & Newton cadmium-free watercolours.

45

THE MIXES

Cadmium-free Lemon and Quinacridone Red

Cadmium-free Lemon and Quinacridone Magenta

Cadmium-free Yellow and Winsor Blue Red Shade

Cadmium-free Red and Cobalt Blue

Cadmium-free Scarlet and Quinacridone Magenta

Cadmium-free Lemon and Permanent Alizarin Crimson

Cadmium-free Lemon and Burnt Sienna

Cadmium-free Orange and Permanent Alizarin Crimson

TRANSPARENT AND OPAQUE PIGMENTS

It is very important to get to know the transparency and opacity of your watercolours. Transparent pigments make cleaner and clearer washes, whereas opaque pigments produce flatter washes. Opaque colours tend to have a matte appearance but can be made more transparent by adding more water. A straightforward guide to understanding transparency and opacity is given below:

Painted on Saunders Waterford, Bockingford White 535gsm (250lb) watercolour paper.

TRANSPARENT: the white of the paper or the underlayer of paint can be seen through transparent watercolour paint.

SEMI-TRANSPARENT: watercolour will absorb most of the light but reflect a small part.

SEMI-OPAQUE: watercolour will let through a small amount of the light.

OPAQUE: watercolour reflects all of the light and can appear matte.

TRANSPARENT AND SEMI-TRANSPARENT PIGMENTS

Indian Yellow **New Gamboge** **Aureolin** **Transparent Yellow** **Burnt Sienna** **Quinacridone Gold** **Raw Sienna** **Raw Umber**

46

Vandyke Brown **Burnt Umber**

Permanent Alizarin Crimson **Permanent Rose** **Rose Madder Genuine** **Permanent Magenta** **Quinacridone Magenta** **Quinacridone Red** **Scarlet Lake** **Permanent Carmine**

Dioxazine **Cobalt Blue** **French Ultramarine** **Indanthrene Blue** **Phthalo** **Antwerp Blue** **Viridian** **Olive Green** **Permanent Sap Green**

OPAQUE AND SEMI-OPAQUE PIGMENTS

Ivory Black	Sepia	Neutral Tint	Davy's Grey	Caput Mort Violet	Indian Red	Venetian Red	Light Red	Yellow Ochre

Indigo	Cerulean	Manganese Blue Hue	Oxide of Chrome

Turner's Yellow	Bismuth	Lemon Yellow	Naples Yellow	Naples Yellow Deep	Potter's Pink

CORNFLOWERS AND SIENNA
38.5 × 38cm (15³/₁₆ × 15in)

Painted on Saunders Waterford High White 638gsm (300lb) Cold-pressed (Not surface) watercolour paper.

A still-life painting using transparent, semi-transparent, opaque and semi-opaque colours.

47

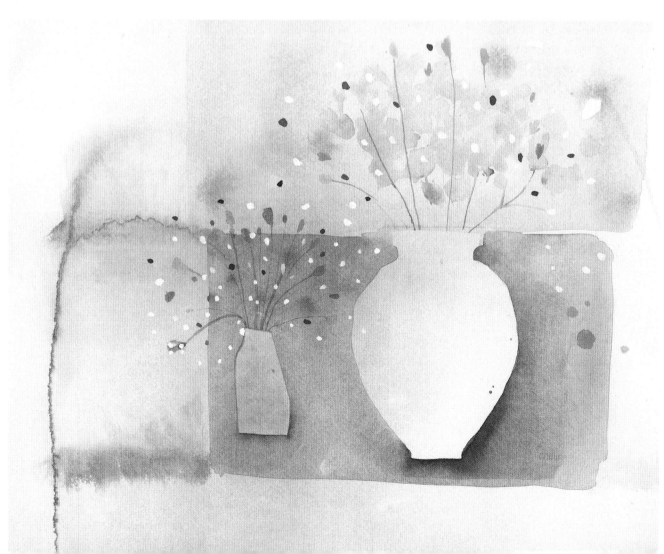

EARTH PIGMENTS

Earth pigments, or earth colours, were traditionally made with natural materials, such as minerals. These days, most earth pigments are made with synthetic pigments. Daniel Smith watercolours, however, still feature some genuine earth pigments, a few of which are shown on this page.

You will notice that the synthetic siennas, umbers and iron oxides vary greatly from one brand to another.

Painted on Saunders Waterford High White 638gsm (300lb) Cold-pressed (Not surface) watercolour paper, using Winsor & Newton Professional watercolours and Daniel Smith Extra Fine watercolours.

WINSOR & NEWTON PROFESSIONAL WATERCOLOURS

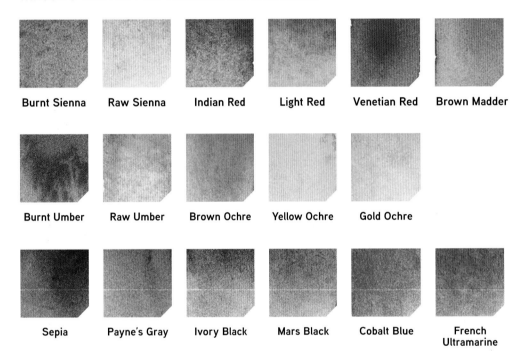

Burnt Sienna	Raw Sienna	Indian Red	Light Red	Venetian Red	Brown Madder
Burnt Umber	Raw Umber	Brown Ochre	Yellow Ochre	Gold Ochre	
Sepia	Payne's Gray	Ivory Black	Mars Black	Cobalt Blue	French Ultramarine

DANIEL SMITH EXTRA FINE WATERCOLOURS

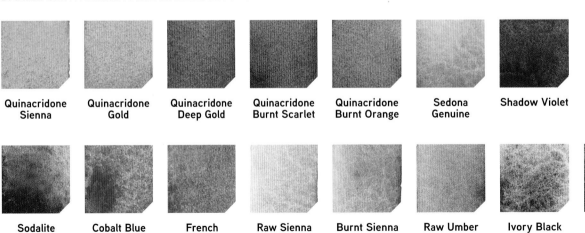

Quinacridone Sienna	Quinacridone Gold	Quinacridone Deep Gold	Quinacridone Burnt Scarlet	Quinacridone Burnt Orange	Sedona Genuine	Shadow Violet	
Sodalite Genuine	Cobalt Blue	French Ultramarine	Raw Sienna	Burnt Sienna	Raw Umber	Ivory Black	Payne's Gray

PAINTING THE LEAF

To paint the leaf, you can use classic earth pigments alongside some quinacridones and Shadow Violet. Similar effects can be achieved using a palette of purely earth colours such as Burnt Sienna, Light Red, Gold Ochre, mixed with French Ultramarine.

Painted on Saunders Waterford 425gsm (200lb) Hot-pressed watercolour paper, using Daniel Smith Extra Fine watercolours.

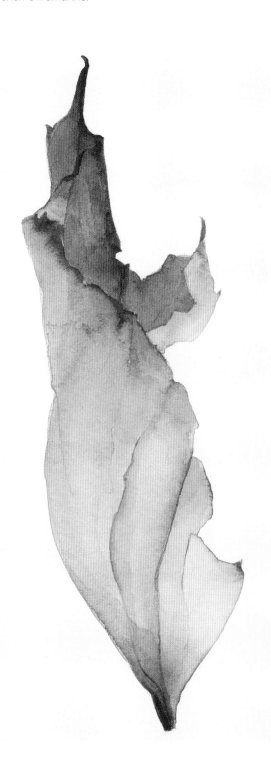

Quinacridone Gold

Burnt Sienna

Shadow Violet

Quinacridone Burnt Sienna

Quinacridone Burnt Sienna + Shadow Violet: more violet

Quinacridone Gold + Shadow Violet

Quinacridone Burnt Sienna + Shadow Violet: more Sienna

49

STAINING COLOURS

Staining colours are made from dyes rather than pigments. They are part of the synthetic–organic group of colours and differ from pigments in that they are completely dissolved in a liquid whereas pigments are suspended in a liquid and form a layer on the surface of the paper.

Dyes stain the paper, and this is why they are categorized as staining colours; they are impossible to lift off. However, the vibrancy of colour and the transparency of staining colours make them wonderful for glazing (see pages 126–135).

Painted on Saunders Waterford High White 638gsm (300lb) Cold-pressed (Not surface) watercolour paper.

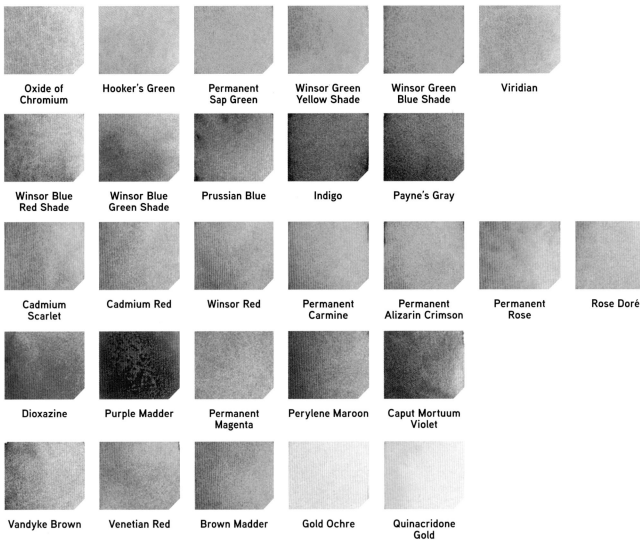

WINSOR & NEWTON PROFESSIONAL WATERCOLOURS

| Oxide of Chromium | Hooker's Green | Permanent Sap Green | Winsor Green Yellow Shade | Winsor Green Blue Shade | Viridian |

| Winsor Blue Red Shade | Winsor Blue Green Shade | Prussian Blue | Indigo | Payne's Gray |

| Cadmium Scarlet | Cadmium Red | Winsor Red | Permanent Carmine | Permanent Alizarin Crimson | Permanent Rose | Rose Doré |

| Dioxazine | Purple Madder | Permanent Magenta | Perylene Maroon | Caput Mortuum Violet |

| Vandyke Brown | Venetian Red | Brown Madder | Gold Ochre | Quinacridone Gold |

DANIEL SMITH EXTRA FINE WATERCOLOURS

 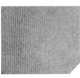

| Pyrrol Orange | Quinacridone Magenta | Quinacridone Red | Quinacridone Fuchsia | Quinacridone Rose | Quinacridone Violet | Quinacridone Purple |

50

GRANULATING COLOURS

Particular pigments, such as Terre Verte and French Ultramarine, have the characteristic of grouping together and drying with a wonderful texture. This is called granulation, as the granulating pigments leave uneven deposits of pigment on the paper. Certain papers increase this effect, such as Bockingford Rough and Arches Rough. Generally, the more textured the paper, the more pronounced the effect.

A granulating colour can be mixed with a non-granulating colour and still make a lovely effect, as seen in the colour charts below. Remember, though, that if you are aiming for a smooth, calm or clear area of paint, then it may be better not to use a granulating pigment.

Lastly, the water that you use will affect the level of granulation. An area with 'hard water' will result in increased granulation.

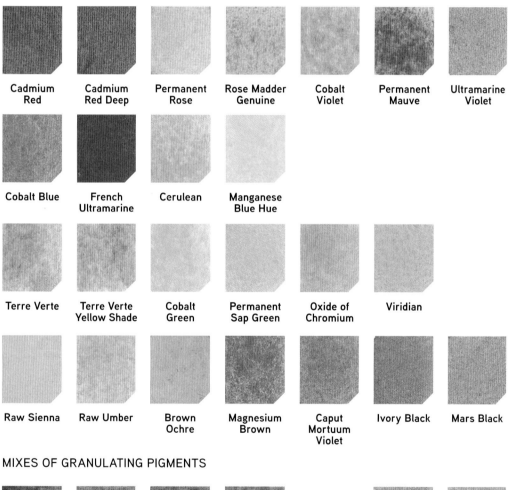

| Cadmium Red | Cadmium Red Deep | Permanent Rose | Rose Madder Genuine | Cobalt Violet | Permanent Mauve | Ultramarine Violet |

| Cobalt Blue | French Ultramarine | Cerulean | Manganese Blue Hue |

| Terre Verte | Terre Verte Yellow Shade | Cobalt Green | Permanent Sap Green | Oxide of Chromium | Viridian |

| Raw Sienna | Raw Umber | Brown Ochre | Magnesium Brown | Caput Mortuum Violet | Ivory Black | Mars Black |

MIXES OF GRANULATING PIGMENTS

Green Apatite Genuine – gradually adding French Ultramarine

Raw Sienna – gradually adding Cobalt Blue

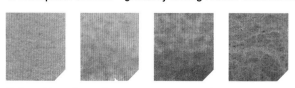

Quinacridone Burnt Orange – gradually adding French Ultramarine

CREATING TEXTURE WITH GRANULATING PIGMENTS

Granulating pigments are fabulous for making texture in your watercolour paintings and there are some great examples here, in these mixes of two granulating pigments. These are painted on Saunders Waterford, Bockingford 535gsm (250lb) Rough watercolour paper, which creates fantastic textures.

MIXING GRANULATING AND NON-GRANULATING COLOURS

Mixing a granulating colour with a non-granulating colour also creates texture in a mix. Below, I have mixed French Ultramarine with other colours to show the granular effect that results even if the other colour is not granulating.

FRENCH ULTRAMARINE +...

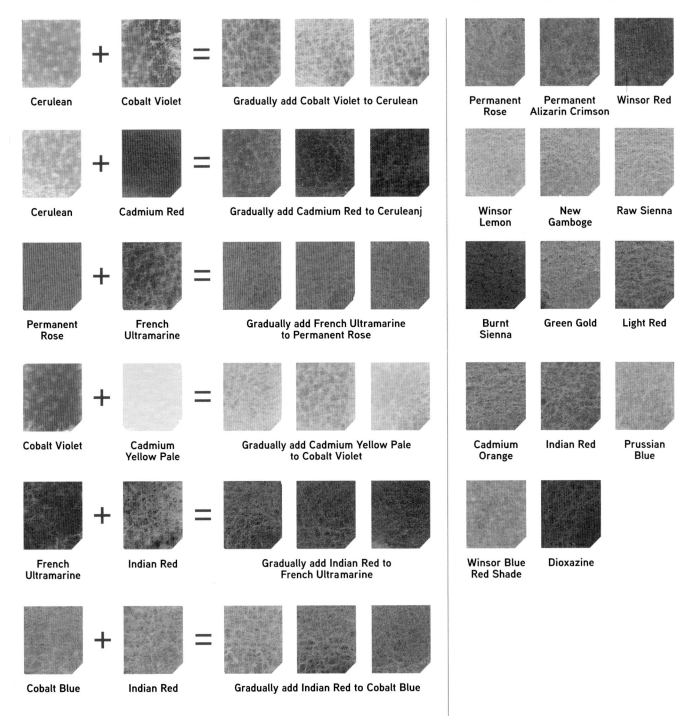

Cerulean + **Cobalt Violet** = Gradually add Cobalt Violet to Cerulean

Cerulean + **Cadmium Red** = Gradually add Cadmium Red to Ceruleanj

Permanent Rose + **French Ultramarine** = Gradually add French Ultramarine to Permanent Rose

Cobalt Violet + **Cadmium Yellow Pale** = Gradually add Cadmium Yellow Pale to Cobalt Violet

French Ultramarine + **Indian Red** = Gradually add Indian Red to French Ultramarine

Cobalt Blue + **Indian Red** = Gradually add Indian Red to Cobalt Blue

Permanent Rose — Permanent Alizarin Crimson — Winsor Red

Winsor Lemon — New Gamboge — Raw Sienna

Burnt Sienna — Green Gold — Light Red

Cadmium Orange — Indian Red — Prussian Blue

Winsor Blue Red Shade — Dioxazine

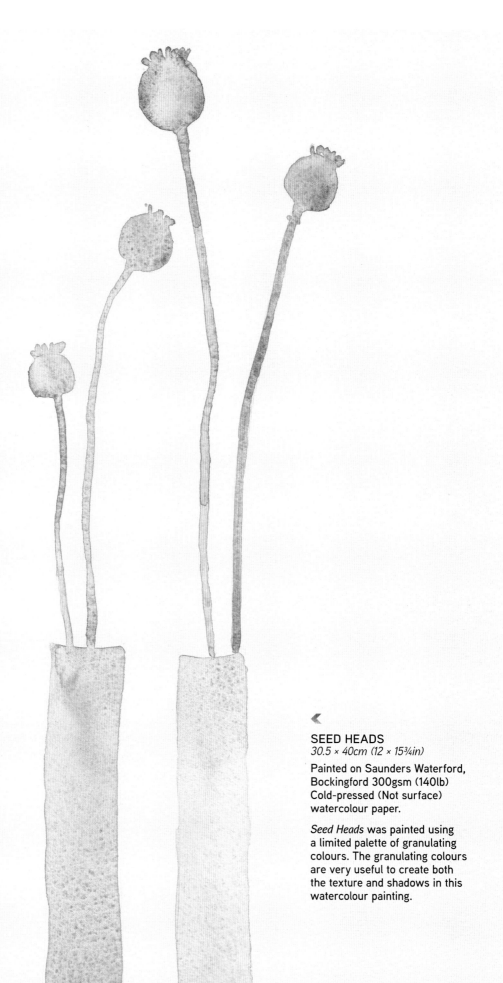

◄

SEED HEADS
30.5 × 40cm (12 × 15¾in)

Painted on Saunders Waterford,
Bockingford 300gsm (140lb)
Cold-pressed (Not surface)
watercolour paper.

Seed Heads was painted using
a limited palette of granulating
colours. The granulating colours
are very useful to create both
the texture and shadows in this
watercolour painting.

QUINACRIDONES

Quinacridone is a synthetic organic compound that is used as a pigment for paint. The minuscule particles are incredibly uniform, which means that this paint behaves very reliably. It is created in the most advanced colour laboratories and Daniel Smith produces the widest range of quinacridone colours of any manufacturer.

Quinacridones have many advantages if you want to paint with intense, vibrant, transparent colour. They comprise rich golds, pinks, reds and violets that are also ideal for glazing (see pages 126–135) and for creating smooth clear watercolour washes. Below, you will see a selection of Daniel Smith Quinacridone Pinks, Reds and Violets. Other quinacridone colours include many rich browns which feature elsewhere in the book, such as on pages 48–49, 'Earth pigments', and specifically in the leaf painting on page 49.

I love the quinacridone colours as they are so bright and transparent. They mix very well together and make a wide range of bright colours but also mix well with other colours to produce more subtle tones.

DANIEL SMITH QUINACRIDONES

| Coral | Red | Pink | Rose | Magenta | Fuchsia | Violet | Purple |

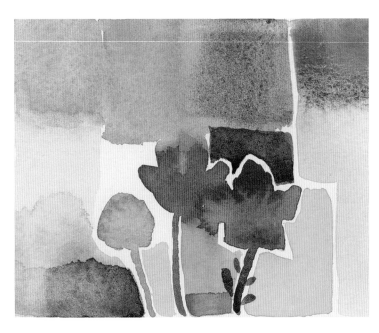

◄

ABSTRACT PAINTING
12 × 9cm (4¾ × 3½in)

This small painting has been created using Daniel Smith Extra Fine watercolours, beginning with Quinacridone Coral, and including Cadmium Yellow Light Hue, Shadow Violet and French Ultramarine.

Quinacridone Coral is a lovely, bright, versatile colour that is in every mix that I made for this painting. This has given the painting several qualities, including uniformity and harmony.

Mixes with quinacridones

Quinacridones mix beautifully together to make a wider range of pinks and violets,
as shown below. They produce other bright colours in mixes, such as orange when
mixed with yellow. Try experimenting with a new palette by mixing one quinacridone –
perhaps a pink – with colours that you already have, such as red, yellow and grey,

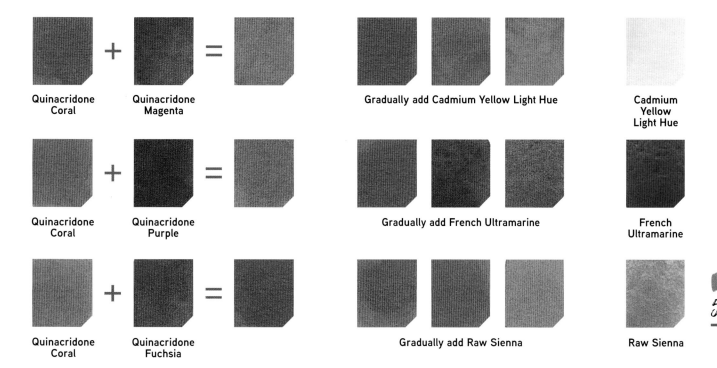

Quinacridone
Coral + Quinacridone
Magenta = Gradually add Cadmium Yellow Light Hue Cadmium
Yellow
Light Hue

Quinacridone
Coral + Quinacridone
Purple = Gradually add French Ultramarine French
Ultramarine

Quinacridone
Coral + Quinacridone
Fuchsia = Gradually add Raw Sienna Raw Sienna

55

PIGMENTS WITH UNUSUAL NAMES

There is continuous development in improving the quality of colours, the stability of paints and permanence of colours. Manufacturers spend a lot of time researching and improving their products, which means that there always new colours and developments. Some manufacturers use very unusual names for their colours: many Daniel Smith watercolour pigments are named after the specific place from where they come, such as Sleeping Beauty Turquoise Genuine, which comes from a mountain with this name. This is covered in more depth in the chapter on *Mineral Pigments & Luminescent Watercolours* (see pages 136–147). Likewise, QoR's Ardoise Grey is made from hydrated aluminium silicate. The French word *'ardoise'* means 'slate'– so this is a more inspiring name for a paint colour than simply 'slate grey': we are instantly intrigued as to what this colour is.

A selection of unusually-named pigments is shown below, in swatches of pure colour, in mixes and in the painting opposite. I have found that using an unusual colour can freshen up my work and make me consider applying new colour combinations and effects. Although I still prefer to use a limited palette, a change can be as good as a rest, as it is all too easy to continue to paint with your old favourites.

Painted on Saunders Waterford High White 425gsm (200lb) Cold-pressed (Not surface) watercolour paper, using QoR watercolours and Daniel Smith Extra Fine watercolours.

56

YELLOWS, ORANGES AND REDS

| Cadmium Yellow Primrose (QoR) | Benzimidazolone Yellow (QoR) | Bismuth Vanadate Yellow (QoR) | Diarylide Yellow (QoR) | Aureolin Modern (QoR) | Transparent Pyrrole Orange (QoR) | Quinacridone Burnt Orange (QoR) | Quinacridone Crimson (QoR) | Permanent Scarlet (QoR) |

GREENS, GREYS AND PINKS

| Bohemian Green Earth (QoR) | Green Apatite Genuine (Daniel Smith) | Amazonite Genuine (Daniel Smith) | Sleeping Beauty Turquoise Genuine (Daniel Smith) | Cerulean Blue Chromium (QoR) | French Cerulean Blue (QoR) | Lapis Lazuli Genuine (Daniel Smith) | Blue Apatite Genuine (Daniel Smith) | Ardoise Grey (QoR) | Ultramarine Pink (QoR) |

MINERALS AND IRIDESCENTS

| Electric Blue (Daniel Smith) | Iridescent Garnet (Daniel Smith) | Rhodonite Genuine (Daniel Smith) | Sodalite Genuine (Daniel Smith) | Moonglow (Daniel Smith) | Iridescent Russet (Daniel Smith) | Iridescent Sunstone (Daniel Smith) |

UNUSUAL COLOURS WORKING TOGETHER

Experiment here with mixing these watercolours on the paper rather than in the mixing palette. You will find that some combinations mix fairly evenly, and others become unstable and move uncontrollably.

Blue Apatite Genuine with Permanent Alizarin Crimson (Daniel Smith)

Electric Blue with Iridescent Garnet (Daniel Smith)

Rhodonite Genuine with Electric Blue (Daniel Smith)

French Cerulean Blue with Bismuth Vanadate Yellow (QoR)

Sodalite Genuine with Electric Blue (Daniel Smith)

Rhodonite Genuine with Electric Blue (Daniel Smith)

Ultramarine Pink with Bismuth Vanadate Yellow (QoR)

Iridescent Garnet with Cadmium Yellow Medium Hue (Daniel Smith)

Iridescent Sunstone with French Ultramarine (Daniel Smith)

Ardoise Grey with Bismuth Vanadate Yellow (QoR)

Iridescent Garnet with Cadmium Yellow Medium Hue (Daniel Smith)

Iridescent Sunstone with French Ultramarine (Daniel Smith)

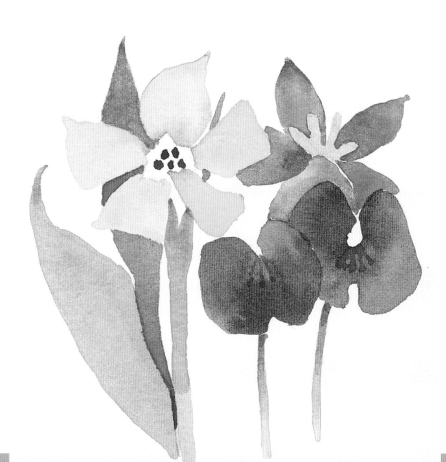

◄

FLORAL TRIO
13 × 15cm (5⅛ × 6in)

This floral trio has been painted using unusually-named QoR watercolours in Bohemian Green Earth, French Cerulean Blue, Quinacridone Crimson and Diarylide Yellow, on Saunders Waterford 425gsm (200lb) Hot-pressed watercolour paper.

TONE & VALUE

In order to understand colour, you must learn about colour relationships. The appearance of any one colour depends entirely on its context.

Colours have three intrinsic attributes: hue, saturation and value. Hue is the actual colour from the spectrum, such as red, blue or orange.

Saturation is the intensity of the colour – that is, how much grey is in it. The more saturated the hue, the more intense the colour. In this chapter, we look at the darkness and lightness of colours – their tone and value.

Value describes the relative lightness and darkness in a composition or painting. The highest value is white; pure black is the lowest. As an example, Lemon Yellow is much lighter in tone than Prussian Blue. However, by adding water to Prussian Blue you can make a tone that is as light as Lemon Yellow. The tonal colour wheels in this chapter will show this clearly.

Tone is the degree of intensity or strength of a colour. A pure lemon yellow has high tones, whereas browns have low tones.

BLUE LEAVES, FROM THE GARDEN OF THE MUSEUM OF FARNHAM
36 × 27cm (14³/₁₆ × 10⁵/₈in)

Painted on Saunders Waterford, Bockingford White 535gsm (250lb) Cold-pressed (Not surface) watercolour paper.

Blue Leaves was painted from life using imaginative colours rather than from reality; I concentrated instead on the tones seen in the plant. I have used one blue and brown to mix as the tones, which range from the palest grey to dark areas of blue and brown.

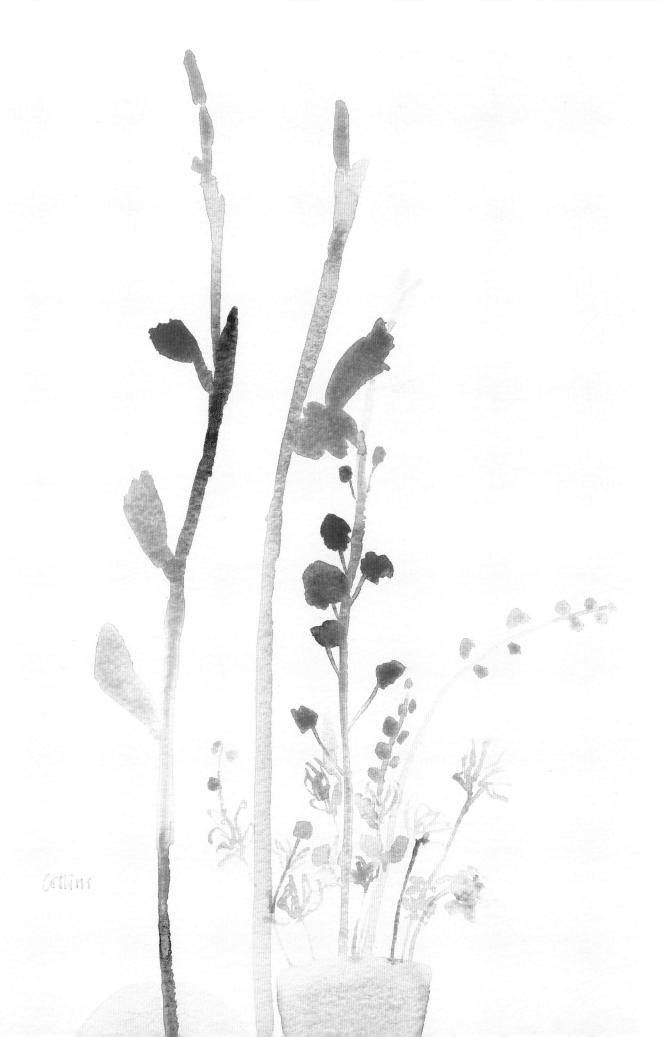

VALUE

Value is the level of lights and darks in a colour. The value or shade of a colour, as seen in the grey scale below, is very important because the contrast between dark and light in a painting is crucial in the success of a picture. If a painting doesn't include a wide range in value and tone, then the picture will fall apart.

MAKING A GREY SCALE

The best way to see the darkness or lightness of a colour accurately is to make a grey scale, as illustrated below. The grey scale is arranged in a linear format from black to white. The scale shown below comprises twelve tones created from a very dark mix of Viridian and Permanent Alizarin Crimson.

To create the scale, start with a swatch of pure black or in this case, a mixed black. Very carefully add water to the mix in the palette and create more swatches until you make the palest tone possible. The empty space at the end of the grey scale is white, or, in watercolour painting terms, the colour – the white – of the paper.

I recommend that you use a grey scale for every painting you create, especially if you are new to watercolour painting. It is a crucial reference for checking the tone of the colours in your paintings. All too often you may have the correct colour but not the right tone. The more regularly you use a grey scale to check tone, the sooner you will be able to mix to the right tone without it. Wide tonal range in a painting is extremely important to its success, with good light tones for highlights and dark tones to create depth.

Mix Viridian and Permanent Alizarin Crimson to create a very dark colour.

Use the dark mix – here, the Viridian and Permanent Alizarin Crimson – as the basis for your grey scale and gradually add more water to the mix until it is too pale to see on the paper.

CHECKING YOUR TONES

Use your grey scale to check the tones of the colours that you have mixed by painting these colours onto a test sheet of paper. This can be time-consuming but in watercolour painting it is difficult and sometimes impossible to lighten a colour once laid in, so checking the tone before you apply it to your painting is well worth the effort.

You can of course lift off watercolour to lighten an area – however, this is something I do not do, as I feel that it alters the texture and freshness of the paint.

Conversely, a colour can be darkened once it has dried, simply by adding another layer of paint over the top.

VASE OF FLOWERS

Vase of Flowers was drawn and painted from life. Notice how dark the shadow areas on the flowers and in the vase are. The palest areas are white, and the darks are mixed dark greys – these correspond with the tonal variations seen in the grey scale on the opposite page.

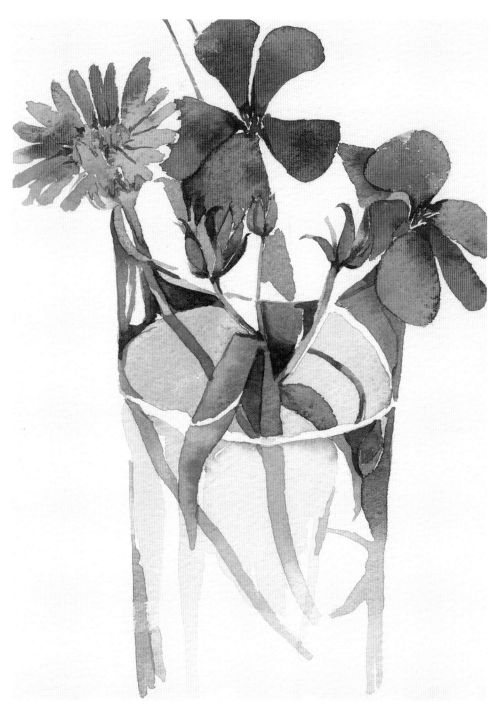

VASE OF FLOWERS
12.5 × 18cm (5 × 7in)

Painted on Saunders Waterford, Bockingford 425gsm (200lb) Cold-pressed (Not surface) watercolour paper.

This finished painting shows wide tonal variation.

A TONAL COLOUR WHEEL

This colour wheel includes the primary, secondary and tertiary colours. The primary colours in this tonal colour wheel are Scarlet Lake (red), French Ultramarine (blue) and New Gamboge (yellow).

To make this tonal colour wheel, divide a circle into twelve sections as you would for a traditional colour wheel. Leave the centre blank and divide the outer section into two 'wheels'. Place the darker tones in the central wheel and the medium tones in the outer wheel. Gradually add the same amount of water to each of the darker tones to achieve the medium tones.

Painted on Saunders Waterford High White 638gsm (300lb) Cold-pressed (Not surface) watercolour paper, using Winsor & Newton Professional watercolours.

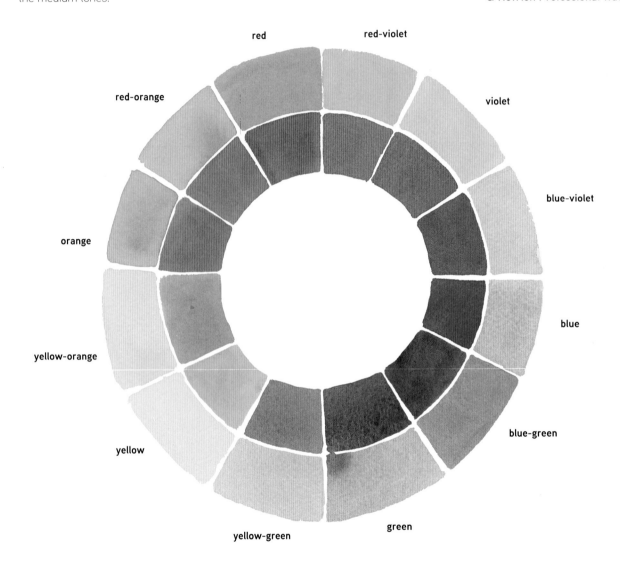

CREATING A WIDER TONAL RANGE

To create a wider tonal range, start with the colour in a dark tone, almost neat, and gradually add water in the same way in which you make a grey scale.

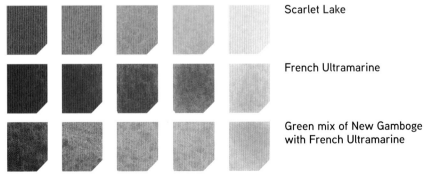

Scarlet Lake

French Ultramarine

Green mix of New Gamboge with French Ultramarine

TONAL EXPERIMENTS

After you have made the tonal colour wheel and colour charts on the previous page, you will have begun to understand more about making colours lighter, and how to control the tone of a colour by the amount of water you add to it. It is now time to be a little more experimental and creative with tone.

Here, I have used the colours Scarlet Lake, French Ultramarine and New Gamboge, and the secondary and tertiary mixes from the tonal wheel opposite, and experimented with how the colours and tones interact with each other.

Begin this exercise by mixing plenty of paint in your mixing palette: Choose any red, yellow and blue and firstly make several tones of each colour – pale, medium and dark. Put a small area of the different tones you have made on the paper, as in the example. Leave some as pure colour and then in others drop in one of the other colours to see the tones and effects that you can make.

Painted on Saunders Waterford High White 638gsm (300lb) Cold-pressed (Not surface) watercolour paper, using Winsor & Newton Professional watercolours.

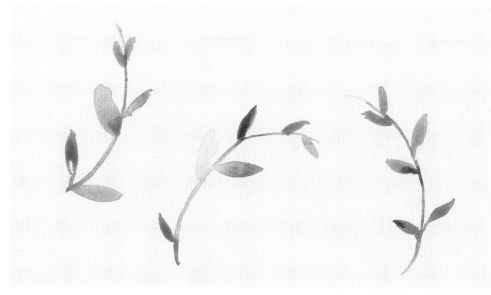

The leaves in the image below can be created using the same technique of dropping in one colour to another as shown above.

PETAL TONAL COLOUR WHEEL

A petal tonal colour wheel is an attractive variation on the more traditional tonal colour wheel on page 62. It includes only the primary colours (red, yellow and blue) and secondary (orange, violet and green) colours; these have all been diluted incrementally to achieve three tones: dark, medium and light.

To make a successful tonal wheel, you must take your time – it is a very worthwhile exercise as the patience involved in creating the correct tone will teach you enough to transfer your knowledge to your watercolour paintings.

To make your petal tonal wheel, copy the format below onto some good-quality watercolour paper – I have used Saunders Waterford High White 638gsm (300lb) Cold-pressed (Not surface) watercolour paper.

Choose one pure red, yellow and blue and mix the secondary colours from these. I have used QoR watercolours in Permanent Scarlet, Bismuth Yellow and French Cerulean Blue. Make sure that the tone of each colour is exactly the same by testing them on a spare sheet of paper. Start in the centre of the petal with the dark tones. Add water to the same mixes to make your medium tones and even more water for the pale tones.

For this to be successful, it is crucial to mix plenty of paint, test your colours and also allow each section to dry before starting the next.

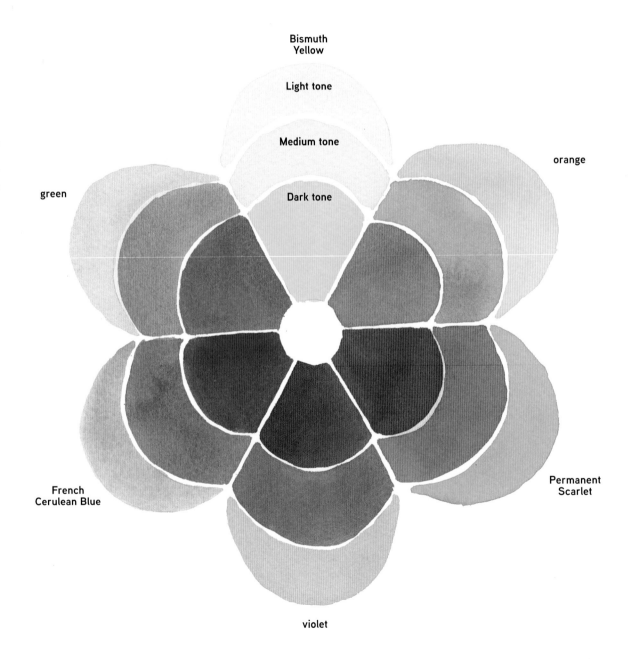

PURE COLOURS AND MIXES

It can be challenging to vary the tone in a very small area of paint, but this is a very useful skill to learn. Practise how to create as much tone as you can in one small area of paint.

The flower study, below, can be created using one red, yellow and blue and mixing the tones shown in the swatches here. As explained for the petal tonal colour wheel opposite, most of the work that you need to do here is in the mixing and the testing of colours. Use a sketchbook to gather your compositional ideas for paintings such as this; you can also draw from life flowers or plants to get basic shapes for an abstract picture. I painted the abstract below freehand after spending a long time considering my composition and mixing and testing all of my colours.

Painted on Saunders Waterford 425gsm (200lb) Cold-pressed (Not surface) watercolour paper, using QoR watercolours.

| **Permanent Alizarin Crimson** | **Winsor Blue Red Shade** | **Aureolin** | **Permanent Alizarin Crimson + Aureolin: 50:50 mix** | **Winsor Blue Red Shade + Aureolin: more yellow** | **Winsor Blue Red Shade + Permanent Alizarin Crimson: more red** | **Winsor Blue Red Shade + Aureolin: 50:50 mix** |

65

Leaf

To learn about tone and value, it can be a useful exercise to use just one colour to create a monochromatic painting. This means that you can concentrate on achieving variation in tone rather than colour mixing, and it will be easier to create the darkest darks to the lightest lights in your painting.

Begin by mixing the tones that you plan to use in a mixing palette that has at least seven wells. Make up a gradient of five tones and test these on scrap watercolour paper before committing them to your painting.

The finished painting can be seen on page 71.

WHAT I USED

Paints used: Daniel Smith Extra Fine watercolours in Sepia.
Brushes used: Squirrel mop – size 2, sable brushes – numbers 6, 4, 1 and 0.
Other tools or materials: Pencil and putty eraser.
Support: Saunders Waterford 425gsm (200lb) Hot-pressed watercolour paper.

FIVE TONES OF SEPIA

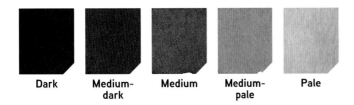

Dark Medium-dark Medium Medium-pale Pale

66

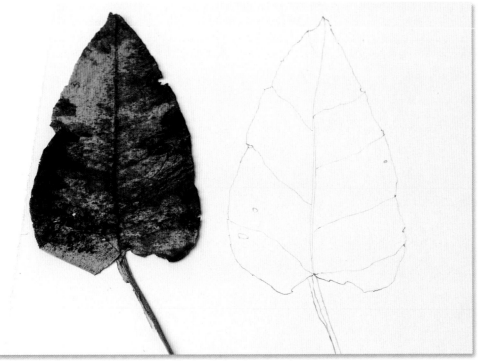

Keep a specimen leaf close to hand as a reference for tonal differences alongside your preliminary pencil sketch.

Tip
I do as little drawing as possible – the outer shape of the leaf and the veins are the most important parts.

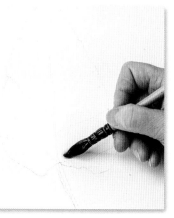 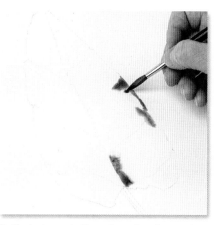 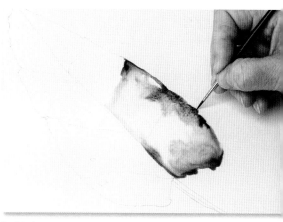

1. With a squirrel mop, size 2, and clean water, wet several sections of your leaf. Work right up to the edge of the pencil marks to ensure that when you apply the paint, it moves into the right places.

2. Begin to apply the paint using the number 6 sable brush. Work on just one section to begin with: I've started on the lower right-hand side of the leaf.

3. Work from the edges in: the paper will still be very wet so the water will do the work of moving the paint around.

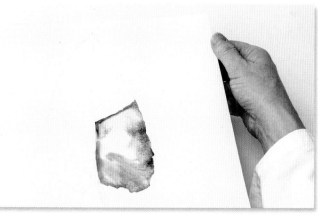 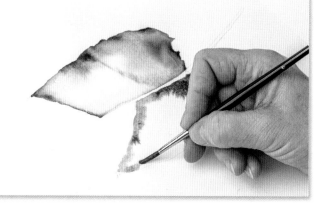

4. Keep looking at the source, the leaf, to check the variations in tone. Tip the paper to allow the watercolour to settle into its texture. Once the section is complete, leave it to dry.

5. Avoid painting the central vein – leave an area of white between the section you have painted and the next section you paint. Start by wetting the outer edges of the section, then move in with the sepia. Use the water to help you vary the tones.

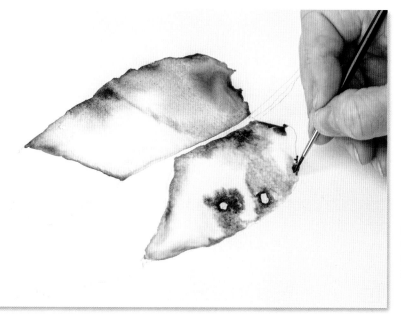

6. Leave areas of the leaf unpainted and work in a dark tone around the naturally-occuring holes. Again, allow the section to dry before you move on to the next.

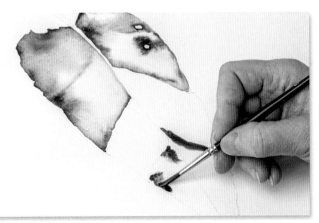

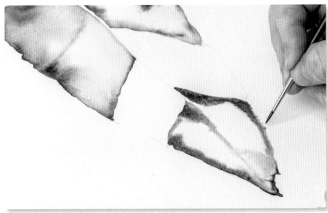

7. Move on to work on the top section, away from the sections you have already worked. Take the number 4 sable brush and apply more water, then drop in paint with the number 1 sable, alternating between applying dark and medium sepia. Go over the whole section here rather than focusing on one side of the leaf.

8. Switch between the five tones of sepia. Use lots of water, and very little paint, and remember to work while the paper is still wet.

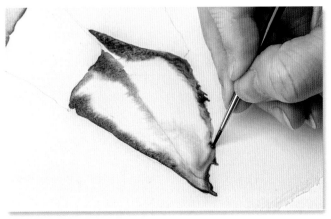

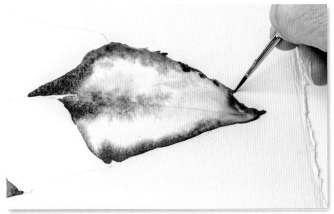

9. Add more dark tone with the smaller brushes and use a very light tone to blend in the areas.

10. Run a little more dark tone on the edge of the leaf. Leave to dry for a while (ideally two to three hours).

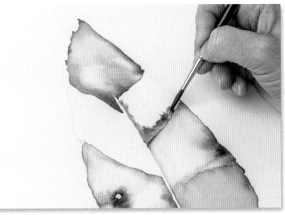

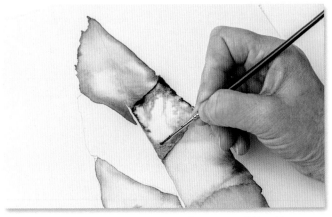

11. Once the top section is fully dry, begin to work on the mid sections of the leaf, starting by applying clean water. Use the number 6 sable for the smaller sections, and the number 4 for medium tone right up to the edge of each section.

12. Switch to the number 1 with the darker tone and blend in the colour, then leave to dry. Rotate the paper as you paint, to avoid smudging the areas of wet paint while you work on the next section.

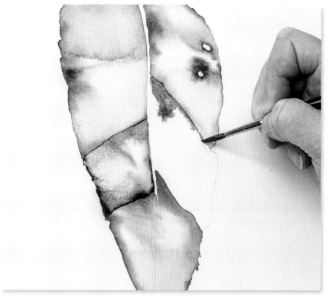

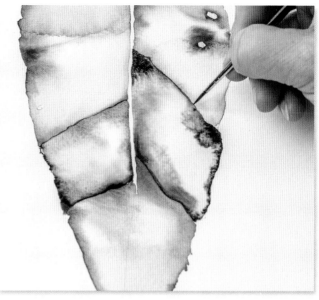

13. Apply water right up to the edge of the section. Paint in the dark tone but retain areas of light. Blend with the number 4.

14. Again, switch to the number 1 with a really dark tone towards the edge of the section. Leave to dry.

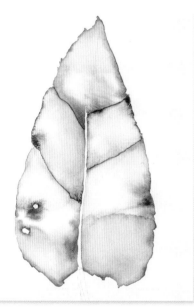

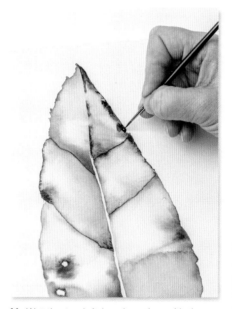

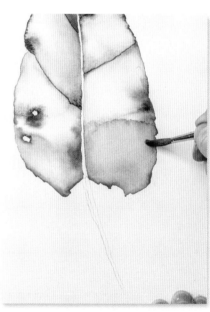

15. Once the leaf is completely dry, assess the tones. Think, 'Where do I need to darken?' Then you can begin to focus on the detail.

16. Wet the top left-hand section with the number 6. Flood in darks in small areas with the number 1; retain ninety per cent of the light areas.

17. In the bottom-right section, wet the area with the number 6 sable, then with the number 1. Flood the area with darker tone.

Demystifying...

Don't rework every section, just where the tone looks flat.

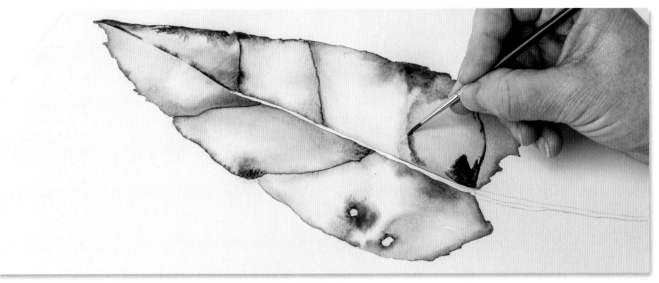

18. Use the number 1 to reinforce areas with darks, then leave to dry again.

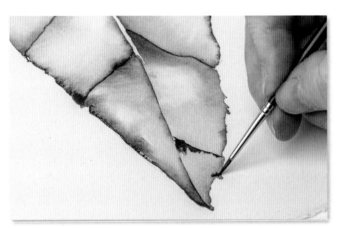

19. Move into the top-left section and the tip of the leaf. Wet the whole section with the number 4 sable, then add detail using the number 1.

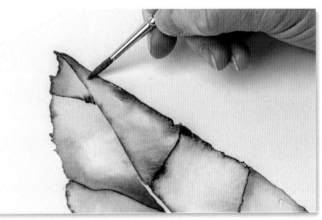

20. Use the number 4 on the top-right section using clean water, and fill in the tones with the number 1 and the dark sepia.

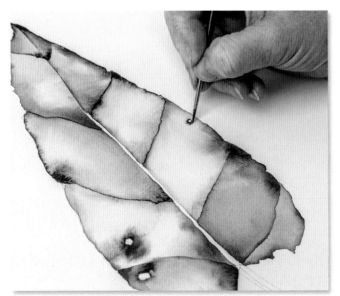

21. To refine the 'hole' on the right side of the leaf: use the number 1 brush and the darkest tone again – don't have too much paint on the brush. Stop, clean the brush and then blend in the tone.

Do the same again to improve the vein; use a dark tone with the number 1 brush, then blend out with clean water.

In the bottom-left corner, apply dark paint with the number 1 and again blend out with a clean brush.

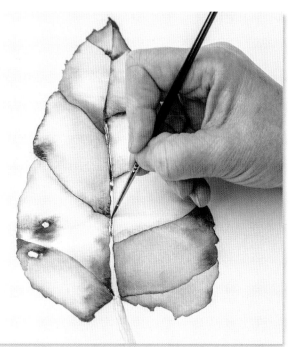

22. Now you can focus on the central vein and stem – do keep in mind that you still need to show tone even in small or fine areas. Wet the vein with the number 1 brush. Use the pale sepia tone, then wet the area again and paint in a dark tone. Start at the top of the central vein, and merge together the two tones so that the central vein looks solid and not split in two. This is working wet-into-wet on a minute scale. Leave to dry.

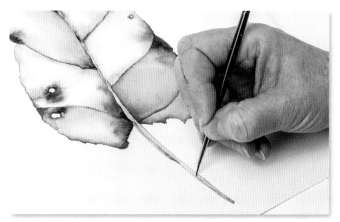

23. To complete your tonal leaf, use a number 0 sable brush to add a tiny amount of detail wherever you feel it necessary, then erase all the pencil marks with a putty eraser.

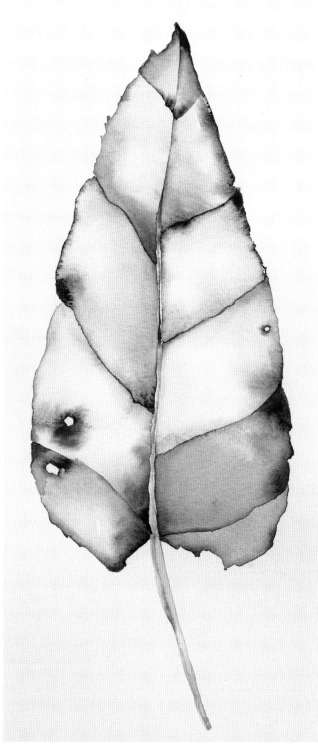

THE FINISHED PAINTING
33 × 33cm (13 × 13in)

PALETTES

Now that we have looked at pigments in some depth and have some insight into how they behave, we can begin to consider the colours that we choose to include in our palettes. By looking at colour in various palette categories, you develop strong ideas on how to use colours together.

THE BASIC PALETTE

I have always encouraged my students to start out by using a limited palette of colours, especially if you are a beginner. A basic palette of fourteen colours is adequate, particularly if you are a new to watercolour painting. When you have learnt the basics of colour mixing, you will find that fourteen colours will provide everything that you need. The advantage of starting with a palette this size is that you will get to know your colours quickly. If you have too many colours in your watercolour box, you can feel overwhelmed. When you have familiarized yourself with fourteen colours, then you can begin to treat yourself to new colours. Remember that this is my personal recommendation and is also the way that I have taught watercolour and colour mixing over the past twenty years.

Each set includes:
One cool yellow, red and blue
One warm yellow, red and blue
One orange
One pink ⎤ These are colours that you cannot
One violet ⎥ mix from three primaries.
One bright blue ⎦
Three earth colours: One deep red
 One warm brown
 One warm yellow.

I never recommend black or Payne's Gray as I prefer to mix my blacks and greys from my primary colours.

The basic palette I recommend is:

	Cadmium Lemon or Lemon Yellow		Cool yellow
	New Gamboge or Indian Yellow		Warm yellow
	Cadmium Orange or Winsor Orange		Orange
	Cadmium Red or Scarlet Lake		Warm red
	Permanent Alizarin Crimson or Permanent Carmine		Cool red
	Permanent Rose or Rose Madder Genuine		Pink
	Dioxazine or Ultramarine Violet		Violet
	French Ultramarine and Indanthrene Blue		Cool blue
	Cobalt Blue (warm blue)		
	Prussian Blue or Winsor Blue Red Shade		Brighter blue
	Winsor Green Yellow Shade or Viridian		Green
	Indian Red and/or Venetian Red		Deep earth red
	Burnt Sienna and/or Burnt Umber		Warm earth red
	Raw Sienna or Yellow Ochre		Warm earth yellow

Most of these colours are pure pigments and will make vibrant paintings. With a good knowledge of colour mixing, you don't need to buy a huge range of colours.

EARTH PALETTES

I briefly looked at earth colours as pigments in the second chapter, *Pigments Demystified* (see page 48). Throughout the ages and up to the present day, artists have used the colours of the earth to create art. We relate strongly to these colours because of their origins; the earth is such an important part of our history and heritage. As we know, the rich earth colours have been used as far back as cave paintings made 25,000 years ago. During many years of teaching I have noticed that students particularly relate to earth colours and this range of colours can be used to make very beautiful art.

The colours and mixes shown here give a lot of information about mixing earth colours, especially browns, taupes, greys and blacks. The charts show that you don't need to have a black in your palette: if you have a few colours such as Burnt Sienna, Burnt Umber, Raw Sienna, Light Red or Indian Red, and mix these with a blue, you can make many greys and browns.

Experiment with these or similar colours in your palette.

Universal nature

In Leonardo da Vinci's book, *The Treatise on Painting*, he advocates that the painter 'ought to study universal Nature'. Nature holds every example of colour and when you paint with earth colours, it is best to paint directly from life.

THE PURE PALETTE

Burnt Umber **Raw Sienna** **Sepia** **French Ultramarine**

THE MIXES

Burnt Umber + French Ultramarine: medium, dark and pale

Raw Sienna + Sepia: medium, dark and pale

French Ultramarine + Raw Sienna: dark **Sepia + French Ultramarine: dark** **Sepia + French Ultramarine: pale**

PAINTING THE CARDOON SEED HEAD

This cardoon seed head was drawn and painted from life. Working from life is very inspiring, especially as you are able to look carefully at your subject and see the colours first-hand. At first glance, it is tempting to think that the dried seed head is just 'grey'. On closer inspection you will see blue-greys, lilac-greys, very pale grey, very dark grey, light sandy brown and very dark brown.

Try mixing the colours that you see and testing them before committing to your watercolour painting.

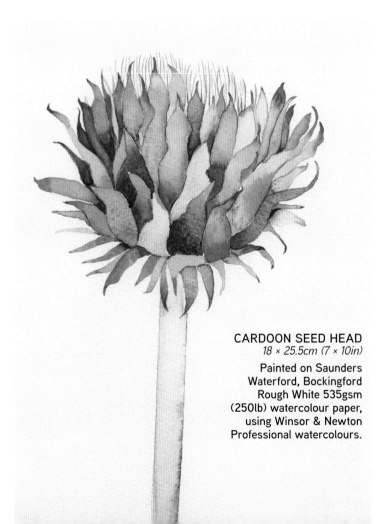

CARDOON SEED HEAD
18 × 25.5cm (7 × 10in)

Painted on Saunders Waterford, Bockingford Rough White 535gsm (250lb) watercolour paper, using Winsor & Newton Professional watercolours.

The artist's palette

Over the following pages, I have included a selection of paintings featuring a variety of subjects and colour palettes by contemporary watercolour artists. Each of the artists that I feature has a unique style and each artist uses colour in a very different way; you will notice that colour choice is a very personal matter – for example, Lilias August never uses Payne's Gray whereas Varsha Bhatia regularly includes Payne's Gray in her palette.

CLAIRE HARKESS

I first saw Claire Harkess's beautiful bird paintings at the Royal Institute of Painters in Water Colours annual exhibition at the Mall Galleries in London, UK. I was struck by her interesting and sensitive use of colour.

In her own words: 'I instinctively grab whatever colour is necessary. I do a lot of mixing on the palette and I avoid using black, greens and white straight from the tube. I work with the white of the paper for the lightest highlights.'

I relate strongly to Claire's use of colour as I also work very instinctively: I will also 'grab' whatever colour I feel like using. This will vary depending on the subject and how I feel on that particular day. An instinctive approach to colour gives a very personal and authentic touch to your painting.

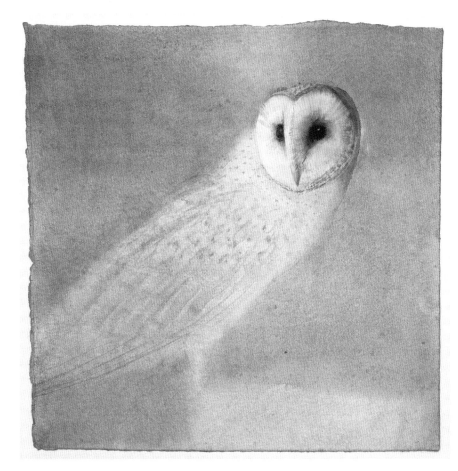

GHOST OWL
Claire Harkess
35 × 35cm (13¾ × 13¾in)
The palette: Raw Umber, Burnt Umber, Raw Sienna, Burnt Sienna, Cerulean Blue, Alizarin Crimson and Transparent Orange.

«

MUTE SWAN
Claire Harkess
Approximately 12 × 12cm (4¾ × 4¾in)
The palette: Burnt Umber, Raw Umber,
Burnt Sienna, Raw Sienna, Cerulean Blue,
Alizarin Crimson and Transparent Orange.

«

MUTE SWAN
Claire Harkess
Approximately 12 × 12cm (4¾ × 4¾in)

Compare this painting with the *Mute
Swan*, above – the subject is the same
but notice the subtle difference in the
background colour.

VARSHA BHATIA, RI

Varsha Bhatia paints beautifully detailed architectural studies in watercolour and uses a very limited palette of mainly earth colours.

RAJENDRA POL, JAIPUR
44 × 38cm (17¼ × 15in)

Painted on Saunders Waterford, Bockingford 535gsm (250lb) Cold-pressed (Not surface) watercolour paper.

Colours include: Payne's Gray, Sepia and Yellow Ochre.

ST PANCRAS WINDOW DETAIL
40.5 × 37.5cm (16 × 14¾in)

Painted on Saunders Waterford 638gsm (300lb) Cold-pressed (Not surface) watercolour paper.

The palette: Burnt Sienna, Yellow Ochre and Cadmium Red, Sepia, Yellow Ochre, Natural Tint and Payne's Gray.

LIMITED PALETTES

It can be tempting to think that you need to use lots of colours to make a bright painting, but this does not have to be the case. I have mentioned working with a limited palette previously and this has been demonstrated on various worksheets. There are many benefits to working with a limited palette of three or four colours: you will learn a great deal about colour mixing and your painting will look fresh and unified. A limited palette means that you have to be disciplined in using only a few colours and cannot be tempted to include any other colours in your painting.

I'm an avid beachcomber and will collect inspiring things and then take them back to the studio to paint from life. I found both of these seaweed samples on the same day and kept them in water in my studio to ensure that their colours remained bright and shiny.

I used a limited palette of only four colours for each of these studies – I worked wet-into-wet and allowed the pure colours to mix on the paper.

Painted on Saunders Waterford 425gsm (200lb) Hot-pressed watercolour paper.

| Quinacridone Magenta | Permanent Rose | Raw Sienna | Burnt Sienna | Quinacridone Magenta + Burnt Umber | Permanent Rose + Raw Sienna |

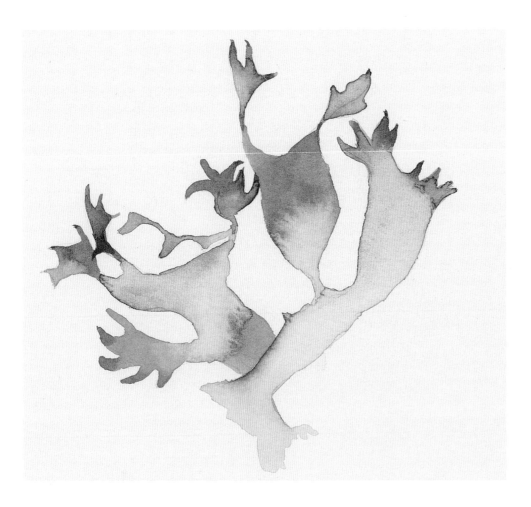

Permanent
Sap Green

Burnt Sienna

Raw Sienna

French
Ultramarine

Permanent
Sap Green +
Burnt Sienna

Permanent
Sap Green +
Raw Sienna

Permanent
Sap Green
+ French
Ultramarine

French
Ultramarine +
Burnt Sienna

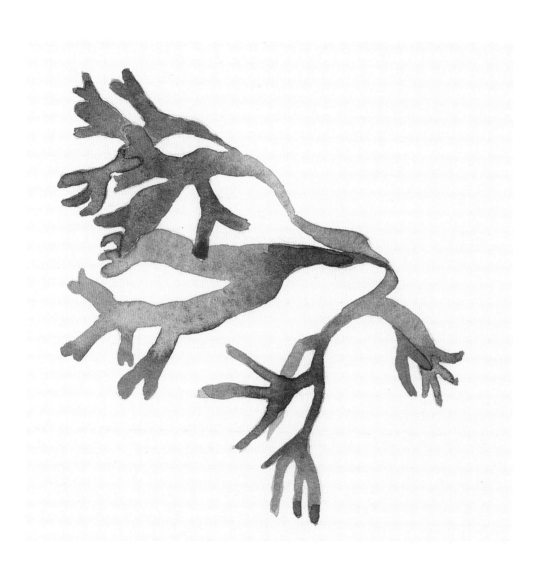

PERFECT COLOUR COMBINATIONS

Using only two colours within a painting can work very well: a very limited palette can still appear bright and colourful. The chart below gives many examples of perfect colour combinations – these can often be, but are not always, complementary colours. It is useful to see charts of two-colour combinations; a painting made using only two colours is still very inspiring.

The paintings on this page have been made using only Phthalo Turquoise and Light Red (the kingfisher) and Phthalo Turquoise and Indian Red (the bird, below). Both have been painted on Khadi 320gsm (140lb) Rough watercolour paper.

Phthalo Turquoise + Light Red

Phthalo Turquoise + Permanent Alizarin Crimson

Winsor Blue Red Shade + Light Red

Winsor Blue Red Shade + Permanent Alizarin Crimson

Phthalo Turquoise + Indian Red

Phthalo Turquoise + Cadmium Orange

Winsor Blue Red Shade + Indian Red

Winsor Blue Red Shade + Cadmium Orange

Winsor Blue Green Shade + Light Red

Winsor Blue Green Shade + Permanent Alizarin Crimson

Cobalt Turquoise + Light Red

Cobalt Turquoise + Permanent Alizarin Crimson

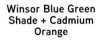

Winsor Blue Green Shade + Indian Red

Winsor Blue Green Shade + Cadmium Orange

Cobalt Turquoise + Indian Red

Cobalt Turquoise + Cadmium Orange

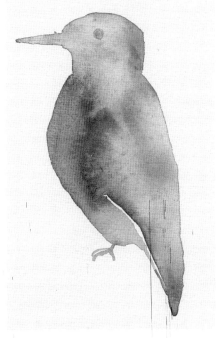

▲ **KINGFISHER**
20 × 20cm (7⅞ × 7⅞in)

▼ **BIRD**
20 × 20cm (7⅞ × 7⅞in)

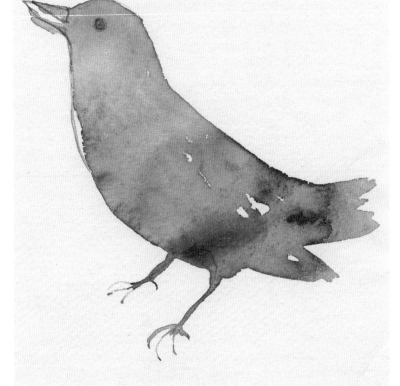

80

PAINTING THE PHEASANT

The palette used for the pheasant painting below comprises the seven colours seen in the plumage of the bird itself. I have listed a set of alternative colours that are very similar and close enough to be used as another option. This is to show that you don't always have to buy new colours to make a particular painting.

 The pheasant was painted from life after a friend brought it round to my studio and it was hung up in the garage for several days while I drew and painted it. Seeing the vibrant colours of this magnificent bird was so inspiring.

THE COLOURS USED FOR THE PHEASANT

Phthalo Turquoise	French Ultramarine	Light Red	Burnt Sienna	Winsor Red	New Gamboge	Sepia

AN ALTERNATIVE PALETTE

Cobalt Turquoise	Cobalt Blue	Venetian Red	Burnt Umber	Scarlet Lake	Cadmium Yellow	Vandyke Brown

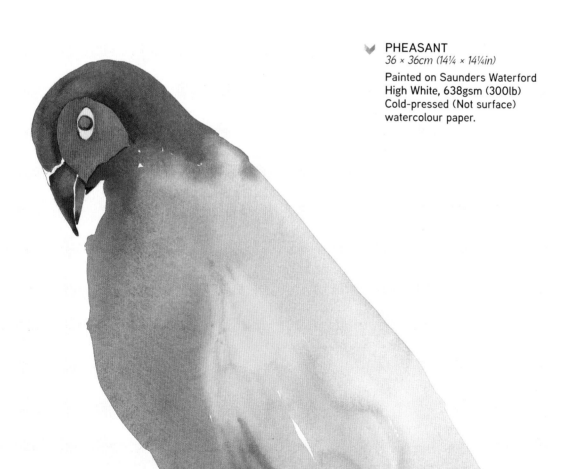

PHEASANT
36 × 36cm (14¼ × 14¼in)

Painted on Saunders Waterford High White, 638gsm (300lb) Cold-pressed (Not surface) watercolour paper.

A LIMITED PALETTE

LILIAS AUGUST, RI

Lilias August paints exquisite still life pictures; here she explains some of her working methods and the colours that she uses.

'My painting is done in layers, building up tone and colour along the way. Sometimes I need to wait a day or two to let things set. I use masking fluid to give me freedom and consistency with my washes and to help me put down the painting's layout – these areas are often washed over and blended in later when the mask is removed.

'My palette is limited: a basic six (two of each primary) and a few extras. I use the most transparent, stain-strong [colours] I can get. Neutrals come from mixing three primaries (I never touch Payne's Gray): most of my neutral colours are mixed using a blue and Raw or Burnt Sienna. Sometimes I use all four and sometimes I add a touch of something else like Quinacridone if it needs it, testing and adjusting as I go. It's very instinctive.'

The six basics that Lilias uses are:

Blues – Ultramarine and Cerulean;

Reds – Cadmium and Quinacridone;

Yellows – Cadmium Yellow and Lemon Yellow.

The extras are usually Viridian, Burnt Sienna and Raw Sienna.

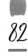

▼ SEVEN BRUSHES
109 × 40cm (43 × 15¾in)

▲ HANGING BY A THREAD
109 × 30cm (43 × 11¾in)

▲ EMPTY NESTS
94 × 31cm (37 × 12³⁄₁₆in)

VIBRANT COLOUR PALETTES

A vibrant palette can be used for flowers, imaginative paintings and painting abroad, on the Mediterranean, for example, where the colours in nature are often exceptionally bright. The paintings featured on the page opposite combine very bright, vibrant colour with subtler tones.

I have deliberately used Opera Rose here to show how bright this particular colour is. However, it is bright because it is fluorescent, and any colour that is fluorescent is not light-fast. This is a very important point to consider when displaying or even selling your work, as colours like Opera Rose will fade in time and lose their vibrancy. However, if you choose to replicate either of these paintings, you can substitute Opera Rose with Quinacridone Red or Pink, or Permanent Rose.

Mixing on the paper

As in the seaweed studies on pages 78–79, I have allowed most of the colours to mix on the paper. To create this effect, you must prepare your colours before you begin so that you can keep the work spontaneous and fresh.

Painted on Saunders Waterford High White 638gsm (300lb) Hot-pressed watercolour paper.

DARK AND MEDIUM TONES

| Opera Rose | Cerulean Blue | Dioxazine | Green Gold | French Ultramarine | Burnt Sienna |

MEDIUM AND PALE MIXES

**Burnt Sienna +
French Ultramarine** **Opera Rose + Green Gold** **Cerulean Blue + Dioxazine**

Opera Rose + Dioxazine **Cobalt Blue + Green Gold**

Opera Rose + French Ultramarine **French Ultramarine + Cerulean Blue**

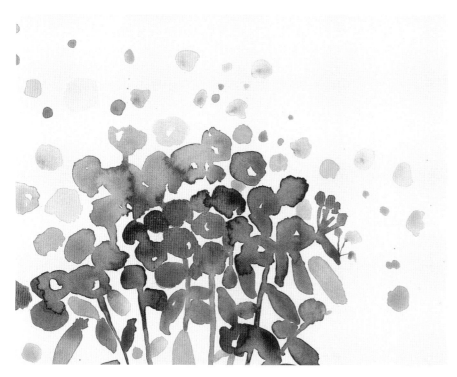

A CLOSE-UP OF VIBRANT COLOURS
27 × 22cm (10⅝ × 8⅝in)

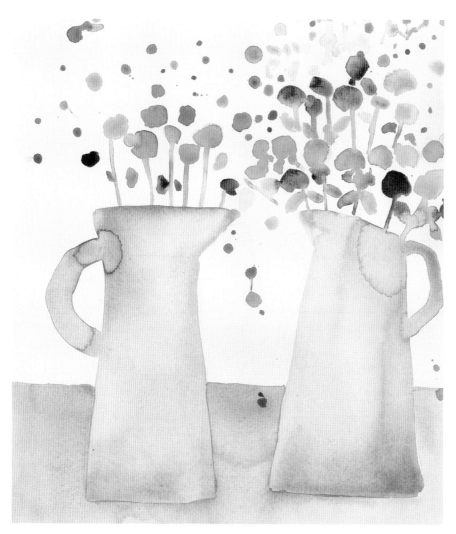

STILL LIFE IN VIBRANT COLOURS
50 × 40cm (19¹¹⁄₁₆ × 15¾in)

Carte Postale Birds

This project uses a limited palette of yellows, blues and greens to demonstrate how even by using very few colours, you will still achieve a colourful painting through the mixes that you choose to make.

Mix the colours with an old brush, and keep clean water to hand. The finished painting can be seen on page 93.

WHAT I USED

Paints: Daniel Smith Extra Fine watercolours in French Ultramarine, Duochrome Emerald, Cadmium Yellow Medium Hue, Green Gold and Burnt Sienna.

Brushes: Sable brushes – numbers 6, 4 and 1.

Other tools or materials: Pencil and putty eraser.

Supports: Saunders Waterford 638gsm (300lb) Hot-pressed watercolour paper.

Demystifying...

It can be difficult to paint birds from life as they are constantly in motion; use a good reference photograph.

86

THE LIMITED PALETTE

French Ultramarine; Green Gold; Duochrome Emerald; Cadmium Yellow Medium Hue and Burnt Sienna.

THE MIXES

French Ultramarine + Cadmium Yellow Medium Hue

French Ultramarine + Green Gold

French Ultramarine + Burnt Sienna

Green Gold + Cadmium Yellow Medium Hue

Duochrome Emerald + Cadmium Yellow Medium Hue

French Ultramarine + Duochrome Emerald: greener mix

French Ultramarine + Duochrome Emerald: bluer mix

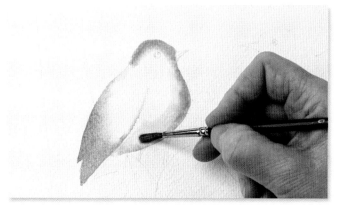

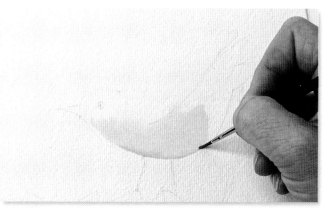

1. Paint clean water on the bird with the number 4 sable brush. Run in a blue mix of French Ultramarine and Duochrome Emerald starting on the underbelly of the left-hand bird (this should be mostly French Ultramarine with just a touch of the Emerald). Work around the 'edge' of the bird and blend the colour into the water. Paint in the first layer, then leave to dry.

2. Move over to the right-hand bird. Paint clean water onto the bird, then run in Cadmium Yellow on its own on the underbelly of the bird. Work in the feathers in one go, using the number 4 sable brush still. Then swap to the number 1 brush to paint in a stronger Cadmium Yellow on the underbelly.

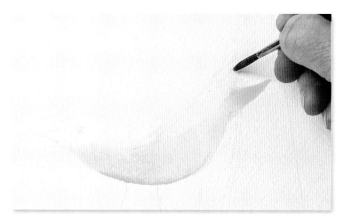

3. Use a stronger yellow on the lower wing tip and tail.

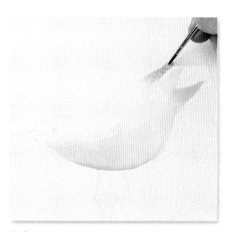

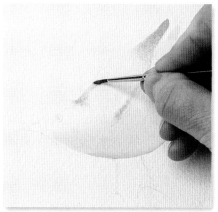

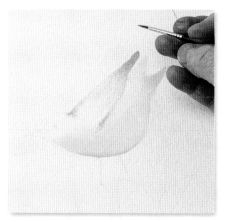

4. Continue to build up the bird's undercoat: use a lot of water and very pale Cadmium Yellow. While the colour is still wet, take the greener mix of French Ultramarine and Duochrome Emerald and apply it with the number 1 sable to the upper edge of the wing.

5. Blend a stronger mix into the wing tip, wet-into-wet.

6. At the top of the wing, paint in a pale green and blue mix without getting rid of all the white areas altogether – retain some highlights.

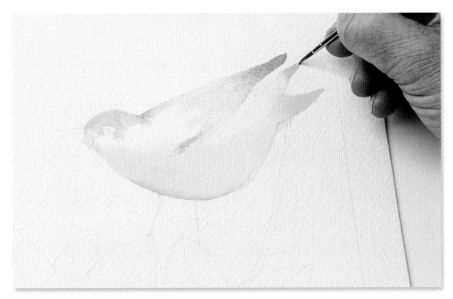

7. With medium yellow, paint in the bird's head while the paper is still wet, then paint in some stronger yellow on the middle section of the tail. Leave to dry. It is worth noting that this particular paper dries quite quickly.

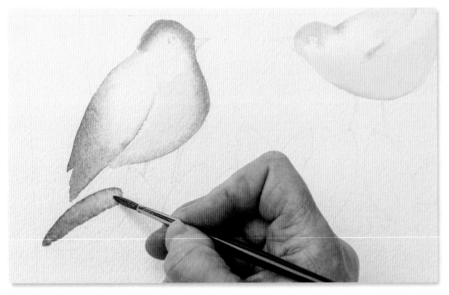

8. Move on to the leaves. Using the number 4 sable, run in a mix of Cadmium Yellow and French Ultramarine. Add a bit of water and blend. Work on one half of each leaf at a time – here, I am working on the top half of the leaf only.

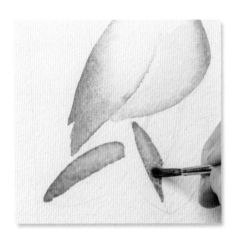

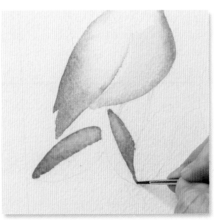

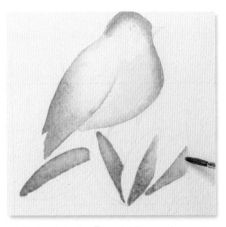

9. Move on to a mix of French Ultramarine and Green Gold, again working one section of the leaf at a time and using water to blend.

10. Use a smaller brush (a number 1 sable) to paint the tips of the leaves.

11. Go back to the French Ultramarine and Cadmium Yellow mix. Add some water and blend the mix into the third leaf along from the left. Use the same mix for the next leaf along and again use water to blend.

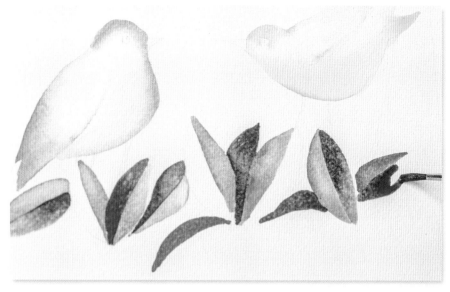

12. Strengthen the same palette you've been working with, then paint some more of the leaves in mixes of French Ultramarine and Green Gold, and French Ultramarine and Cadmium Yellow. Apply the darker mixes to the leaves with the number 4 brush, then blend with water, to alternate mixes and tones. Leave to dry.

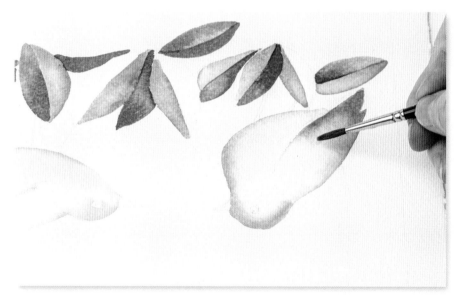

13. Make up two new mixes of the Duochrome Emerald with a bit of French Ultramarine: one bluer mix for the left-hand bird, one greener mix for the right-hand bird. Wet part of the wing of the left-hand bird with clean water, working into the white areas. Blend in the bluer mix to strengthen the wing, using the number 4 sable. Tidy it up with the number 1. You may wish to rotate your paper at this stage to work closely on the left-hand wing.

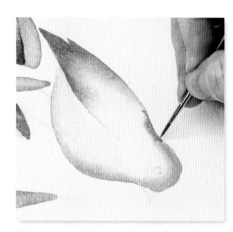

14. Work on the back of the bird's head in the same mix, then leave to dry and move on to work on the right-hand bird.

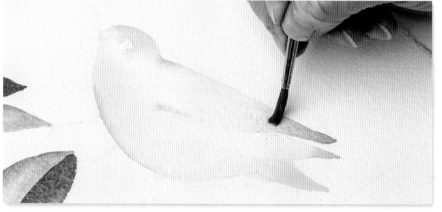

15. Use the number 4 sable to paint water onto the top wing of the right-hand bird; blend with the more green mix.

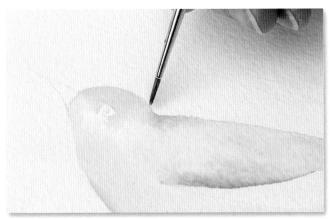

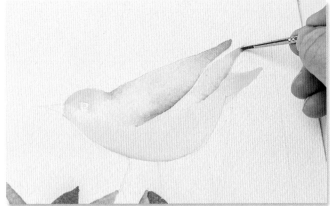

16. Paint a little bit of green over the bird's head so that the colour shines through.

17. Wet the middle section of the tail and run in Cadmium Yellow on its own, then a little bit of the greener mix underneath and on the tip of the tail.

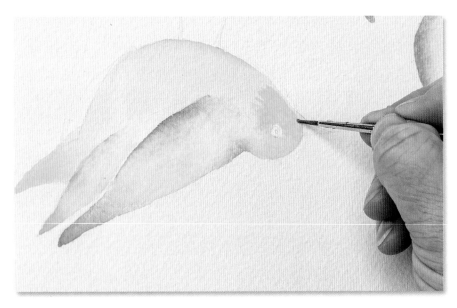

18. Turn the board 180 degrees again. Wherever the colour looks as if it isn't strong enough, add more. Merge Cadmium Yellow into the bird's head, and blend. Add a bit more yellow under the wing as well. Leave to dry.

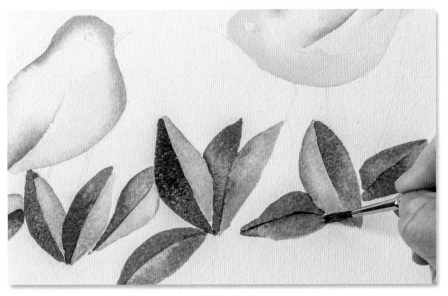

19. Go back to the leaves. Alternate between the mixes of French Ultramarine and Green Gold, and French Ultramarine and Cadmium Yellow. Paint any of the leaves that you have not yet painted, then leave to dry again.

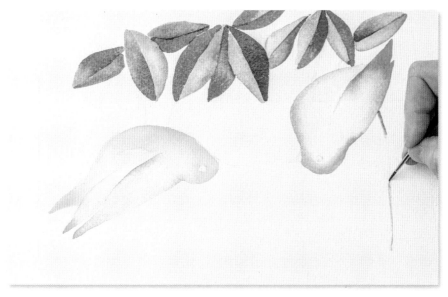

20. Add the darks in next, such as the stems of the leaves, and the birds' legs: make both a dark and a pale version of a French Ultramarine and Burnt Sienna mix. Using the number 1 sable, run some clean water into the stems and twigs. Then with a very dark mix of French Ultramarine and Burnt Sienna, run the colour into the water to create the stems. Paint darks and lights into different areas so that the stems do not look flat.

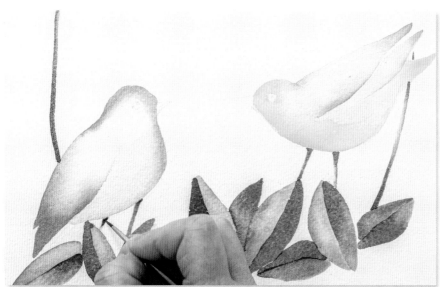

21. Use a paler mix of the French Ultramarine-Burnt Sienna for the birds' legs to begin with, then paint with the darker mix at the bottom. Allow to dry.

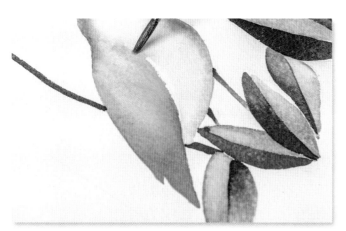

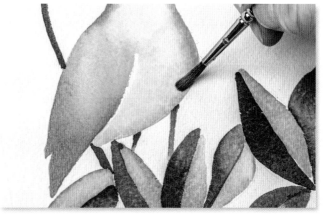

22. Go back into the birds' bodies to add more detail. Rewet the paper and add colour to the left-hand bird first: a medium mix of Cadmium Yellow Hue with Duochrome Emerald, with the number 6 sable brush.

23. Apply pure Duochrome Emerald to the bird, using the number 4. Then paint in some watery-green over the head, with a much stronger mix on the wing. Paint pure Cadmium Yellow onto the bird's underbelly.

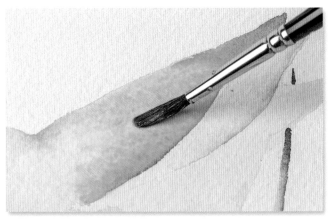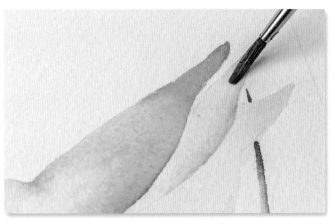

24. You now need to balance out the birds. Wet the top wing of the right-hand bird, and then apply a strong Duochrome Emerald. Use clean water to blend the colour in a little more.

25. Paint clean water onto the second wing, then drop in a medium Duochrome Emerald. Again blend in the colour with clean water. Allow to dry while you move on to the details of the birds' faces.

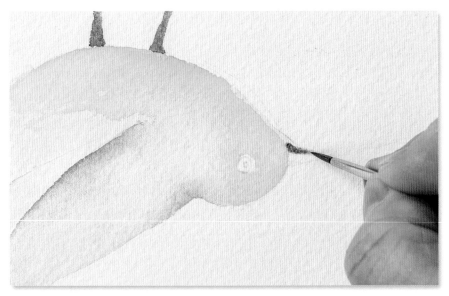

26. Go back to the faces of the birds and paint water into the beaks. With the number 1 brush, alternate between dark and light versions of the French Ultramarine-Burnt Sienna mix. Do one half of both beaks at the same time: paint water onto the bottom half of each beak. Apply the pale mix first, then move across to fill in the same area of the second bird's beak. Then apply the dark mix and allow both to dry.

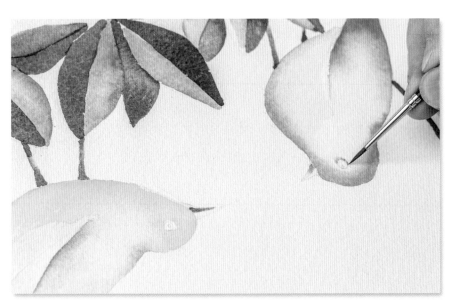

27. Work around the eyes with clean water, then apply a tiny bit of paint under the eye. Blend with a clean brush for a shadow. Do the same for the second bird's eyes. Finally, fill in the tops of the beaks with a pale French Ultramarine-Burnt Sienna mix. Erase your pencil marks with a putty eraser once all the paint is dry.

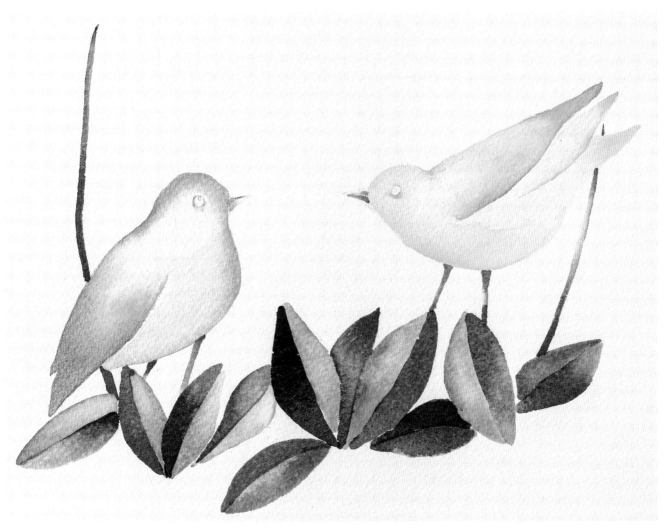

▲ THE FINISHED PAINTING
26 × 28cm (10¼ × 11in)

CHRISTINE FORBES

Christine Forbes's beautiful flower paintings are full of life and expression. She successfully uses a fresh and bright palette of colours, some of which she allows to mix on the paper. For inspiration for a vibrant palette, refer to the colour suggestions and charts on page 84.

SUMMER INTO AUTUMN ⌃
Rendered in watercolour and ink.

f.forbes

GERANIUM 5
Rendered in watercolour and ink.

A COLOURFUL PALETTE

Claire Harkess's bird paintings have all been created using
the palettes listed alongside each picture. As you can see,
each painting is very bright and colourful. This has been
achieved using limited palettes of colours; for example *Hoopoe*
(see opposite) is so vibrant – yet it has been made with only
five colours.

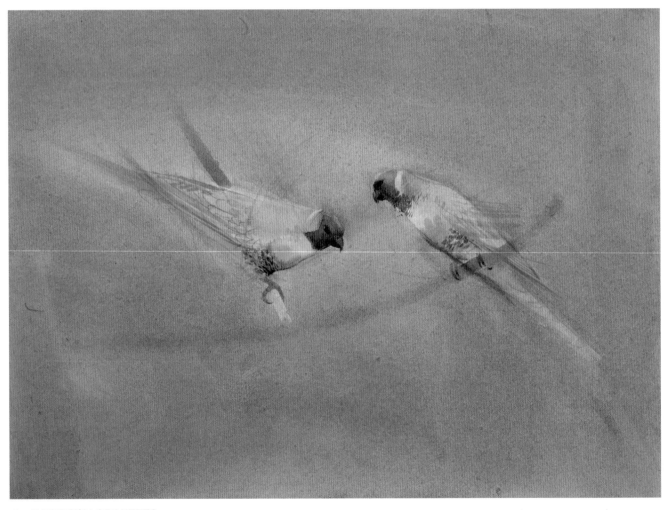

RAINBOW LORAKEETS
The palette: Raw Sienna, Raw Umber, Winsor Blue, Ultramarine, Cadmium Red,
Cadmium Yellow, Lemon Yellow and Alizarin.

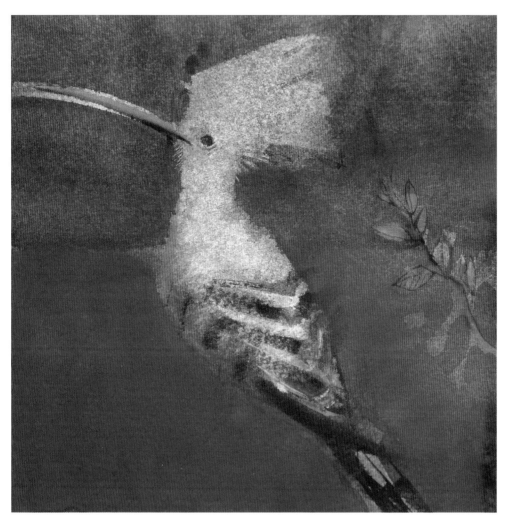

HOOPOE

The palette: Alizarin Crimson, Cadmium Red, Burnt Sienna, Cadmium Yellow and Winsor Blue.

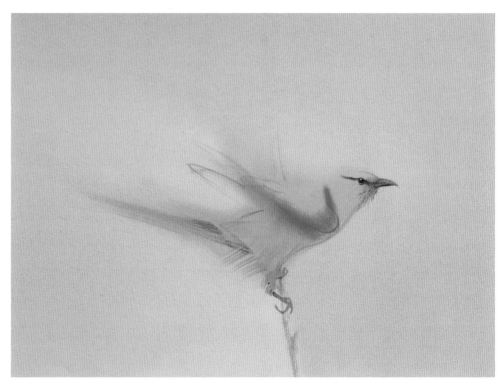

ROLLER II

The palette: Cadmium Turquoise, Winsor Blue, Alizarin, Raw Umber, Cadmium Yellow and New Gamboge.

THE INTERACTION OF COLOUR

Colour must be considered in context: we never see a colour in isolation. In a landscape, for example, a green will appear in accordance with the colours around it. This chapter, on the interaction of colour, explores in more depth how colours work or appear alongside one another.

We have seen various colour schemes throughout the book. Complementary colour schemes give high contrast, for example, the contrast of putting the complementary colours red and green next to each other can literally make the edge of the red look like it is shimmering.

Colours will also appear differently when placed next to certain others, for example a pale blue surrounded by yellow will appear darker than when it is surrounded by a dark green, where it will recede. Colours have a back and forth effect on each other depending on the combination.

Colours in an analogous scheme are easier to define (see pages 30–33) as they are next to each other on the colour wheel. Other combinations are less easy to define and are also seen subjectively.

To get the most out of this chapter, I recommend that you complete the exercises and the worksheets so that you have your own colour charts to refer to.

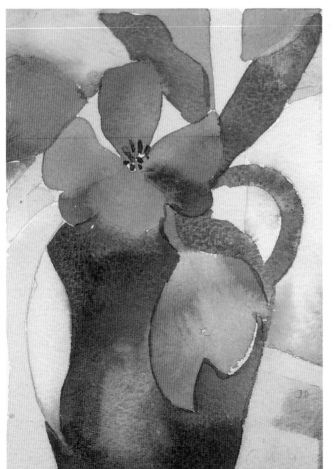

STILL LIFE
14 × 19cm (5½ × 7½in)
Painted on Saunders Waterford, Bockingford 425gsm (200lb) Rough watercolour paper.

This *Still Life*, painted wet-into-wet, is an example of how particular bright colours complement each other and make each other look brighter. I began with a very simple drawing from a vase of tulips in front of a window. Here you must think of shapes and not your subject. Before painting, carefully plan which areas you want to be light and dark. I wanted the vase and flowers to stand out, so the background is generally lighter than the vase and flowers. The dark blue complements the pink-orange flowers and also the yellow in the leaves and background. The green leaves are the complement to the orange in the background. Notice how the bright yellow leaf appears next to the blue vase. The dark blue and bright flowers stand out and make the background recede. The pale pink in the background is also a perfect complement to the blue vase.

WORKING WET-ON-DRY

Look closely at the chart of circles below to see the different effects that one colour has on others: whether a colour jumps out or recedes depends upon its relationship with a second colour.

To paint this chart yourself, choose a blue, a violet, a pink, a red-pink, a red and an orange from your palette. Make a note of the specific colours you have used, for future reference.

Paint a row of five circles in each colour and allow them to dry fully. Then paint a different-coloured ring around each circle in the row. You will see clearly how the original colour appears to look different depending on the colour surrounding it.

To paint both *Circles 1* (below) and *Circles 2* (overleaf), each adjacent ring of colour must dry fully before you paint the next one, so that one colour doesn't bleed into another – this is known as painting wet-on-dry.

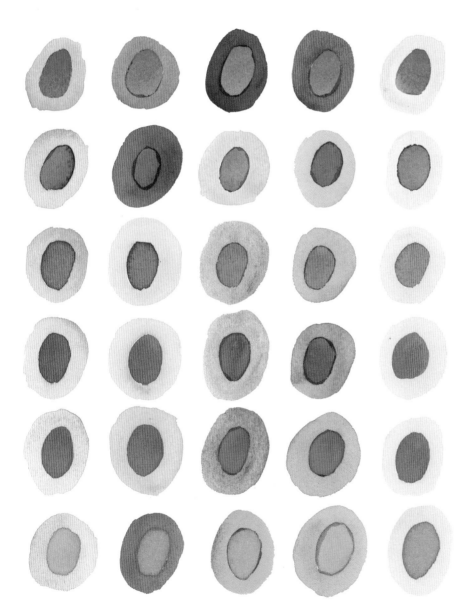

CIRCLES 1

Painted on Saunders Waterford High White 638gsm (300lb) Cold-pressed (Not surface) watercolour paper.

COMBINING THREE COLOURS

When you combine three colours, things become a lot more complex. On this relatively simple example you will see how some colours jump out when they are put in particular combinations. The back-and-forth effect of the colour combinations alter our perception of the colour relationships. For example, a bright yellow around a blue makes the blue look dull; then a blue surrounded by a green looks brighter. You never quite know what will happen when you place one colour next to another. The circles example here, is a good way to experiment with this.

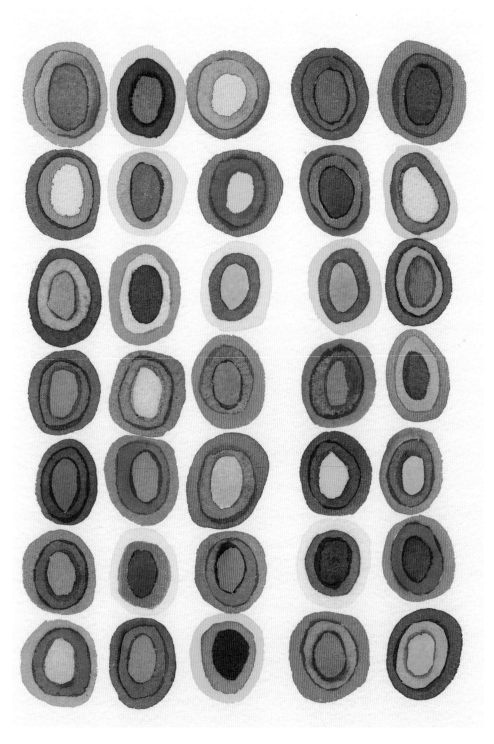

CIRCLES 2
Painted on Saunders Waterford High White 638gsm (300lb) Cold-pressed (Not surface) watercolour paper.

WORKING WET-INTO-WET

Whereas the previous two colour charts were painted working wet-on-dry, the circles in the painting below were painted wet-into-wet. This is another simple way of seeing how colours work together.

Start by premixing the colours that you want to experiment with, and then paint circles freehand. Let some dry and others run into each other. Try experimenting with this method as a contrast to the way in which you painted the previous colour circle charts. As you notice the softening effect of one colour merging into the next, you will also see that the resultant wet-into-wet circles are less harsh and less definite than those seen in *Circles 1* and *Circles 2*. Working in this way – wet-into-wet – will also help you understand how to achieve a painting like the *Still Life* on page 98.

Choose a good range of colours from your palette to experiment with here. I have used the following colours: Quinacridone Crimson, Cadmium Scarlet, New Gamboge, Lemon Yellow, Terre Verte, Prussian Blue and Quinacridone Burnt Orange.

Painted on Saunders Waterford 425gsm (200lb) Hot-pressed watercolour paper, using Daniel Smith Extra Fine watercolours.

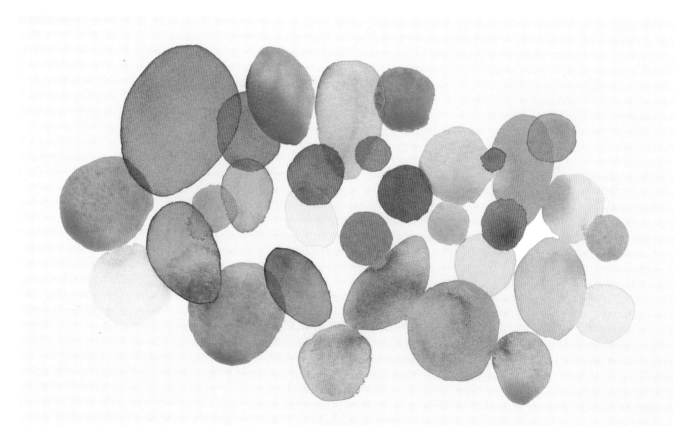

COMPARING WORKING WET-ON-DRY AND WET-INTO-WET

There are times when you will paint one colour and let it dry before you paint the colour next to it and other times when you will work wet-into-wet and allow the colours to merge into each other. Both techniques are invaluable in watercolour painting and it is useful to see both examples in isolation. Try experimenting in this way to see how different pigments work together.

In the first example I have used different colours as the base colour and added the same colour to them. If we look at the top row, the Permanent Rose looks completely different when combined with several greens. These are all different greens, and the Permanent Rose recedes with the first in the row, a paler green, such as Sap Green but becomes very strong when combined with the last in the row, a bright green such as Viridian. Here the paint is spreading into the green rather than being adjacent to it.

Painted on Saunders Waterford, Bockingford White 535gsm (250lb) Cold-pressed (Not surface) watercolour paper.

Varying the base colour

Greens with Permanent Rose

Blues with Permanent Alizarin Crimson

Reds with Prussian Blue

Violets with Vandyke Brown — **Earth colours with French Ultramarine**

Varying the top colour

In this example, I have used the same base colours and added different colours to them. Some pigments are extremely dominant – for example, in the third row down, the Permanent Alizarin Crimson takes over the Cerulean Blue, but in the top row it blends nicely with the French Ultramarine.

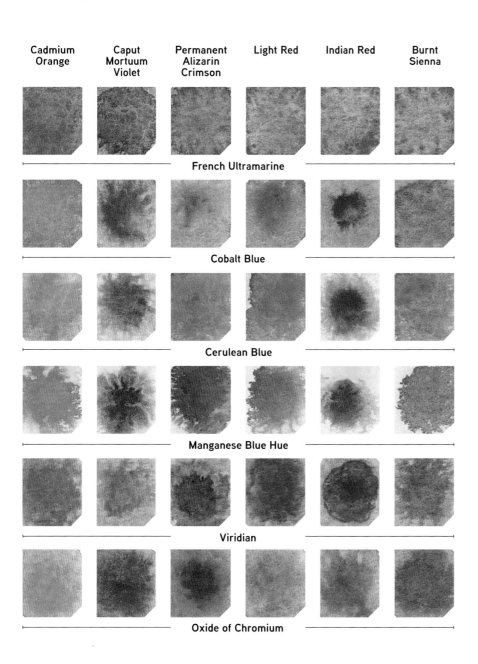

| Cadmium Orange | Caput Mortuum Violet | Permanent Alizarin Crimson | Light Red | Indian Red | Burnt Sienna |

French Ultramarine

Cobalt Blue

Cerulean Blue

Manganese Blue Hue

Viridian

Oxide of Chromium

Christmas Cactus

The Christmas Cactus is another perfect example of complementary colours found in nature. I decided to paint a pale pink background as I wanted the painting to appear warm. I could have chosen a pale blue or grey background, but this would have given a cooler feeling. Background colours must be considered carefully so as to achieve a successful colour combination in the painting.

The finished painting can be seen on page 111.

The finished painting can be seen on page 111.

WHAT I USED

Paints: Daniel Smith Extra Fine watercolours in Permanent Alizarin Crimson, Raw Sienna, Viridian, Burnt Sienna, French Ultramarine; Quinacridone Rose and Quinacridone Fuchsia.
Brushes: Squirrel mop – size 2/0, sable brushes – numbers 1 and 4.
Other tools or materials: Pencil and kitchen paper.
Support: Saunders Waterford 638gsm (300lb) Hot-pressed watercolour paper.

THE PALETTE

Quinacridone Rose; Quinacridone Fuchsia; Permanent Alizarin Crimson; Burnt Sienna; Raw Sienna; French Ultramarine and Viridian.

THE MIXES

Viridian and Burnt Sienna – left: 50:50 mix, right: more Burnt Sienna

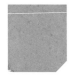

Viridian and Raw Sienna – left: 50:50 mix, right: more Raw Sienna

Viridian, Burnt Sienna and French Ultramarine – left: dark tone, right: medium tone

Permanent Alizarin Crimson and Raw Sienna; 50:50 mix, pale

Quinacridone Rose and Quinacridone Fuchsia, dark to pale

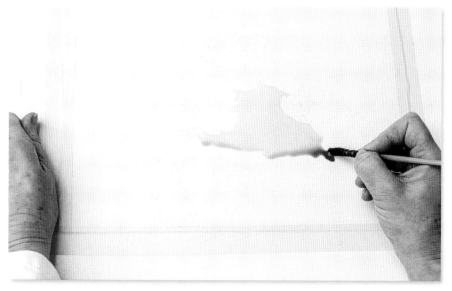

1. First, apply the background with the Permanent Alizarin Crimson and Raw Sienna mix using the size 2/0 squirrel mop brush. Prop your board on a slight angle so that the paint runs down, giving you a wet edge to work with. When you have completed a section of the background, gently bang the board against your work surface to settle the pigments on the paper.

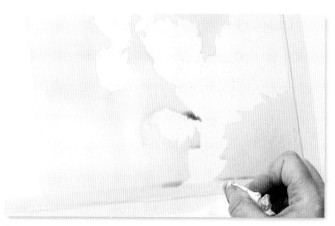

2. Use water to fade the colour to the bottom of the paper, then merge the tones to avoid hard lines. Mop up any wet areas with kitchen paper and leave to dry.

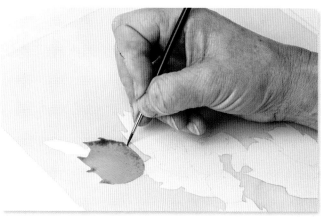

3. Sketch in some extra leaves on top of the wash, then paint the leaves with the assortment of green mixes. Begin with the number 6 brush but keep numbers 4 and 1 close to hand. Apply a Viridian–Raw Sienna mix first.

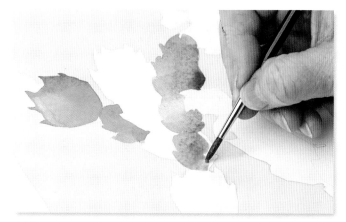

4. Use a Viridian–Burnt Sienna mix for some darker greens – keep in mind that this plant is lit from the left, so the leaves on the right will be darker.

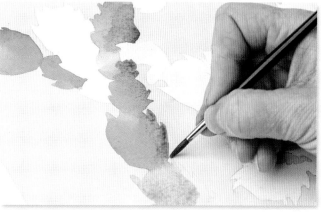

4. Work each section in the same way, but alter the tone slightly each time. Rotate the paper if you need to.

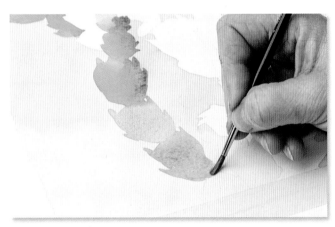
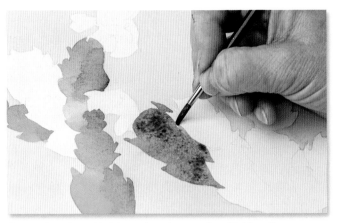

6. Paint in dark mixes of Viridian-Burnt Sienna and Viridian-Burnt Sienna-French Ultramarine wet-into-wet. Apply the darks using a number 4 for larger areas and number 1 for smaller areas of paint. Use a very dark Viridian-Burnt Sienna-French Ultramarine mix for the bottom-most leaves.

7. Move into the mid-right and apply a medium Viridian-Burnt Sienna mix, again using the number 4 sable and working into the edges of the leaves. For the top area behind the leaves, use a yellowy-green mix of Viridian and Raw Sienna, then apply a darker tone of the same mix. Leave to dry.

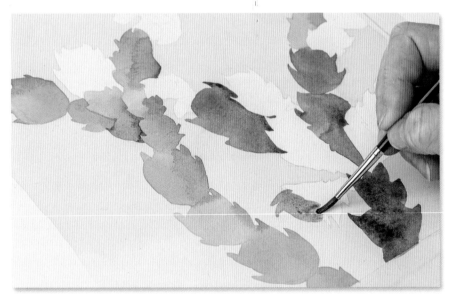

8. Use the same mix as in step 7 but darken it in order to illustrate the leaves in the background. Then paint Viridian-Burnt Sienna-French Ultramarine onto the ends of the leaves.

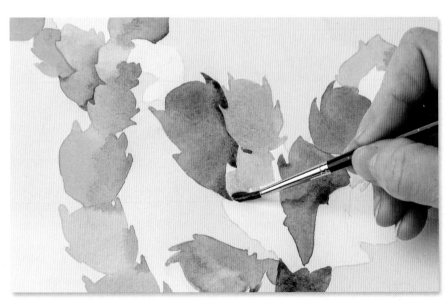

9. Use a medium mix of the Viridian-Burnt Sienna-French Ultramarine for the middle-right area of leaves; run darks into the edges and blend while wet. Apply a medium mix of Viridian and Burnt Sienna mix on the top-right leaf.

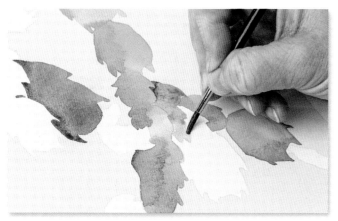

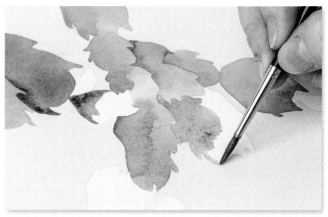

10. Turn the board around to paint the leaves on the central branch. Use the number 4 with the medium mix and some darks. Leave some parts of the leaves unpainted and revisit these after the first layer has dried.

11. Apply some more mediums and darks, then a mix of Viridian and Raw Sienna on the parts of the leaf where it catches the light, then leave to dry.

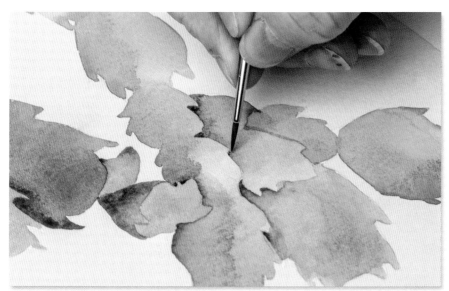

12. Go back over with the green mixes and finish with these before you move on to the pinks at step 14. Use the Viridian-Burnt Sienna medium mix with the number 4 sable, and a darker mix with the number 1 sable.

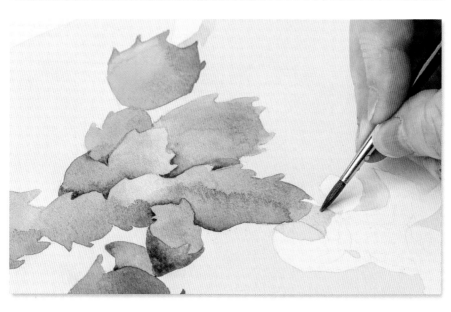

13. Paint the more yellow mix of Viridian and Raw Sienna onto the last areas of leaves, then leave to dry. If you notice that any green areas needing darkening, blend these out with water and a mix of Viridian-Burnt Sienna-French Ultramarine using the number 1 sable.

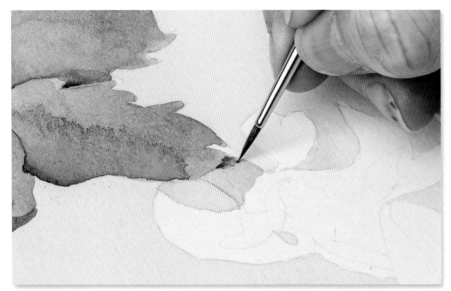

14. Now move on to the flower. Apply a small amount of green – Viridian and Raw Sienna – at the base of the flowerheads, then, with the number 1 brush, touch in a small amount of Quinacridone Fuchsia while the flowerheads are still wet.

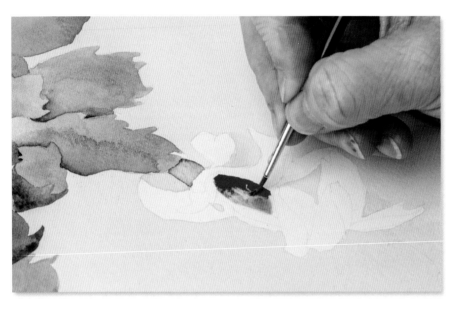

15. Use both Quinacridone Rose and Quinacridone Fuchsia neat, and mix them on the flower itself. You may wish to rotate the paper in order to get closer to the flower detail.

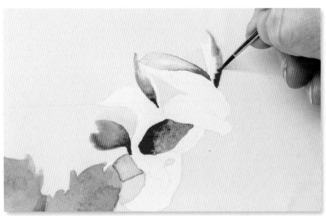

16. For the petals, apply clean water and flood in the pinks, working wet into wet, using the number 1. Start with the petals of the largest flower first, then move on to the more fiddly flowers. Start with Quinacridone Rose; leave it to dry, then go into the Quinacridone Fuchsia, both still with the number 1 brush.

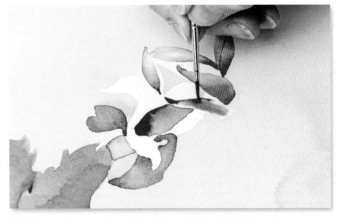

17. Now make up a mix of the Quinacridone Fuchsia and Quinacridone Rose and use this to paint the largest areas. For smaller petals, wet with the number 1, then use a mix of the two pinks.

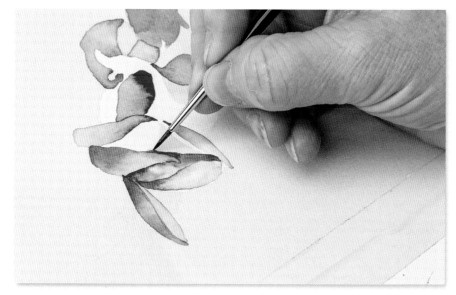

18. Apply some more clean water, then a mix of the pinks at the ends of the flowers using the number 1. Paint additional darks with the Quinacridone Fuchsia on its own. Leave to dry again.

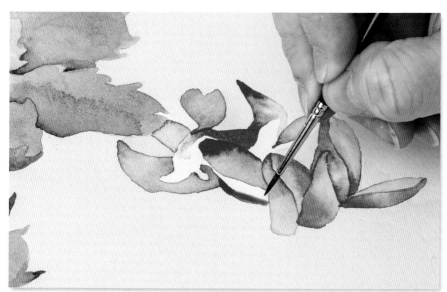

19. For extra darks, dot in more Quinacridone Fuchsia, then leave to dry.

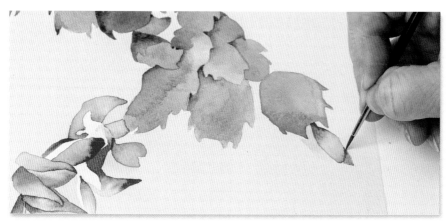

20. Turn the board around 180 degrees. Apply water onto the bud on the far left of the painting, then a mix of both pinks. Then drop in some strong Quinacridone Fuchsia before turning the board back again.

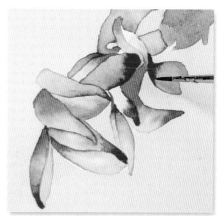

21. Working on the darks with the number 1 brush, apply water and a mix of the pinks for the insides of the folded petals. Then apply the Quinacridone Fuchsia neat to the undersides of the flowerheads. Leave to dry.

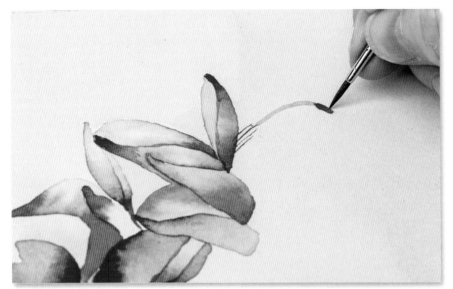

22. Turn the board around 180 degrees again. Apply clean water, the medium mix of pinks and a tiny dot of dark to the stamen.

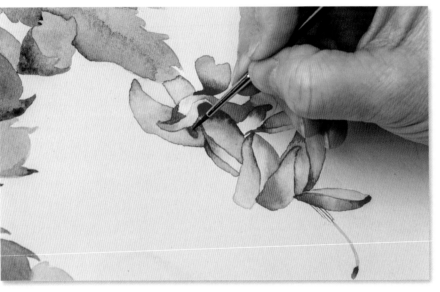

23. Use a fairly dry brush for the last details in the pink: apply the colour, then pull it out and soften it with water. Finish the painting with a few more dark areas.

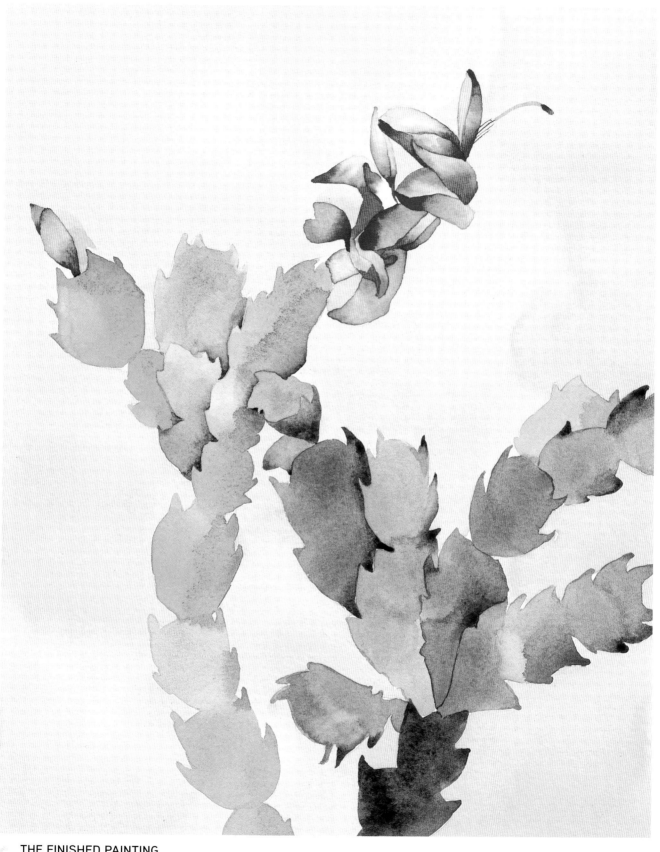

THE FINISHED PAINTING.
24.5 × 30cm (9⁵⁄₈ × 11¾in)

MODIFYING YOUR COLOURS

Colour mixing is a subtle art and the smallest addition of one colour to another can produce the perfect colour or the shadow that you need for your painting.

Modifying colour is very important: it means that you do not have to rely on colours as they come straight from the tube or pan, and you can think about the precise shade that you need for your painting. Sometimes this will be a pure colour, but if you are painting shadows, then the colour will inevitably be created through modifying a pure colour. Similarly, a colour such as French Ultramarine, straight from the tube, is fantastic, but can be far too bright or unsubtle to be used as a pure colour, such as for painting a blue sky on a dull day. If, however, you add a tiny amount of a brown, such as Burnt Sienna or Burnt Umber, this will give you the right shade of blue for a duller sky. Experiment by modifying the colours you already have in your watercolour collection.

In this chapter, we look at ways in which you can change your colours through subtle mixing. You will see considerable benefits in learning these skills – you will no longer settle for a colour that is 'wrong'; you will move away from using a colour straight from the tube or pan; you will discover how to make very bright colours less brash and conversely learn to create the perfect shadow colour. Ultimately, you will begin to think more about how to acquire the perfect colour for your painting.

PANSIES
47 × 22cm (18½ × 8¹¹⁄₁₆in)

Painted on Saunders Waterford 425gsm (200lb) Hot-pressed watercolour paper, using Winsor & Newton Professional watercolours in Dioxazine, Permanent Alizarin Crimson, French Ultramarine, Burnt Sienna, Lemon Yellow, Viridian and Cadmium Orange.

At first glance, the pansies appear to be one dark, velvet purple, but on closer inspection, we see a lot of subtle colour variation in each petal.

I started with Dioxazine, adding various amounts of Permanent Alizarin Crimson and French Ultramarine to make many different violets.

COLOUR MODIFICATION CHART

In the simple chart that I have created, below – the original colour, a), is modified by only a small amount of colour b). Try out as many combinations as you can to learn more about modifying your colours.

Painted on Saunders Waterford 425gsm (200lb) Hot-pressed watercolour paper, using Daniel Smith Extra Fine watercolours and Winsor & Newton Professional watercolours.

a) French Ultramarine + b) Light Red

a) French Ultramarine + b) Raw Sienna

a) Raw Sienna + b) Cobalt Blue

a) Viridian + b) French Ultramarine

a) Viridian + b) Light Red

a) Viridian + b) Burnt Sienna

a) Raw Sienna + b) French Ultramarine

a) Viridian + b) Raw Sienna

a) Iridescent Electric Blue + b) Light Red

a) Iridescent Electric Blue + b) Burnt Sienna

a) Iridescent Electric Blue + b) Raw Sienna

a) Iridescent Electric Blue + b) Viridian

MODIFYING GREENS

A great range of greens can be made by modifying any pure green with earth colours such as browns, siennas and earth yellows. This is demonstrated in the painting of the dandelion, below.

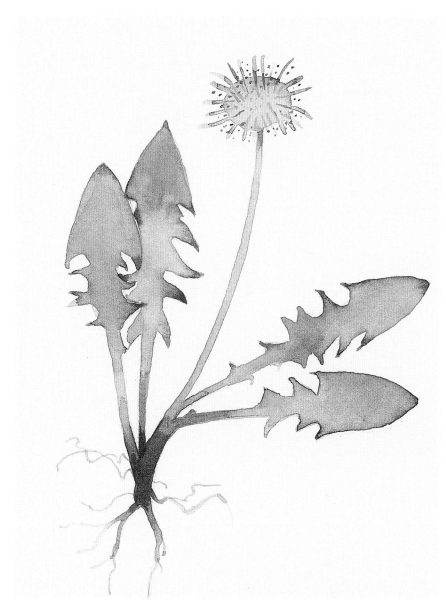

DANDELION
20 × 16.5cm (7⅞ × 6½in)

The dandelion has been painted on Saunders Waterford 425gsm (200lb) Hot-pressed watercolour paper.

| Permanent Sap Green | Permanent Sap Green + Raw Sienna | Raw Sienna | Raw Sienna + Sepia | Sepia | Sepia + Permanent Sap Green |

MODIFYING A LIMITED PALETTE

Remember that you can make a very colourful painting using only three colours. Through careful modification of each colour, the raven is still very dramatic and varied in tone.

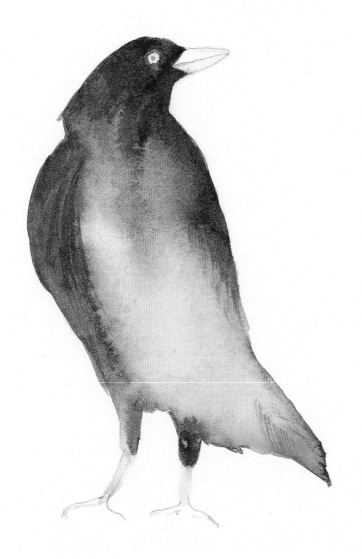

RAVEN
20 × 16.5cm (7⁷⁄₈ × 6½in)

The raven has been painted on Saunders Waterford 425gsm (200lb) Hot-pressed watercolour paper.

| French Ultramarine | Shadow Violet | Mayan Blue Genuine | French Ultramarine + Shadow Violet: medium tone | French Ultramarine + Shadow Violet: dark tone | Mayan Blue Genuine + Shadow Violet: medium tone | Mayan Blue Genuine + Shadow Violet: dark tone |

MODIFYING A MORE COMPLEX PALETTE

Here I have used a more complex palette, but have still modified the colours. The colour modification indicates subtle changes in the colours on the fish, particularly seen on the scales of the fish.

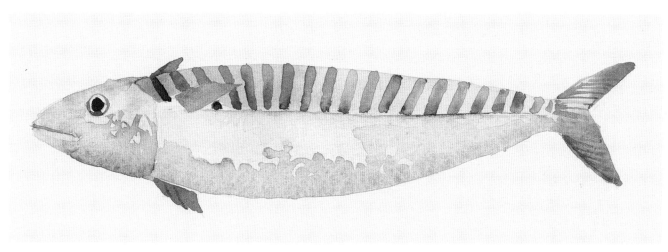

MACKEREL
24.5 × 10cm (9⅝ × 4in)
The mackerel has also been painted on Saunders Waterford 425gsm (200lb) Hot-pressed watercolour paper.

THE PALETTE

French Ultramarine (pale mix)	French Ultramarine (dark mix)	Light Red	Viridian	Iridescent Electric Blue	Raw Sienna	Burnt Sienna

THE MODIFIED COLOURS

Burnt Sienna + French Ultramarine (dark)	Burnt Sienna + French Ultramarine (pale)	French Ultramarine + Iridescent Electric Blue	Iridescent Electric Blue + French Ultramarine	Viridian + Iridescent Electric Blue	French Ultramarine + Burnt Sienna (very dark)

DARKENING COLOURS AND CREATING SHADOW COLOURS

You may believe that the easiest way to make a shadow colour or to darken a colour is to add black, but black will instead deaden your watercolours. Therefore, to darken a colour in watercolour, you can add a darker complementary pigment from the colour wheel to a lighter pigment – so for example you can darken a yellow by adding a touch of violet.

The chart below gives many examples of how to darken a colour gradually to produce successful – naturalistic – shadow colours. This method will still dull a lighter colour to some degree, but the result will be a more vibrant and colourful painting than if black had been used.

Painted on Saunders Waterford High White 638gsm (300lb) Cold-pressed (Not surface) watercolour paper, using Winsor & Newton Professional watercolours.

118

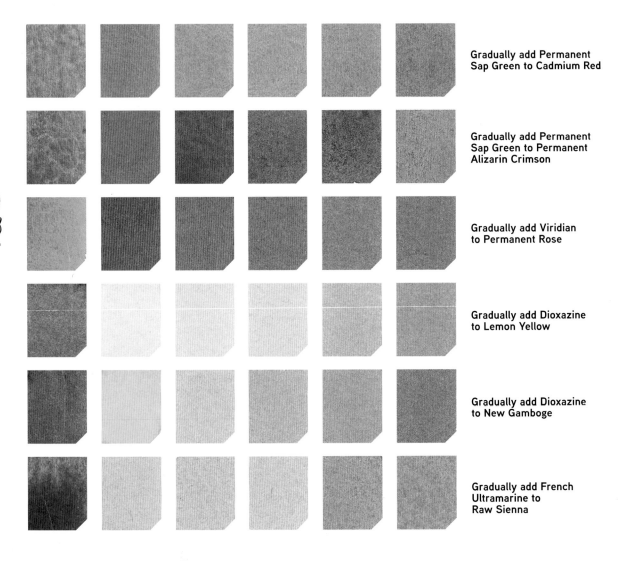

Gradually add Permanent Sap Green to Cadmium Red

Gradually add Permanent Sap Green to Permanent Alizarin Crimson

Gradually add Viridian to Permanent Rose

Gradually add Dioxazine to Lemon Yellow

Gradually add Dioxazine to New Gamboge

Gradually add French Ultramarine to Raw Sienna

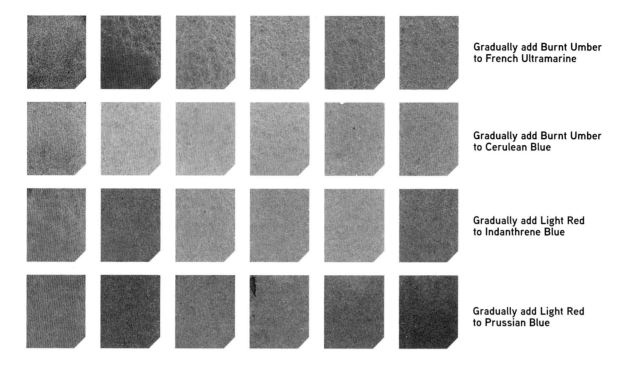

Gradually add Burnt Umber to French Ultramarine

Gradually add Burnt Umber to Cerulean Blue

Gradually add Light Red to Indanthrene Blue

Gradually add Light Red to Prussian Blue

SUCCESSFUL SHADOWS

Shadow colours need to be subtle and not too harsh. There are two kinds of shadows; the shadow on an object (an object shadow) and the shadow made by the object (a cast shadow). In the painting of a pear, below, there is both a shadow on the pear and a shadow cast by the pear on the surface.

In this context, you need to consider the local colour to know which colour needs to be mixed in for a successful shadow. In this example, a touch of complementary Cobalt Blue was added to the Lemon Yellow of the pear, and a touch of red-brown (Burnt Sienna) to Cobalt Blue for the shadow on the surface below it.

PEAR WITH SHADOWS
14 × 20cm (5½ × 7⅞in)

Painted on Saunders Waterford, Bockingford 535gsm (250lb) Rough watercolour paper, using Winsor & Newton Professional watercolours.

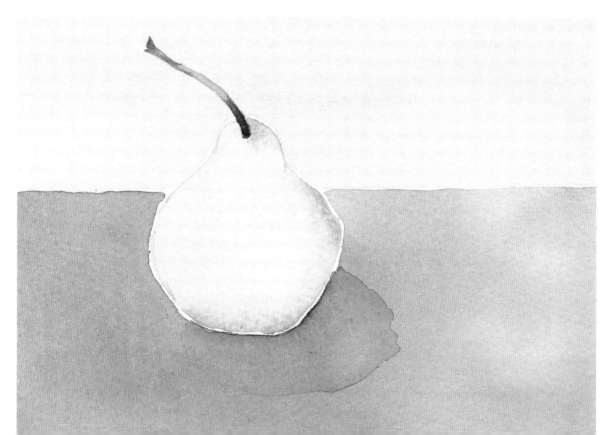

Daina's Teapot

This is very bright and cheerful painting using a limited palette of only four colours. A lot of the colours used are pure colours in various tones, but the shadows and background area are created by using modified colours. The shadows are an important part of the painting, which create depth and link up different areas within the painting.

The finished painting can be seen on page 125.

WHAT I USED

Paints: Daniel Smith Extra Fine watercolours in Cobalt Blue, Aureolin, Quinacridone Red and Burnt Sienna.
Brushes: Squirrel mop – size 2/0, sable brushes – numbers 6, 4 and 1.
Other tools or materials: Pencil.
Support: Saunders Waterford High White 638gsm (300lb) Cold-pressed (Not surface) watercolour paper.

THE PALETTE

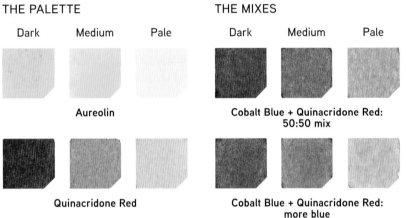

Dark | Medium | Pale

Aureolin

Quinacridone Red

Cobalt Blue

Burnt Sienna

THE MIXES

Dark | Medium | Pale

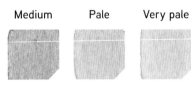

Cobalt Blue + Quinacridone Red: 50:50 mix

Cobalt Blue + Quinacridone Red: more blue

Medium | Pale | Very pale

Cobalt Blue + Burnt Sienna

Before you begin

Make up three tones of each colour – dark, medium and pale – using your mixing brush, and test them on a spare scrap of watercolour paper before you begin.

1. Start by painting in the striped cloth, the largest area. Load the number 6 sable with plenty of paint – start with the darkest tone of Cobalt Blue, then move onto pale to alter the tone in each stripe. Shake the board gently to settle the pigment and then lay it flat to dry.

2. Work around the handle of the teapot; work from the top of the paper with the dark tone, on to the medium tone, then down into the lightest tone. Work inside the teapot handle with a medium Cobalt Blue and a loaded number 1 brush. Paint in the other 'inside' details in the same way.

Demystifying...

You could use masking fluid at this stage, but you need a steady hand to apply the fluid, and there is a risk of the fluid ruining the paper.

3. Resume painting in the stripes using the number 6, working from dark to medium to light from top to bottom. Turn the paper 180 degrees around to focus on the lighter areas at the bottom.

4. Leave to dry.

5. Switch between the numbers 1, 4 and 6 sable brushes at this stage: start with the 6 and the strongest, darkest Aureolin to block in the teapot. Vary the tone slightly with medium, then pale.

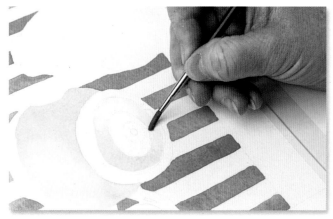

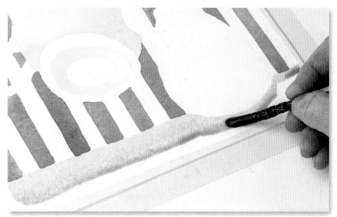

6. Allow to dry before painting the lid, to avoid the pot smudging. Apply the darkest yellow first, then the medium, then the pale, then finish with the medium yellow again.

7. Work in the largest areas of the painting next – the top and side of the background. Use a blue mix of Cobalt Blue and Quinacridone Red, quite pale, along the top,

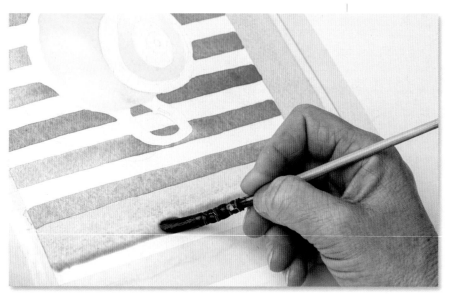

8. Turn the board 90 degrees around and use a squirrel mop, size 2/0, to lay in the wash along the side in a 50:50 mix of Cobalt Blue and Quinacridone Red.

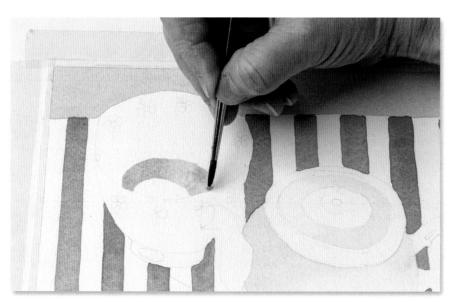

9. On the cup, use the number 1 and number 4 sable brushes to apply shadows. Apply the medium-grey shadow mix with the number 4 first, then change to the pale mix.

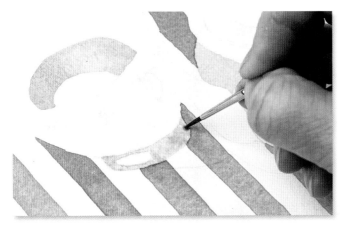

10. Apply the medium mix to the base of the cup: remember to alternate the tones. Use the medium mix with the number 1 wherever the shadows could be darker.

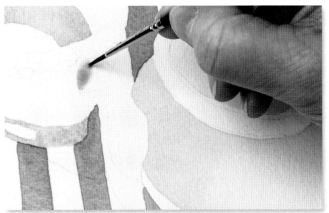

11. Move on to the teapot: use the number 1 and the darker mix to apply shadow on fine areas such as the inside of the spout.

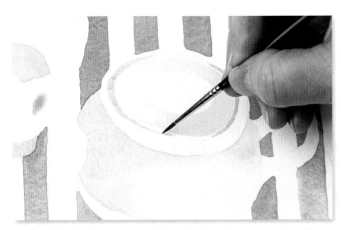

12. Paint the dark areas around the lid using the number 1, again alternating between the medium and pale tones. Modify the Cobalt Blue slightly to add to the shadow around the lid.

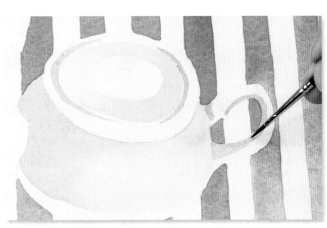

13. On the teapot handle, paint shadows using the number 1 brush. If you have a similar object in front of you, study it to see where the darks naturally fall. Leave to dry.

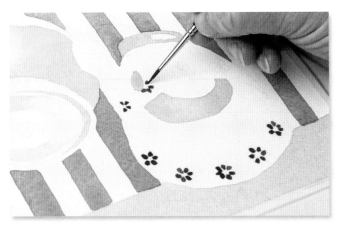

14. Once the teacup and teapot are dry, start putting in the flower details on the teacup. Start with Quinacridone Red on its own, with the number 1 brush. You can work with the board upside down if you choose. Dot in the flowers around the rim, both outside and inside the cup.

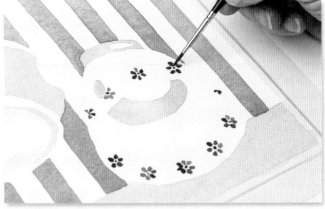

15. Swap to the mix of Quinacridone Red with Cobalt Blue. Still using the number 1 brush, paint the flower centres. Leave to dry.

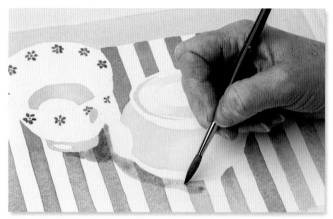

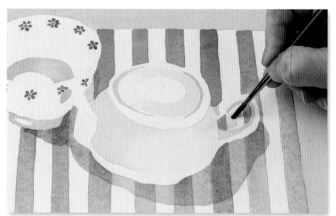

16. Use a dark mix of Cobalt Blue and Burnt Sienna – grey – to paint shadows under the pot and the cup, using the number 6. Introduce a medium tone as you work round the corners.

17. Use the palest mix for the top of the pot and under the handle using the number 4. Switch to the number 1 brush for the details on the lid. Move around to the back of the pot and add more details there.

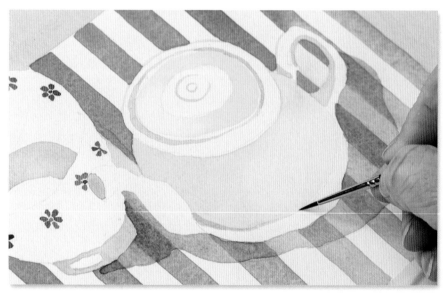

18. Paint the shadow on the top of the pot with the pale shadow mix and the number 1 brush, then do the same around the base and on the side.

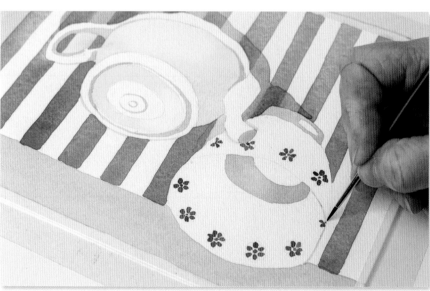

19. Finally, add more shadow behind the spout – a medium tone with the number 1 brush – and along the top rim of the cup.

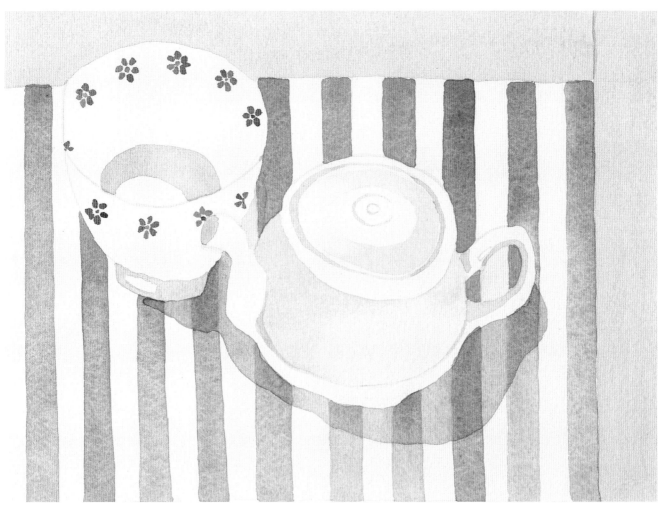

THE FINISHED PAINTING.
27 × 19cm (10⅝ × 7½in)

GLAZING

So far, we have been studying how to mix colours together to create another colour. Colours can also be mixed by layering paint – this is called glazing. Glazing is a wonderful way of creating beautiful effects and creating depth in your watercolour paintings.

The transparency of the paint is crucial for this method to work well. Each layer, or glaze, must be allowed to dry thoroughly before the next layer of paint is applied. The glazes must be very transparent so that the underlayers shine through. The end result is that the colours are mixed by the eye and mystery and atmosphere can be created in your paintings.

Glazing is useful in many ways. If, like me, you are often intimidated by a sheet of pure white paper, you can get over this feeling by painting a light glaze over the whole sheet. This underlayer then has the effect of unifying the whole painting. The glazing technique is often used for landscapes and skies, as glazing can create luminosity in a way that can't be achieved by other watercolour techniques.

ABSTRACT PAINTING
36 × 29cm (14³/₁₆ × 11⁷/₁₆in)

Painted on Saunders Waterford 635gsm (300lb) Cold-pressed (Not surface) watercolour paper.

The abstract painting is a good example of where glazing is used to create depth and interest in a painting.

Here, several layers of paint give the illusion of space in the picture. I gave each layer of paint many hours to dry before I applied the next glaze. This gave each glaze the appropriate time to settle and dry properly so that the next layer would not disturb the underlayer of paint.

Transparent and semi-transparent watercolours are generally the best paints to use for the glazing technique. See pages 128–131 for useful information on glazing colour combinations and mixes.

IDEAL COLOURS FOR GLAZING

Transparent colours (see page 46) are perfect for glazing as they allow colours underneath to shine through a second or third layer of paint. All of the colours in this chart are transparent and therefore ideal for glazing. This is best shown in several charts in the next few pages.

Painted on Saunders Waterford White 535gsm (250lb) Cold-pressed (Not surface) watercolour paper, using Winsor & Newton Professional watercolours and Daniel Smith Extra Fine watercolours.

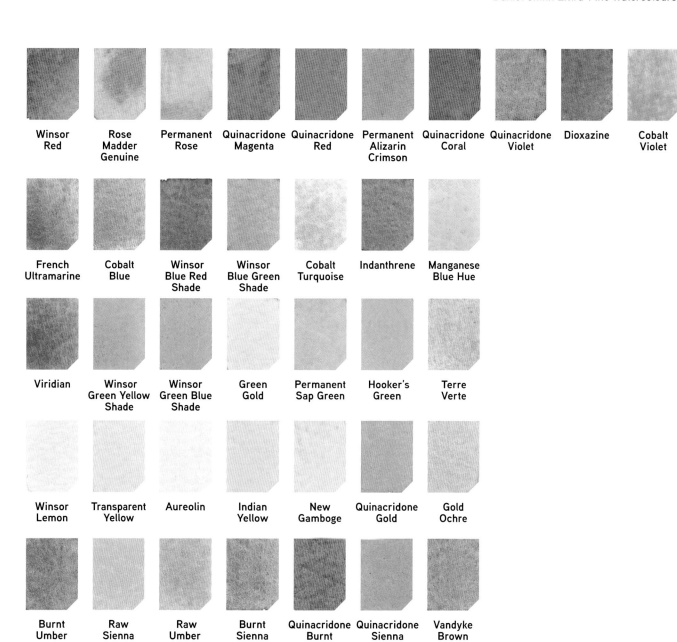

Winsor Red · Rose Madder Genuine · Permanent Rose · Quinacridone Magenta · Quinacridone Red · Permanent Alizarin Crimson · Quinacridone Coral · Quinacridone Violet · Dioxazine · Cobalt Violet

French Ultramarine · Cobalt Blue · Winsor Blue Red Shade · Winsor Blue Green Shade · Cobalt Turquoise · Indanthrene · Manganese Blue Hue

Viridian · Winsor Green Yellow Shade · Winsor Green Blue Shade · Green Gold · Permanent Sap Green · Hooker's Green · Terre Verte

Winsor Lemon · Transparent Yellow · Aureolin · Indian Yellow · New Gamboge · Quinacridone Gold · Gold Ochre

Burnt Umber · Raw Sienna · Raw Umber · Burnt Sienna · Quinacridone Burnt Orange · Quinacridone Sienna · Vandyke Brown

There are many other colours that are suitable for glazing, including opaque colours (see page 47). Make sure that any colours you use for glazing are mixed with plenty of water.

UNDERSTANDING UNDERLAYERS

The simple exercise of painting one colour as the first layer and allowing it to dry completely, before applying stripes of several colours on top, is a great way to learn how colours work together in glazes.

By making a chart like this, you can see the pure colour of the underlayer and the differences when adding various second layers of paint. This is a simple, fun way of learning about glazing without experimenting on your real watercolour paintings. Allow your underlayer to dry thoroughly before adding the next layer or glaze.

The watercolours I have used here are Daniel Smith Extra Fine watercolours, painted on Saunders Waterford, Bockingford High White 638gsm (300lb) Cold-pressed (Not surface) watercolour paper.

STRIPES FOR EACH SET
OF THREE UNDERLAYERS
Top to bottom:

Indian Yellow

Prussian Blue

Permanent Rose

Raw Sienna

Pyrrol Scarlet

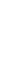

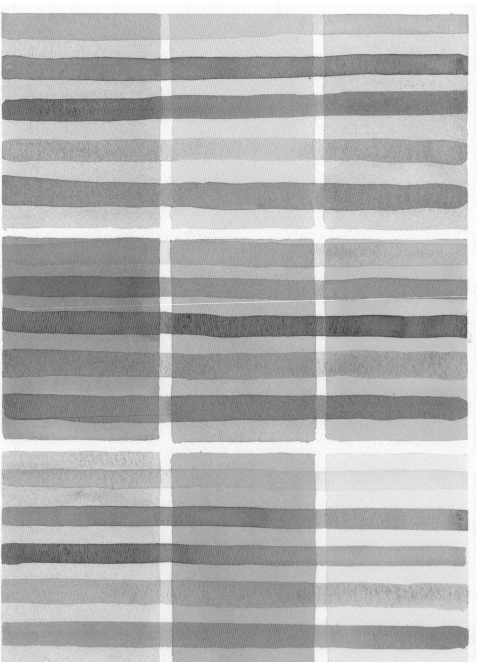

1

« UNDERLAYERS
Left to right:

French Ultramarine

Quinacridone Gold

Viridian

2

« UNDERLAYERS
Left to right:

Quinacridone Coral

Dioxazine

Sap Green

3

« UNDERLAYERS
Left to right:

Cobalt Blue

Permanent Alizarin Crimson

New Gamboge

SQUARE GLAZING CHARTS

The square chart is a more experimental way of working with glazes. Work in a more intuitive way and don't plan the layers as logically as with the striped chart opposite. There are two layers of paint in most squares but a few of the squares have only one layer in them, so that you can see the pure colour of that underlayer.

Painted on Saunders Waterford High White 638gsm (300lb) Cold-pressed (Not surface) watercolour paper with Winsor & Newton Professional watercolours.

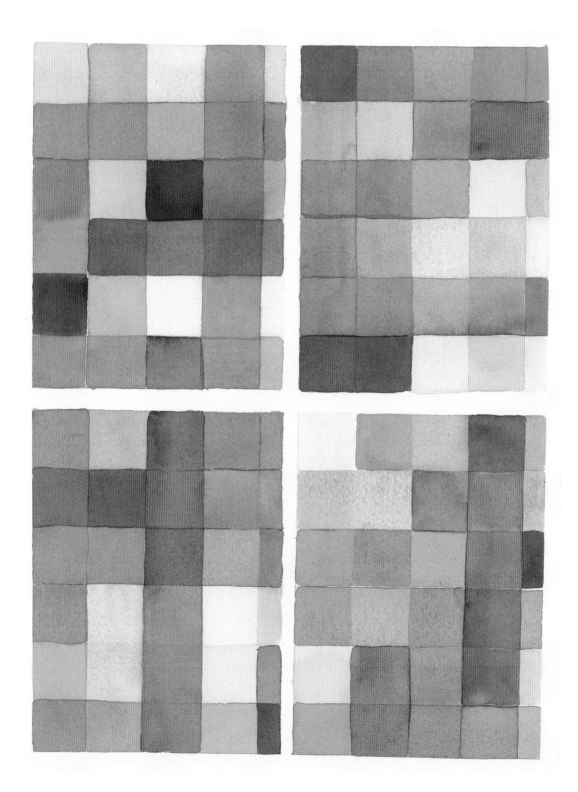

GLAZING WITH MIXES

Moving on from glazing with pure colours, this chart shows the effect of glazing with mixes. In the top row, begin with a mix of Burnt Sienna and French Ultramarine and layer the pure colours on top.

Painted on Saunders Waterford 425gsm (200lb) Hot-pressed watercolour paper.

UNDERLAYER

French Ultramarine + Burnt Umber

 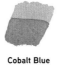

| Burnt Umber | French Ultramarine | Cobalt Blue | Cerulean Blue |

French Ultramarine + Burnt Sienna

| Burnt Umber | Cerulean Blue | French Ultramarine | Winsor Blue Red Shade |

Cobalt Blue + Burnt Sienna

| Permanent Alizarin Crimson | Cobalt Blue | Burnt Sienna | Light Red |

Cerulean + Raw Sienna

| Burnt Sienna | Cerulean | Raw Sienna | Permanent Rose |

Cerulean

| Light Red | Permanent Rose | Permanent Alizarin Crimson | Quinacridone Red |

Raw Sienna

| Light Red | Permanent Rose | Quinacridone Red | Quinacridone Magenta |

Burnt Sienna

| Light Red | Cerulean Blue | Cobalt Blue | French Ultramarine |

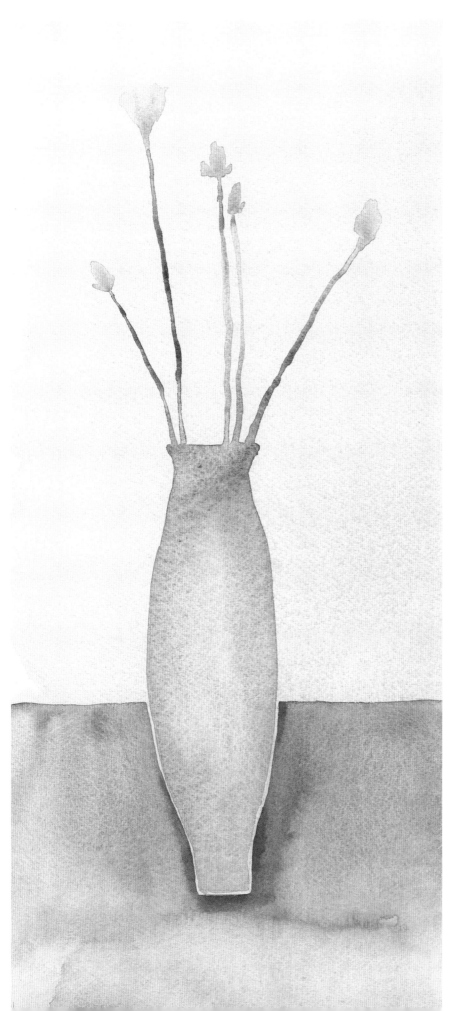

VASE

25 × 56cm (10 × 22in)

Painted on Saunders Waterford, Bockingford 535gsm (250lb) Rough watercolour paper, using a limited palette of French Ultramarine, Burnt Sienna and Cerulean.

Vase is an example of a painting using glazing. The background or underlayer shines through some of the flowers, vase and the darker surface at the bottom.

Still Life with Tulips

This still-life project shows how glazing can be used in other subjects. A vase, a leaf and their background can be given more depth by the addition of another layer of paint. A glaze will enhance the colour of the flowers, with the underlayer shining through.

The finished painting can be seen on page 135.

WHAT I USED
Paints: Daniel Smith Extra Fine watercolours in Perylene Green, French Ultramarine, Quinacridone Violet, Burnt Sienna, Quinacridone Rose and Lemon Yellow.
Brushes: Squirrel mop – size 2/0, sable brushes – numbers 12, 6, 4 and 1.
Other tools or materials: Pencil.
Support: Saunders Waterford High White 638gsm (300lb) Cold-pressed (Not surface) watercolour paper.

THE PALETTE

Perylene Green: dark and medium

Quinacridone Violet: dark and medium

Burnt Sienna: dark and medium

French Ultramarine: dark and medium

Lemon Yellow: dark and medium

Quinacridone Rose: dark and medium

THE MIXES

Perylene Green + French Ultramarine: medium, pale and very pale

Quinacridone Rose + Lemon Yellow: pink to orange mixes

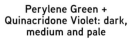

Perylene Green + Quinacridone Violet: dark, medium and pale

French Ultramarine + Burnt Sienna: medium, pale and very pale mixes

Before you begin

Make up two mixes of Perylene Green and French Ultramarine, one that is mostly green and one that is mostly blue.

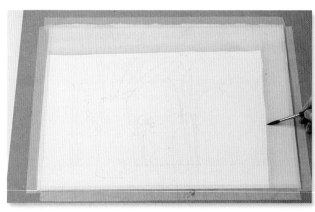

1. Paint in the top and side edges with the number 12 in a predominantly green mix of Perylene Green and French Ultramarine, and leave to dry.

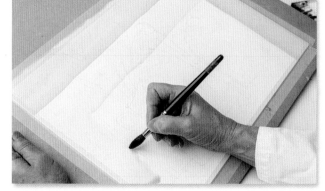

2. With the board angled, run a wash of the bluer mix of French Ultramarine and Perylene Green along the top edge, then down the left edge and onto the bottom edge. Work around the jug but under the glass vase. Again, leave to dry.

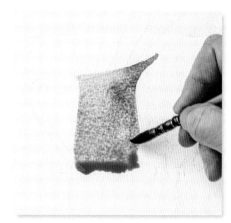

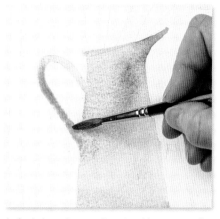

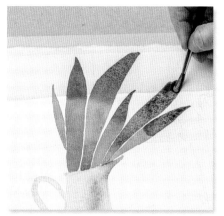

3. To paint in the jug, take the size 2/0 squirrel mop first, and alternate between strong and medium mixes of French Ultramarine. Keep the board angled as you work and keep the area very wet; paint the colour in one go, but vary the tones.

4. Switch to the number 6 sable to control the colour at the base of the jug. While the paint is still wet, paint the handle. Gently shake and bang the board to settle the pigments, then allow to dry.

5. Paint the leaves with a mix of Perylene Green and Quinacridone Violet with the number 6 brush. Vary the tones – start with the darks, then move on to the lighter mixes. Add pure Perylene Green to the dark areas of the leaves and leave to dry.

6. Move on to the large vase next: make up two pale mixes of French Ultramarine and Burnt Sienna. Use the number 1 brush to paint the ridge at the top of the vase, then move on to the number 6 for the larger areas.

7. For the tulip heads themselves, make up three mixes from Quinacridone Rose and Lemon Yellow, from pink to orange, switching between the number 4 and the number 1 brushes.

133

8. Move on to the small vase: put this in with a very pale mix of French Ultramarine and Burnt Sienna with the number 4 brush. Allow to dry.

9. For the smaller flowers, use Quinacridone Rose, in dark and medium tones. Touch up the leaves to separate them; glaze them to darken them, using a quite-dark tone of Perylene Green.

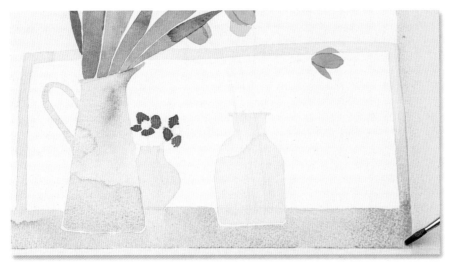

10. Paint the border using a grey mix of French Ultramarine and Burnt Sienna as a one-layer glaze. Keep the border quite narrow, using the number 4 brush. Paint a glaze onto the foreground using the number 6 brush and a pale mix of French Ultramarine and Burnt Sienna.

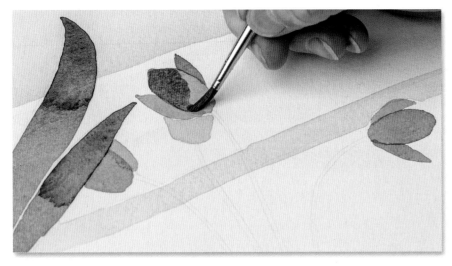

11. Layer over the tulips to brighten them; use the number 4 and the pinkest mix of Quinacridone Rose and Lemon Yellow. You may not need to apply the mix to all the flowerheads.

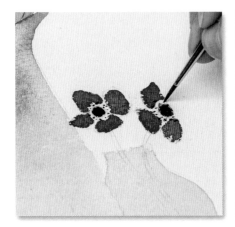

12. Go into the small flower centres with a dark mix of Perylene Green and Quinacridone Violet with the number 1 brush, then dot in the stamens with the tip of the brush.

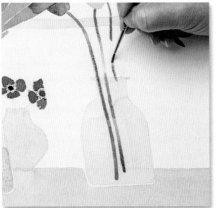

13. For the stems in the largest jar, use Perylene Green but keep Quinacridone Violet to hand in case a darker tone is needed. Still with the number 1 brush, paint clean water onto the stems first, then apply the colour. Keep the stems darker at the bottom, and work from the flowerhead downwards. Paint the smaller stems in the same way.

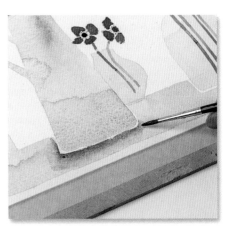

14. Glaze in some shadows using a darker mix of French Ultramarine and Burnt Sienna. Blend out the colour with clean water; paint shadows under all three vases or pots to anchor them.

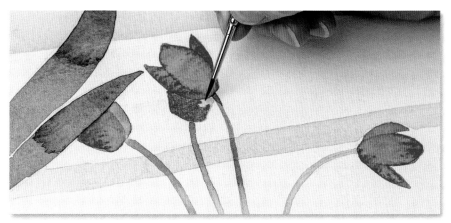

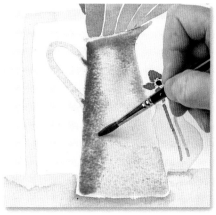

15. Apply more of the pink mix of Quinacridone Rose and Lemon Yellow on any tulips that are left purely yellow; but let the yellow shine through.

16. FInally, glaze over the large jug to strengthen it, with more, darker French Ultramarine – wet the jug with the squirrel mop and clean water, and use the number 6 brush to apply the blue itself. The glaze can correct any tone that you want to amend.

❧ THE FINISHED PAINTING.
41 × 28.5cm (16⅛ × 11¼in)

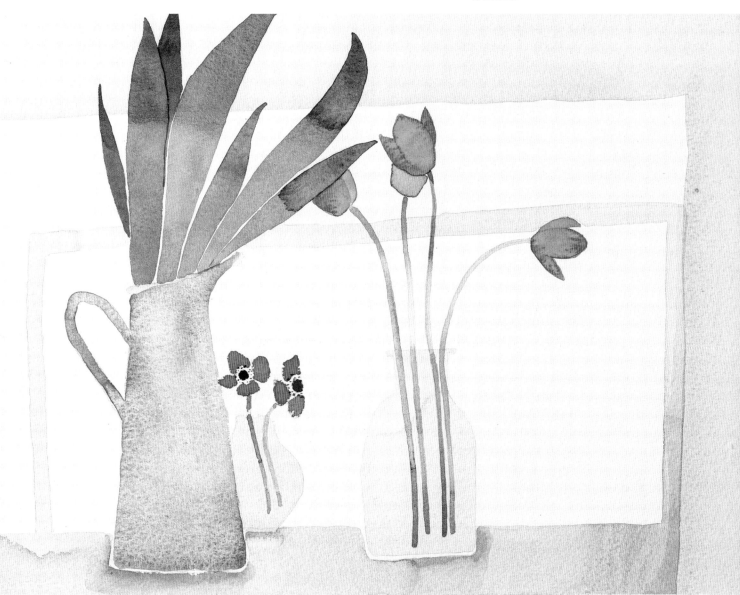

MINERAL PIGMENTS & LUMINESCENT WATERCOLOURS

Mineral pigments and luminescent watercolours are exciting additions to your watercolour palette. These paints can be used to create many beautiful effects in your paintings. These effects are subtle and glimmering rather than 'glittery' – this is because to create the mineral paints the manufacturer has used natural materials collected from around the world. The stories, geography and history of where the minerals in pigments are sourced are fascinating and, for me, add a special element to these paints.

Within this chapter are the explanations of the various mineral and luminescent paints available.

MINERAL PIGMENTS

The mineral pigments shown on these pages and overleaf have been painted on Saunders Waterford High White 425gsm (200lb) Cold-pressed (Not surface) watercolour paper, using Daniel Smith PrimaTek paints. These paints are made from minerals that are sourced from the ground – a mineralogist travels the world to find new pigments for the range, which began with Lapis Lazuli Genuine, shown below, which was sourced from the mountains of Chile. This colour is made from at least 80 per cent pure gem pigment suspended in a binder.

Lapis Lazuli Genuine has been prized for its beauty throughout history. It remains hugely expensive, and its hardness makes it difficult to mine. It is mined in Chilean mountains and is a clean, opulent blue. The inclusion of golden pyrite adds a touch of shimmer to this paint.

Bronzite Genuine is mined in Bellahorizonte in Brazil. It is a warm honey-bronze colour with a sparkle that comes from iron oxide. It falls somewhere between ochre and sienna and is a granulating pigment.

Sleeping Beauty Turquoise Genuine is from the Sleeping Beauty Mountain in Arizona. Environmental factors have enhanced the structure to gemstone-quality, and this gives a tonal richness to this amazing blue. It is lightfast and permanent, which is a huge bonus, as so many turquoise colours fade over time.

Tiger's Eye Genuine is made from a brownish gold stone. It is a strongly granulating, very transparent pigment, which contains a combination of quartz and iron oxide. The stone is mined in Africa.

Blue Apatite Genuine is a fabulous dense, rich midnight blue pigment that granulates on hot press or cold press watercolour paper surfaces. It is a striking mineral too soft to be used for jewellery but wonderful as an artist pigment.

Garnet Genuine is a beautiful warm, red orange that is mined in Brazil. It's similar to Quinacridone Burnt Scarlet but has more texture as it is a granulating colour.

Jadeite Genuine is made from two minerals: Jade and Nephrite. Its lustre is vitreous and it is another fabulous granulating colour.

Bloodstone Genuine is a sacred mineral and its intense velvety aubergine tone develops into a series of warm greys. It mixes well with most watercolours but works particularly well when mixed with Rhodonite Genuine and Quinacridone Burnt Orange.

Minnesota Pipeline Genuine is made from the same shade of stone that Plains Indians revered for making Sioux peace pipes. It's a semi-opaque, permanent, granulating pigment that makes beautiful washes.

Amazonite Genuine is a very versatile, transparent, non-staining colour that lifts off easily. It is a beautiful teal, which is mined from Minas Gerais in Brazil.

Piemontite Genuine is ground from a scarlet-streaked mineral and is a deep, rich colour. It is a semi-transparent violet brown that granulates with a carmine tone.

Green Apatite Genuine is a dark, almost olive green and when mixed it is very useful for creating a beautiful range of greens. It was once sourced from Yates Mine in Canada.

Sickerlite Genuine is a fabulous cocoa-brown pigment, mined in Colorado, USA. It is a transparent colour that has wonderful granulating properties.

Sedona Genuine is an ethereal red, made with authentic rock from the Arizona desert. It is a rich earth red with coral undertones and is a permanent pigment.

Sodalite Genuine is one of the components of Lapis Lazuli. It is a distinctive deep inky-blue colour that granulates as it dries. It is very useful for creating texture in a painting as it creates a wonderful three-dimensional quality as it dries.

Rhodonite Genuine is a beautiful rose pink and a versatile colour that is useful for portraits and landscapes. It is a transparent, low staining and non-granulating pigment.

Mayan Blue Genuine is mined in Texas and is a fabulous green-tinged indigo. The Mayan people used it in their murals and sculpture, and it formed an important part of their ancient rituals. It has since been recreated using an eco-friendly process. It is a versatile and very durable pigment.

MIXING MINERAL PIGMENTS WITH PURE WATERCOLOUR

Mineral pigments mix very well with pure watercolour pigments to create additional interest and texture. Here, I have mixed a selection of mineral pigments with Cobalt Blue.

Cobalt Blue + Tiger's Eye Genuine **Cobalt Blue + Bronzite Genuine** **Cobalt Blue + Minnesota Pipeline Genuine** **Cobalt Blue + Jadeite Genuine** **Cobalt Blue + Amazonite Genuine**

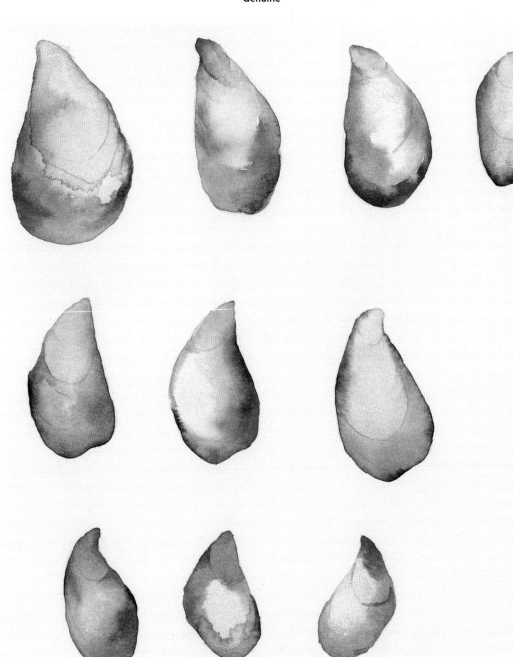

LUMINESCENT WATERCOLOURS

The luscious, shimmering quality of good luminescent paint is beautiful to work with. When these paints are used sparingly and mixed with other colours, wonderful effects are created.

There are four different categories of luminescent watercolours: iridescent, interference, pearlescent and duochrome – over the following pages, I explain these categories and suggest how you can use them to their full advantage.

IRIDESCENT COLOURS

These reflect light directly, giving intense colour and sheen. They are all lightfast and transparent. Iridescent colours add intensity and sheen when they are mixed with pure watercolours, as shown in the painted examples here.

Moonstone	Sunstone	Aztec Gold	Gold
Moonstone + Cadmium Orange Hue	Sunstone + Permanent Rose	Aztec Gold + Quinacridone Magenta	Gold + Permanent Alizarin Crimson
Jade	Garnet	Russet	Scarab Red
Jade + Viridian	Garnet + Permanent Alizarin Crimson	Russet + Cobalt Blue	Scarab Red + Cobalt Blue

The subtlety of luminescence

I used to have an aversion to luminescent or iridescent paints and to the slightest amount of shimmer in a painting. For me, it was too reminiscent of heavy glitz and glitter – that is, apart from the gold leaf found in illuminated manuscripts and in the work of Gustav Klimt (1862–1918). I do love silver and gold as colours, but I never used to use any shimmer in my paintings. Now that I have discovered the beautiful and very subtle luminescent, iridescent watercolours, I have completely changed my mind.

«

MUSSEL SHELLS
37 × 29cm (14½ × 11½in)

Painted on Saunders Waterford 425gsm (200lb) Hot-pressed watercolour paper, using Daniel Smith Extra Fine watercolours in Duochrome Lapis Lazuli, Prussian Blue and Permanent Alizarin Crimson.

Luminescent watercolours hold fantastic qualities for particular subjects in watercolour. Many shells have a natural silvery sheen which can't be rendered in pure watercolour. The addition of one Duochrome colour to a limited palette of Prussian Blue and Permanent Alizarin Crimson meant that I could replicate the sheen and colour shifts that you see in a mussel shell.

Electric Blue	Sapphire	Antique Copper	Antique Gold
Electric Blue + Viridian	Sapphire + Permanent Rose	Antique Copper + Raw Sienna	Antique Gold + Viridian

INTERFERENCE COLOURS

Interference colours refract and scatter light, and are all lightfast and transparent. When interference colours are mixed with pure colours, they take on different hues depending on where the light is striking and the viewer's perspective.

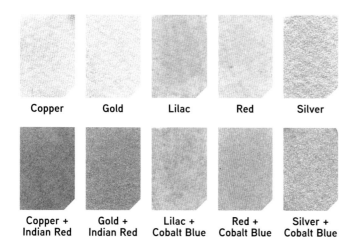

Copper	Gold	Lilac	Red	Silver

Copper + Indian Red	Gold + Indian Red	Lilac + Cobalt Blue	Red + Cobalt Blue	Silver + Cobalt Blue

PEARLESCENT COLOURS

Pearlescent colours will give an opalescent sheen when they are mixed with pure watercolours. This is a milky iridescent quality, rather like an opal gem.

Pearlescent White

Pearlescent White, French Ultramarine + Burnt Sienna

Pearlescent Shimmer

Pearlescent Shimmer + Cobalt Blue

⌄ BELLA'S FEATHERS
26 × 25cm (10¼ × 10in)

Painted on Saunders Waterford 435gsm (200lb) Hot-pressed watercolour paper, using Daniel Smith Extra Fine watercolours.

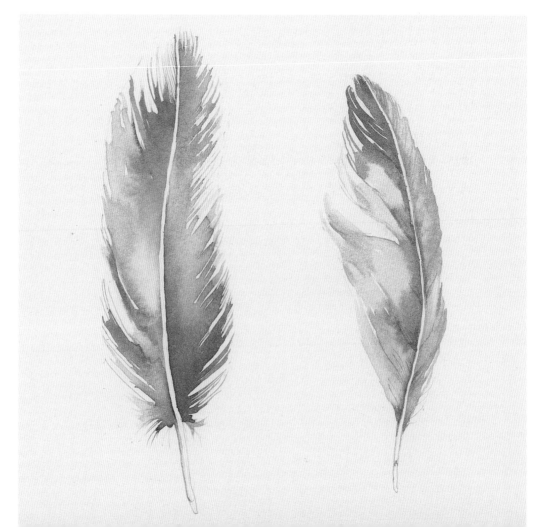

DUOCHROME COLOURS

Duochrome colours bounce between two different hues depending on the source of the reflective light. Each colour is lightfast and transparent and will also create beautiful shifting colour effects when mixed with pure colours.

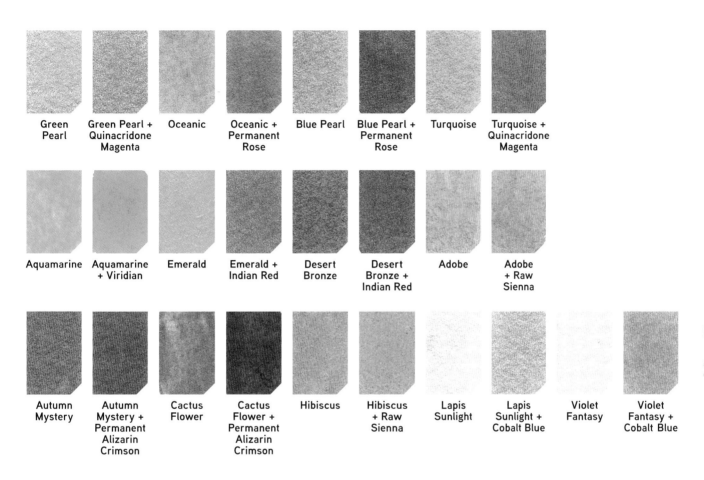

| Green Pearl | Green Pearl + Quinacridone Magenta | Oceanic | Oceanic + Permanent Rose | Blue Pearl | Blue Pearl + Permanent Rose | Turquoise | Turquoise + Quinacridone Magenta |

| Aquamarine | Aquamarine + Viridian | Emerald | Emerald + Indian Red | Desert Bronze | Desert Bronze + Indian Red | Adobe | Adobe + Raw Sienna |

| Autumn Mystery | Autumn Mystery + Permanent Alizarin Crimson | Cactus Flower | Cactus Flower + Permanent Alizarin Crimson | Hibiscus | Hibiscus + Raw Sienna | Lapis Sunlight | Lapis Sunlight + Cobalt Blue | Violet Fantasy | Violet Fantasy + Cobalt Blue |

PAINTING LUMINESCENT COLOURS ON A DARK BACKGROUND

The luminescent colours are beautiful on white paper, but if you want to create a more dramatic and intense effect, you can try them on a black painted ground (see page 8). Apply it to Saunders Waterford High White 638gsm (300lb) Cold-pressed (Not surface) watercolour paper, allow the ground to dry thoroughly and then paint over the top with colours from the duochrome selection above.

PAINTING WITH LUMINESCENT WATERCOLOURS

In each of these examples, you can use a fairly limited palette, with the addition of some luminescent paint. The luminescent element adds extra interest to delicate subjects such as feathers and flowers.

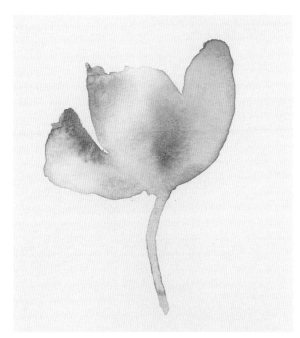

142

Painted on Saunders Waterford 425gsm (200lb) Hot-Pressed watercolour paper, using Daniel Smith Extra Fine watercolours.

FLOWER STUDIES

These simple flower studies can be painted freehand using one pure colour with one luminescent colour, such as Quinacridone Rose with Iridescent Sunstone, and Ultramarine Turquoise with Duochrome Oceanic.

Try out one pure colour mixed with one iridescent colour for the flowers on your own worksheet.

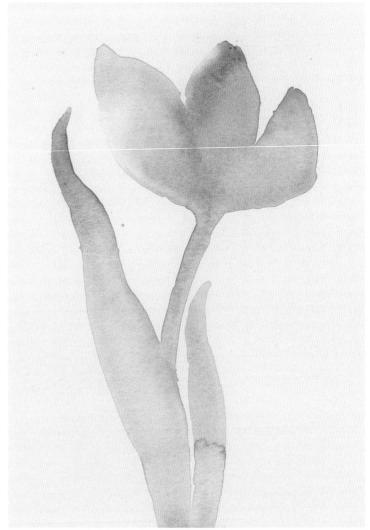

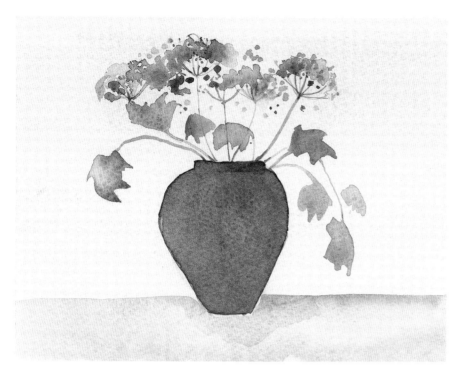

Painted on Saunders Waterford High White 638gsm (300lb) Cold-pressed (Not surface) watercolour paper, using Daniel Smith Extra Fine watercolours.

STILL LIFE

Recreate this *Still Life* using a palette of French Ultramarine, Burnt Sienna and Interference Lilac. The composition can be created using glazing techniques; here, the interference colour adds interest by giving different hues to certain areas in the picture.

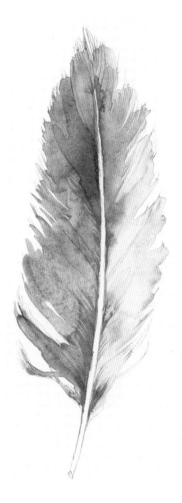

143

FEATHER

This feather can be painted in the same way as the *Inside, Outside* project starting on page 144. It features a limited palette of French Ultramarine, Burnt Sienna and Duochrome Adobe: the duochrome bounces between hues depending on the viewer's perspective, and adds richness to the painting.

Inside, Outside

Shells are a perfect subject for luminescent and mineral watercolours. Areas of subtle colour typically seen on the surface of the shell lend themselves to being painted wet into wet with a touch of iridescent sheen. The blooms created by the wet into wet technique are used to recreate the markings on the shells.

 Both the inside and the outside of a shell are shown in this painting – hence the title of this project. The larger area, the outside, is painted first.

 This painting is the only project that does not need to be worked on a board

WHAT I USED

Paints: Daniel Smith Extra Fine watercolours in Shadow Violet, Cobalt Blue, Iridescent Sunstone, Quinacridone Rose and Sepia.
Brushes: Sable brushes – numbers 6, 4 and 1.
Other tools or materials: Pencil and putty eraser.
Support: Saunders Waterford 638gsm (300lb) Hot-pressed watercolour paper.

THE PALETTE

Iridescent Sunstone; Quinacridone Rose; Cobalt Blue; Shadow Violet and Sepia.

THE MIXES

Iridescent Sunstone with Quinacridone Rose gradually added

Iridescent Sunstone, Quinacridone Rose, Cobalt Blue, Shadow Violet and Sepia

Iridescent Sunstone with Quinacridone Rose + Cobalt Blue – mixes ranging from pink to violet

Pure Shadow Violet, with Cobalt Blue gradually added

Pure Shadow Violet, with Cobalt Blue gradually added

The full-size finished painting can be seen on page 147.

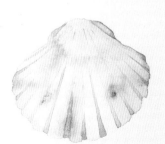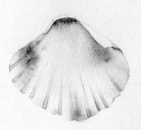

1. Mix the colours you will need: Shadow Violet-Cobalt Blue, Sepia-Shadow Violet and Iridescent Sunstone-Quinacridone Rose in various tones in your palette. Then begin by painting clean water over the whole surface of the larger shell, using the number 6 brush. Do this carefully to make sure that the water is even all over with missing areas. You can check this by tipping the painting to catch the light.

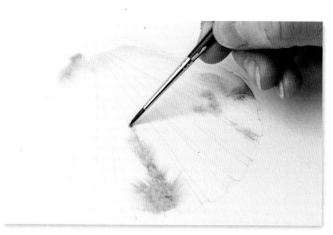

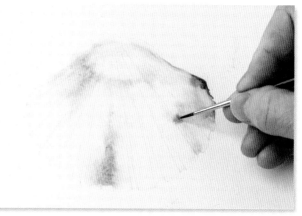

2. Paint the Shadow Violet–Cobalt Blue wet-into-wet around the right-hand edge of the larger shell, and leave it to dry.

3. Switch to the number 1 brush to apply Iridescent Sunstone with Quinacridone Rose, then switch to the Cobalt Blue and Shadow Violet mix.

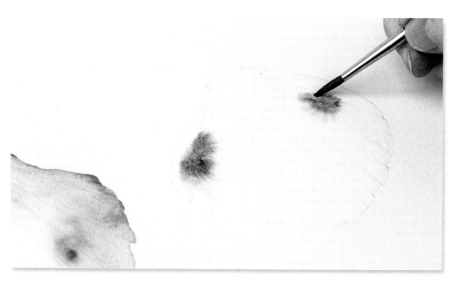

4. Now begin work on the smaller shell. Paint clean water over the entire shell with the number 6 brush (as in step 1). Paint the Shadow Violet-Sepia mix, wet into wet with the number 4 brush.

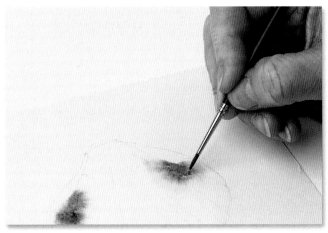

5. Work over the Shadow Violet-Sepia mix with a small amount of Quinacridone Rose.

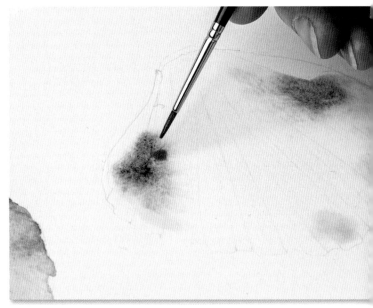

6. Work over the shell again in Sepia with Shadow Violet, and the Iridescent Sunstone. Leave to dry.

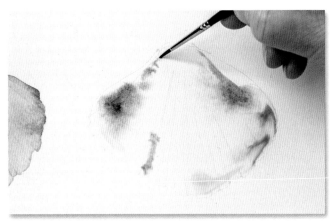

7. Ensure that the painting is completely dry before beginning to work on the shadows. With a number 1 brush, paint the shadows with a dark Shadow Violet-Sepia mix. The technique here is to apply a small amount of dark paint and then blend it with a small amount of water.

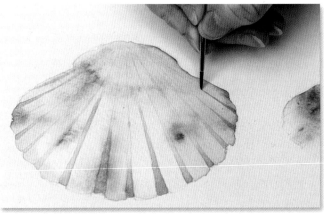

8. Paint in Iridescent Sunstone and Quinacridone Rose to make the larger shell appear more three-dimensional. Paint this in on both sides of the ridge of the shell, then repeat on the second shell.

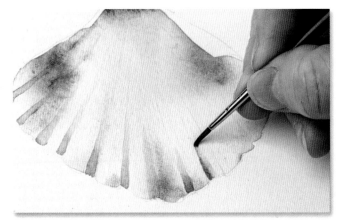

9. Apply Shadow Violet with Sepia and blend out the darks with clean water.

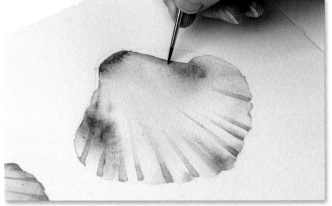

10. Paint a shadow under the ridge of the shell using the same mix (Shadow Violet with Sepia).

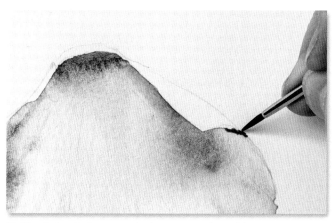 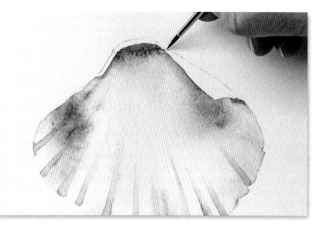

11. Check the shell to see whether you need to add any extra darks or details. Take care not to be too fussy and overdo the detail.

12. Define the curve of the edge using a dry brush technique with the number 1 sable. Leave to dry, then erase your pencil drawing to complete the project.

❤ **THE FINISHED PAINTING.**
 33 × 18cm (13 × 7in)

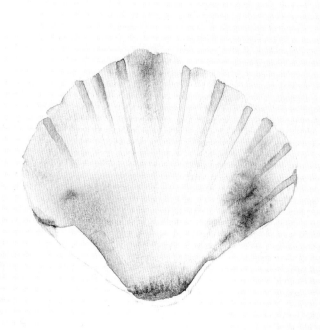 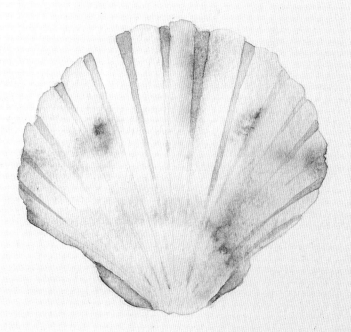

EXPERIMENTATION & INSPIRATION

A LAST WORD

Once you have put in the groundwork and you feel more confident with your watercolours, the next, most exciting thing is to experiment and become more creative with your colour combinations. For me, this is the most rewarding element of watercolour: when colour becomes more personal to you, you can work with colours that truly appeal to you and begin to work more instinctively.

Experimentation is a very personal thing. This chapter will give you some starting points, but to be truly creative you will need to develop your own ideas and trust your instincts as to the direction to go with your colours and your work.

ABSTRACTION AND COLOUR

In the twentieth century, early abstract painters were concerned about the expressive qualities of colour. Then after the Second World War, American Abstract Expressionism became widespread. Artists experimented with paint and colour on a grand scale. I was taught by a generation of painters who related very strongly to Abstract Expressionism and this has influenced some elements of my own work.

The Abstract Expressionist movement began in American in the late 1940s and became a dominant trend in western art during the 1950s – artists wished to express themselves through gesture, composition and colour. These artists included Mark Rothko (1903–1970), Helen Frankenthaler (1928–2011), Arshile Gorky (c.1904–1948) and Jackson Pollock (1912–1956). Pollock used expressive gestures to create his abstract works; then other Abstract Expressionists, for example Rothko, made outstanding 'colour-field' paintings, which consisted of large-scale combinations of soft-edged, solidly coloured rectangular areas that shimmered and resonated.

JODRELL BANK
38 × 38cm (15 × 15in)

Painted on Saunders Waterford 638gsm (300lb) Cold-pressed (Not surface) watercolour paper.

Painted in watercolour and acrylic.

Jodrell Bank was selected by the great abstract painter Albert Irvin, RA, to be exhibited at the Mall Galleries, London. I used a bright and colourful palette for this painting, which was developed from one of my many trips to Cornwall, UK, where I always work outside, happily sketching and painting the landscape.

COLOUR EXPERIMENT
42 × 29.7cm (16⁹/₁₆ × 11¹¹/₁₆in)

Painted on Saunders Waterford 425gsm (200lb) Hot-pressed watercolour paper.

This colour experiment is an expressive colour painting. Here, I have used a limited palette of only three colours: New Gamboge, Winsor Blue Red Shade and Permanent Rose.

The painting was done on A3–size paper with no initial drawing. I mixed plenty of paint before I began, and only had a rough idea of the grid pattern that I wished to create. My idea was to allow the paint to 'do the work', so I painted in a very wet style, allowing the colours to merge and mix on the paper. Working freehand with a lot of paint, I was able to produce this abstract colour experiment.

EXPERIMENT WITH COLOURS

The following eight experimental paintings are examples of how to begin to explore
a subject with colour in an imaginative way.

 The starting point for each painting is the colour: spend plenty of time deciding which
sets of colours you will use. Select a limited palette of no more than four colours.
You can use a piece of test paper to try out various combinations before you begin.
Each painting shown here is no bigger than 20 × 20cm (8 × 8in) but you can work on
whatever size of paper you prefer.

 Decide on a subject matter that is inspiring and personal to you. Will your painting be
a still life, a leaf composition, a flower arrangement or an imaginative abstract painting?
I find it very inspiring to set up a simple still life in the studio where there is a great
collection of vases, pots, jugs, shells, stones, feathers and tablecloths to choose from.
As a very keen gardener I can usually find some good flowers or foliage to include too.

2 Use a wide range of colours
mixed from your limited palette and
then work in an intuitive way to
create this abstract pattern.

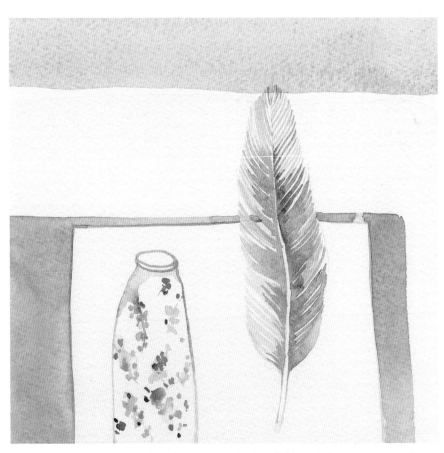

1 To create a painting like this, set up a simple still life and plan your composition
and your colours before you begin. Here, we are using one yellow, one blue, a pink
and a brown. Glazing techniques can be used to create the background (see pages
126–135).

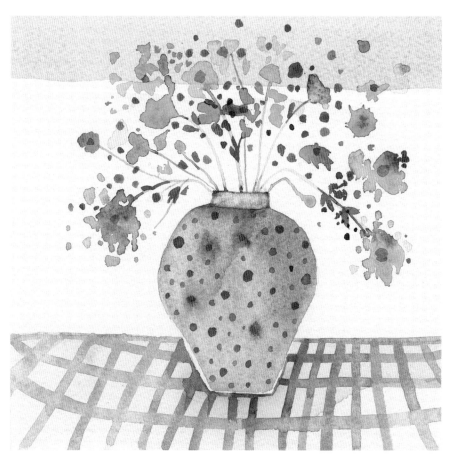

3 This still life can be created in the same way as number 1, opposite, again using a limited palette of one red, one yellow and one blue.

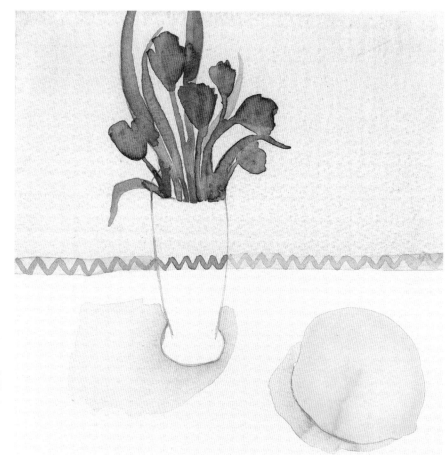

4 This is a similar exercise to numbers 1 and 3, using different colours; here, I have worked from life, with a vase of tulips and a lemon for the composition.

5 Choose a limited palette of one yellow, red, blue and brown. Working from life with, for example, a rose, a shell and a plate, think carefully about how to create unusual compositions.

6 This painting uses the same palette as number 5, but the colours can be mixed differently to make a more subdued painting.

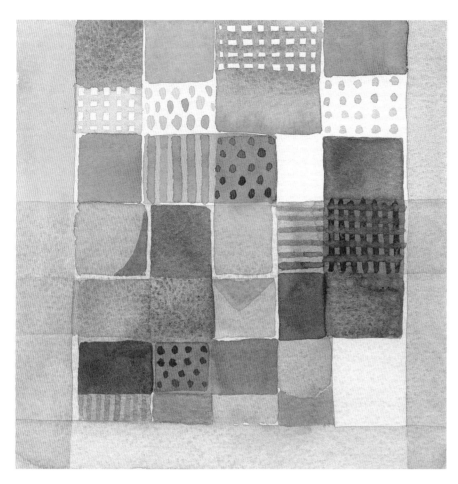

7 You can refer to the chapter on glazing (see pages 126–135) to create an abstract painting like this. Page 128 shows some colour combinations that you can use.

8 Again, refer to the glazing chapter (see pages 126–135) and *The Interaction of Colour* (see pages 98–111) to inspire a painting like this.

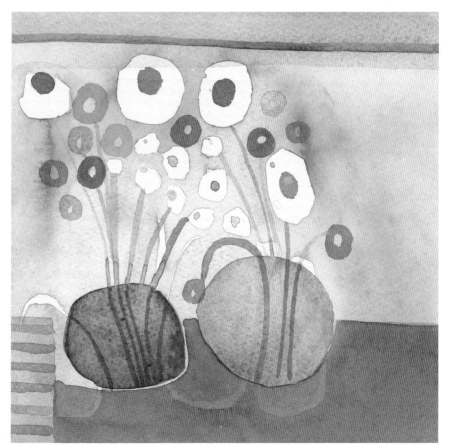

Trees and Birds

The final project features a much larger palette of colours to create an imaginative piece. When using a wider palette of colours, it is good practice to take your time working carefully through each step.

The finished painting can be seen on page 157.

WHAT I USED

Paints: Daniel Smith Extra Fine watercolours in Cobalt Blue, Quinacridone Rose, Cadmium Red Medium Hue, Viridian, Burnt Sienna, Raw Sienna, Aureolin, Iridescent Electric Blue, Shadow Violet, Quinacridone Purple and Permanent Alizarin Crimson.

Brushes: Squirrel mop – size 2, sable brushes – numbers 6, 4, 1 and 0.

Other tools or materials: Pencil and wax candle.

Support: Saunders Waterford High White 638gsm (300lb) Cold-pressed (Not surface) watercolour paper.

THE PALETTE

Quinacridone Purple; Quinacridone Rose; Permanent Alizarin Crimson; Cadmium Red Medium Hue; Cobalt Blue; Iridescent Electric Blue, Viridian; Shadow Violet; Burnt Sienna; Raw Sienna and Aureolin.

THE MIXES

Cobalt Blue with Quinacridone Purple gradually added

Background wash colours: pale Cobalt Blue + pale Quinacridone Rose; Cobalt Blue + Quinacridone Purple, medium and pale mixes

Viridian + Burnt Sienna; Viridian + Raw Sienna

Viridian + Aureolin: 50:50 mix; more yellow; more green.

Cadmium Red Medium Hue + Permanent Alizarin Crimson; Shadow Violet + Iridescent Electric Blue; Quinacridone Purple + Iridescent Electric Blue.

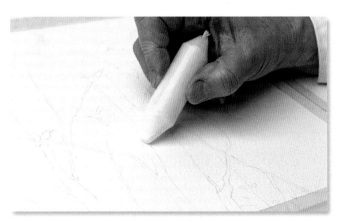

1. Apply candle wax resist for the white areas on the tree trunks and in parts of the sky. (See the finished painting on page 157 for guidance on the white areas.) You can also do this with masking fluid, but I like the irregular marks that the candle makes in the painting.

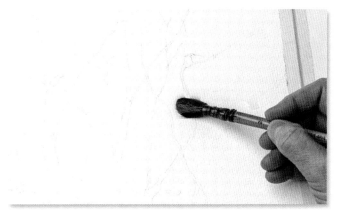

2. Wet the paper with the squirrel mop, size 2. Apply the water like a wash: keep the board at an angle and catch the wet edge with the brush. Hold the paper up to the light to ensure the water is even all over the paper.

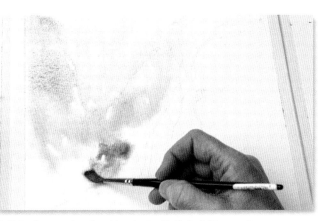

3. Take the number 6 sable; start with Cobalt Blue on its own over the background, then work in the violet mix of Cobalt Blue and Quinacridone Rose.

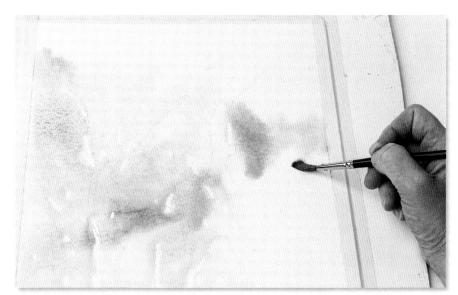

4. Apply the pink – Quinacridone Rose – by itself.

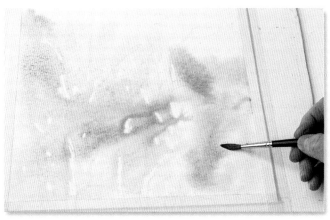

5. Apply more Cobalt Blue along the bottom of the paper.

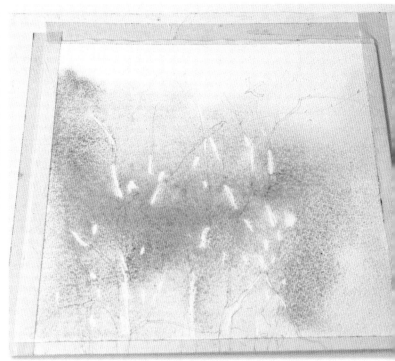

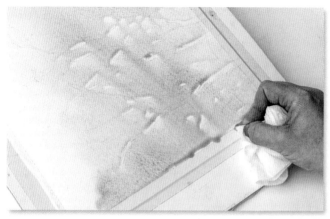

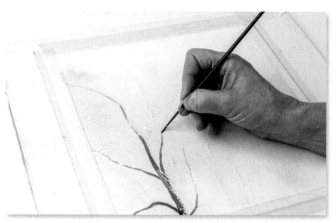

6. Tilt the board around to make the colour coverage even. The wax will begin to show through. Mix the colours on the paper, then mop up along the wet edge of the wash with kitchen paper. Leave to dry.

7. With the number 4 sable and the darker green mix – Viridian and Burnt Sienna – paint in the tree trunks. Then switch to the number 1 for the smaller branches. Use the lighter green mix of Viridian and Raw Sienna towards the tops of the trees.

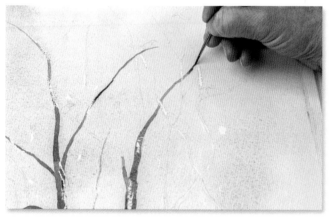

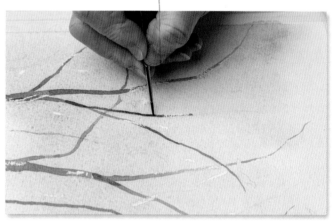

8. Use the number 4 and the lighter green mix for the second tree along from the left. Keep the greens lighter behind and darker in the foreground; keep the tone varied especially where the branches cross over. You can always go back and darken some of the branches if they don't read properly after you apply the first layer of colour.

9. Paint some thin branches that aren't on your original pencil sketch; work on instinct to decide where the branches need to be. Leave to dry.

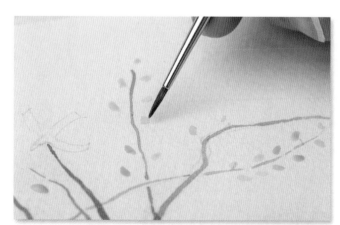

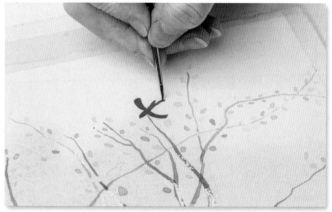

10. Dot in the leaves in four different colour mixes: three Viridian and Aureolin mixes – one 50:50 mix, one that is more yellow and one that is more green – with the occasional leaf in a dark green mix of Viridian with Burnt Sienna. Using the number 1 sable; work freehand (don't predraw the leaves). Alternate between the different greens, and paint them in towards the ends of the branches. Leave to dry.

11. For the birds, use the number 1 sable for the bodies of the smaller birds; switch to the number 0 for the wing tips and details. Mix a dark blue-purple from Iridescent Electric Blue and Quinacridone Purple and a grey from Iridescent Electric Blue and Shadow Violet. Start with the blue-purple mix and drop in the darkened grey mix.

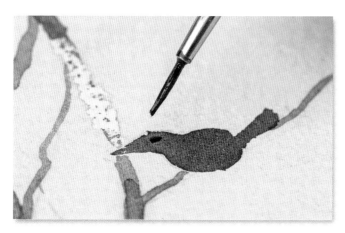

12. Now paint some of the red birds, alternating between Cadmium Red Medium Hue and Permanent Alizarin Crimson, then the grey mix for shadow once the birds have dried. Finally, add any necessary details with the number 0 sable brush either in the shadow mix or in Shadow Violet on its own to complete.

THE FINISHED PAINTING.
25.5 × 26.5cm (10 × 10½in)

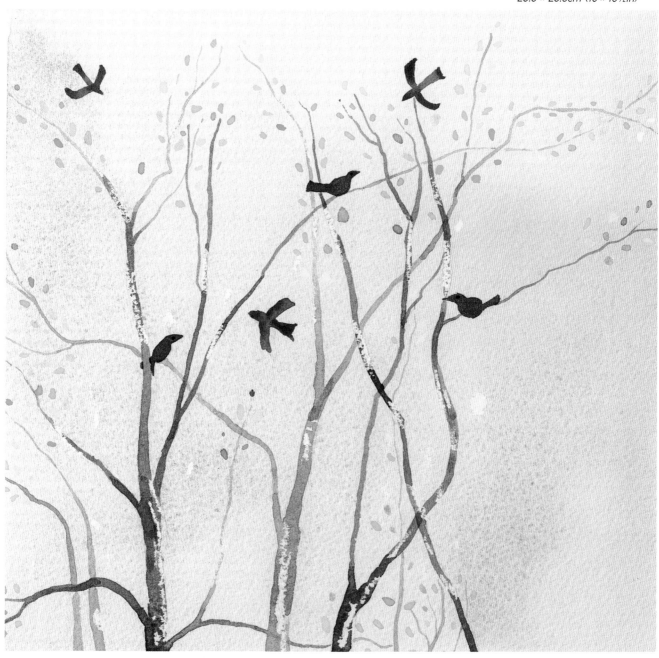

157

Glossary

Acrylic paint Paint for which thermoplastic resins are used as a medium to bind particles of pigment.

Analogous Describes three colours that sit next to each other on the colour wheel.

Artists' watercolours See: Professional watercolours.

Attributes of colour Colours have three intrinsic attributes: hue, value and saturation.

Binder A medium used to bind loose particles of pigment to become paint. Gum arabic is used as a binder for watercolour and gouache paint.

Cadmium A paint that has cadmium as one of its components: these are reds, oranges and yellows.

Cobalt An intense blue pigment.

Cold-pressed Describes a medium-textured watercolour paper, also known as Not (Not-pressed). This paper is smoother than Rough paper, but more textured than Hot-pressed paper.

Colour interaction How colours work or appear together.

Colour temperature This term refers to whether a colour is considered to be warm or cool.

Colour scheme A set of colours chosen to combine in a painting.

Colour wheel A round, two-dimensional arrangement of colours that shows colour relationships.

Complementary Describes two colours that are opposite each other on the colour wheel and when placed side by side enhance the brilliance of one another.

Contrast The difference in colours, such as complementary pairings, or in tone, such as between light and dark colours.

Cool colours Usually blues, violets and some greens, which are used to portray the coolness of water, sky and so on.

Duochrome Colours that appear to 'bounce' between two different colours.

Earth colours Colours traditionally made from natural materials such as clay or minerals.

Fluorescent Describes an extremely bright colour, such as Opera Rose. Fluorescent colours are not lightfast.

Glazing A technique of applying thin layers of transparent paint where each layer dries before applying the next. Each layer shines through and alters the colours of the succeeding layers.

Granular, granulating The grainy characteristic of some pigments that separate on the paper, creating interesting textures.

Grey scale A useful scale that shows tone.

Ground A base layer on watercolour paper. This could be a thin layer of paint or a special medium that gives a coloured or textured layer.

Harmonious Describes balanced colour relationships.

Highlight A light accent in a painting, such as an intense area of light on an apple.

Hot-pressed Hot-pressed paper is the smoothest texture of watercolour paper and is made by passing the paper through heated rollers to smooth the surface.

Hue The name of a given colour – such as blue or yellow.

Inorganic pigments (also natural or synthetic) These are derived from chemical compounds that don't include carbon. They contain metallic oxides, salts and other compounds.

Intensity The brightness or dullness of a colour.

Interference colours Colours that refract and scatter light.

Iridescent Describes colours that reflect light directly, resulting in intense colour and sheen.

Layering see: Glazing.

Lightfast Describes a colour or pigment that will not fade if exposed to light for a prolonged time.

Local colour The colour, as seen in isolation, of an object – for example, a red rose.

Luminosity The quality of giving off light or glow.

Masking The use of something to protect an area from being painted – for example, masking fluid (see below).

Masking fluid A fluid painted over an area to keep it white while surrounding areas are painted. The fluid can then be rubbed off when the painting is dry.

Medium A textured substance added to paint or pigment.

Monochromatic Describes a painting made using only one colour.

Muller A hand-held or automated device used to grind and disperse pigment into a liquid base or binder.

Neutral A neutral is made by dulling a colour, ideally by mixing two complementary primaries together, such as for a shadow mix.

Not (or Cold-pressed) Describes paper that has a medium-textured surface, which is smoother than Rough paper, but more textured than Hot-pressed paper.

Ochre Ochres have been used in art since the Stone Age. These are natural earth pigments, consisting of silica and clay with iron oxide. Colours include reds, oranges, yellows and browns.

Opaque Not transparent. Some watercolours and all gouache paints are opaque.

Organic colours These are pigments derived from plants or animals or are made synthetically, and contain carbon.

Palette A surface on which to hold pigments, with space to mix paint.

Pans Solid blocks of watercolour.

Pearlescent Describes colours with an opalescent sheen.

Permanent Describes a reliable, fast colour that will not fade.

Pigment A material in powdered form that gives a paint its colour.

Primary colours Colours that cannot be mixed from any other colours – these are red, yellow and blue.

Prism An object used to refract light and recreate the colours of the rainbow.

Professional watercolours The highest-quality watercolours with the highest content of pigment.

Quinacridone An organic molecule used to produce organic pigments. The quinacridones are bright, transparent colours ranging from oranges, reds, to pinks and violets.

Rough paper Describes paper that has a highly textured surface.

Saturation This is the degree of purity in a hue or colour. The more saturated the hue, the more intense the colour.

Secondary colours The colours made by mixing two primary colours – these are orange, green and purple.

Semi-opaque Describes a colour that is not fully opaque, and is slightly transparent.

Semi-permanent Describes a colour that is not fully permanent and may fade in light.

Semi-transparent Describes a colour that is not fully, but fairly, transparent.

Shade A shade is made by adding a complementary colour to dull the original colour.

Size This is a gelatinous substance applied to watercolour paper to reduce its absorbency.

Spectrum A band of colours organized in wavelengths from an array of electromagnetic energy.

Staining Describes colours that permanently tint – or stain – the paper.

Students' watercolours Less expensive than artists' or professional watercolour paints but with inferior pigment content.

Support The surface on which you apply watercolour paint – generally paper.

Synthetic pigments These are made from chemical syntheses or processes, and may be organic or inorganic.

Terre verte A green pigment also known as 'green earth', made from marine sediment.

Tertiary colours These are made from mixing a primary colour with a secondary colour adjacent on the colour wheel.

Tonal wheel A round, two-dimensional diagram, created in order to depict and understand tone.

Tone The degree of intensity or strength of a colour, described as a range from light to dark. It is also referred to as value (see below).

Transparent See-through.

Translucent Describes pigments that are semi-transparent – neither fully transparent nor opaque.

Ultramarine 'Ultramarine' means 'beyond the sea': it originated in Afghanistan when it was originally made from lapis lazuli.

Value Value is the range from light to dark in a painting or colour. It is also referred to as tone.

Vibrant colours Refers to bright colours.

Viridian A vivid, transparent green.

Warm colours These are colours associated with heat, such as red, orange and yellow.

Wash A thinly diluted layer of watercolour paint applied to the paper.

Watermark The manufacturer's symbol or name embossed on the edge of an expensive watercolour paper. It can be seen clearly when the paper is held up to the light.

Wet-into-wet A technique whereby watercolour paint is applied to paper that has already been made wet with water or paint.

Wet-on-dry A technique whereby watercolour paint is applied to dry paper or a layer of paint that has already dried fully.

Index